ART DISCOURSE/
Discourse in Art

JESSICA PRINZ

ART DISCOURSE/
Discourse in Art

RUTGERS UNIVERSITY PRESS
NEW BRUNSWICK, NEW JERSEY

Library of Congress Cataloging-in-Publication Data

Prinz, Jessica
 Art discourse/discourse in art / Jessica Prinz.
 p. cm.
 Includes bibliographical references and index.
 ISBN 0-8135-1673-0
 1. Postmodernism. 2. Performance art. 3. Arts, Modern—20th
 century. I. Title.
 NX456.5.P66P75 1991
700′.9′04—dc20 90-19388
 CIP

British Cataloging-in-Publication information available

FOR MY PARENTS

CONTENTS

Illustrations

ACKNOWLEDGMENTS

I am indebted to four scholars whose work greatly aided the development of my own ideas here: Henry Staten (*Wittgenstein and Derrida*), Gregory Ulmer (*Applied Grammatology*), Craig Owens (for his excellent essays on postmodern art), and Marjorie Perloff (*The Poetics of Indeterminacy: Rimbaud to Cage*). The books by Staten and Ulmer helped me to view interdisciplinarity as a cross-cultural phenomenon, as important for the theorists of our time as for its artists. Staten's book was especially welcome, since it articulated a "minority" view of Wittgenstein, close, I think, to how an artist like Joseph Kosuth probably read him. Owens's essays on Smithson and Anderson are outstanding, and I have tried in my own writing to confirm his ideas in a general way without following too closely in his footsteps; if I "decenter" or "disrupt" his arguments in places, it is only to create "detours," as it were, from his pathbreaking observations.

The greatest debt here is to Marjorie Perloff. Her essay on Cage and Antin in *The Poetics of Indeterminacy* inaugurates a new discussion of literature, or rather, a discussion of a new kind of literature, one that breaks through the traditional "margins" of art. My gratitude here goes far beyond the reading of Professor Perloff's books; in reading this manuscript, she provided invaluable feedback and criticism. I am especially grateful for her receptivity and openness to new art and to new ideas, which led her not only to tolerate but to actively encourage these "marginal" studies of my own.

I would like to thank Susan Larsen-Martin, Leo Braudy, James Phelan, Mac Davis, Anthony Libby, and Gregory Ulmer for taking time from their own work to read this study either in part or in whole. The strengths of the manuscript derive from their insightful criticism, its weaknesses I acknowledge to be mine. Special appreciation is also offered to my colleagues and friends at The Ohio State University who have always been emotionally supportive and intellectually stimulating.

Some gratitude is due to Michael Engel, who not only introduced me

to the Fluxus book, *An Anthology*, but also introduced me to his father, S. Morris Engel, a Wittgenstein scholar who took time from a busy teaching schedule for a very pleasant discussion about language games. It was not, however, our talk that helped to clarify my ideas so much as the Engel family itself, which enacts in a visible way the filial relation of Wittgenstein and concept art that I saw operating within Kosuth's work.

For permission to reproduce images within this study, grateful acknowledgment is made to Nancy Holt, Joseph Kosuth, Jasper Johns/ VAGA, The Leo Castelli Gallery, HarperCollins Publishers, The Institute of Contemporary Art (University of Pennsylvania), The Philadelphia Museum of Art, The Norton Simon Art Foundation, The Hirschhorn Museum, The Los Angeles County Museum of Art, Gianfranco Gorgoni, Perry Hoberman, Allan Tannenbaum, Jonathan Borofsky, Isshi Press, Mac Wellman, Dona McAdams, Paula Court and John Jesurun.(Warner Bros. Records permitted me to borrow Anderson's video, *O-Superman*. I am especially grateful to Nancy Holt for permission to make slides and photographs from *The Spiral Jetty* film. Finally, special thanks are extended to The Ohio State University for a grant that made possible the reproduction of these images.

For kind permission to quote material published by them, grateful acknowledgment is made to the following:

David Antin, for permission to quote from "remembering, recording, representing."

Artforum, for permission to quote from "Entropy and the New Monuments" by Robert Smithson, copyright © *Artforum*, June 1966; from "A Sedimentation of the Mind: Earth Projects" by Robert Smithson, copyright © *Artforum*, September 1968; from "Incidents of Mirror Travel in the Yucatan" by Robert Smithson, copyright © *Artforum*, September 1969; from "Toward the Development of an Air Terminal Site" by Robert Smithson, copyright © *Artforum*, Summer 1967; and from "Cultural Confinement" by Robert Smithson, copyright © *Artforum*, October 1972.

Arts Magazine, for permission to reprint "Quasi-Infinities and the Waning of Space" by Robert Smithson, copyright © *Arts Magazine*, November 1966.

Basil Blackwell, for permission to quote from *Philosophical Investigations* by Ludwig Wittgenstein, copyright © 1958 by Basil Black-

well; and quotations from *The Blue and Brown Books* by Ludwig Wittgenstein, copyright © 1958.

Jonathan Borofsky, for permission to quote from *Dreams*, copyright © 1987 by Jonathan Borofsky, artist.

Grove Press, for permission to quote from *The Unnamable* by Samuel Beckett, copyright © 1958 by Grove Press, Inc. Used by permission of Grove Weidenfeld.

HarperCollins Publishers, Inc., for permission to quote from *The Blue and Brown Books* by Ludwig Wittgenstein, copyright © Basil Blackwell, 1958; and for permission to quote from *United States* by Laurie Anderson. Copyright © 1984 by Laurie Anderson.

Jenny Holzer, for permission to quote from *Truisms* and "The Survival Series," copyright © Jenny Holzer.

Houghton Mifflin Company, for permission to reprint the rabbit-duck image from Jastow's *Fact and Fable in Psychology*, copyright © 1900.

Isshi Press/Watari-Um, for permission to quote from *Dreams*, copyright © 1987 by Jonathan Borofsky.

John Jesurun, for permission to quote from *Everything That Rises Must Converge*, copyright © 1989 by John Jesurun.

Joseph Kosuth, for permission to quote from the works of Joseph Kosuth.

Macmillan Publishing Company, for permission to quote from *Philosophical Investigations* by Ludwig Wittgenstein. Reprinted with permission of Macmillan Publishing Company from *Philosophical Investigations* by Ludwig Wittgenstein. Copyright © 1953 by Macmillan Publishing Company.

Hansjorg Mayer, for permission to quote from *The Bride Stripped Bare by Her Bachelors, Even*, a typographical version by Richard Hamilton of Marcel Duchamp's *Green Box*, translated by George Heard Hamilton, published by Edition Hansjorg Mayer, Stuttgart, London.

Steve McCaffery, for permission to quote from *Evoba* by Steve McCaffery, copyright © 1987 by Steve McCaffery; and "Wordsworth: A Performance Transform" by Steve McCaffery, copyright © 1979 by Steve McCaffery.

New Directions Press, for permission to quote from *Labyrinths* by Jorge Louis Borges, copyright © 1962, 1964 by New Directions Publishing Corp.; and for permission to quote from David Antin's "remembering, recording, representing."

The Estate of Robert Smithson, for permission to quote from *The Writings of Robert Smithson*, copyright © 1979 by Nancy Holt.

Mac Wellman, for permission to quote from *Terminal Hip*, copyright © 1984, 1986, 1990 by Mac Wellman.

Sections of this study were presented at the Conference on Twentieth-Century Literature in Louisville (February 1986), the American Society for Aesthetics Conference (Boston, 1986), The Modern Languages Association (New York, 1986), and The International Conference on the Fantastic in the Arts (Ft. Lauderdale, 1988). I am grateful to these audiences for their kind comments and criticism. Thanks are also extended to *Genre* for permission to reprint the chapter on Laurie Anderson which appeared in the (1987) special issue on post-modern genres.

Finally and most importantly, in his process of learning language, my son, Joseph, offered more convincing evidence for the validity of Wittgenstein's later theory than any scholar could have; if he has not yet entirely "mastered the technique" of language, he succeeded long ago in mastering his mother's heart.

ART DISCOURSE/
Discourse in Art

Any interpretation still hangs in the air with what it interprets, and cannot give it any support. Interpretations by themselves do not determine meaning.

LUDWIG WITTGENSTEIN, *Philosophical Investigations*

meaning, n. 1, = that which exists in the mind (e.g. yes, that is my —, *mihi vero sic placet, sic hoc mihi videtur;* see INTENTION, WISH, OPINION ; 2, see PURPOSE, AIM ; 3, = signification, *significatio* (of a word), *vis* (= force of an expression), *sententia* (= the idea which the person speaking attaches to a certain word), *notio* (= original idea of a word ; see IDEA), *intellectus, -us* (how a word is to be understood, post Aug. t.t., Quint.) ; it is necessary to fix the — of the verb "to be in want of," *illud excutiendum est, quid sit* CARERE ; to give a — to a word, *verbo vim, sententiam, notionem sub(j)icĕre;* well- —, see BENEVOLENT.

Joseph Kosuth, "Titled (A.A.I.A.I.)." Courtesy of Joseph Kosuth.

1 THE TEXT IN THE EYE

And yet *there is* pleasure, some still remains; *there is, es gibt, it gives*, the pleasure is what *it gives;* to nobody but some remains and it's the best, the purest. And it is this remainder which causes *talk*, since it is, once again, primarily a question of *discourse* on the beautiful, of discursivity *in* the structure of the beautiful and not only of a discourse supposed to happen accidentally *to* the beautiful.

JACQUES DERRIDA, *The Truth in Painting*

Robert Smithson's description of a drawing by Sol LeWitt effectively describes an entire generation of art (Fig. 1.1): "The information on his announcement for his show (Dwan Gallery, Los Angeles, April, 1967) is an indication of a self-destroying logic. He submerges the 'grid plan' . . . under a deluge of simulated handwritten data. The grid fades under the oppressive weight of 'sepia' handwriting. It's like getting words caught in your eyes" (Smithson, *WRS* 69). When we look at much of the art produced within the past few decades, we can't help getting "words caught in our eyes." Whether printed or painted, xeroxed or sculpted, typed or taped, words have surfaced both as a prominent image within the visual arts and also in many cases as a central subject.

In the following chapters, I submit to close reading works by artists for whom language is an essential constituent part of art. They are, however, representative cases for a much larger "eruption" of language into the field of the visual arts (Owens 1979, 126). This "eruption" began early in the century, exploded on the scene in conceptual art, and is still evident today in performance modes and multimedia installations. Some sense of this larger preoccupation with language on the part of visual artists is important for understanding the artists treated here—Jasper Johns, Joseph Kosuth, Robert Smithson, and Laurie Anderson.

Figure 1.1. Sol LeWitt, One Set of Nine Pieces, *1967. Drawing. Courtesy Estate of Robert Smithson.*

Indeed the pervasiveness and the variety of "language works" produced during the past few decades is remarkable. It encompasses paintings with words as dominant images (Edward Rusha, Arakawa), words painted on walls (Lawrence Weiner, Robert Barry, Mel Bochner), words printed on sheets of vinyl (Edwin Schlossberg), visual signs contextualized by theoretical essays (Daniel Buren), essays on aesthetics presented as art (The Art and Language Group), wall texts that are stories (Jean Le Gac), collage or sculptural objects with fictional texts (Alexis Smith, Edward Kienholz), performed texts (Guy de Cointet, Joseph Beuys, Jacki Apple), discussion art (Ian Wilson), books (Lawrence Weiner, Dan Graham), card files (Robert Morris), postcards with words (On Kawara), puns conveyed through body art (Bruce Nauman, Chris Burden), thesaurus works (Kosuth, Acconci), sculptures with texts (Alice Aycock), rooms filled with painted words (Kaprow), installations designed like books (Alison Knowles's *The Big*

Book) or like novels (Acconci's *Plot*) to walk through, scripted events (George Brecht), the exchange of spoken or written secrets (Acconci, Huebler), videos with spoken narratives (Lynda Benglis), multi-media installations with texts (Jonathan Borofsky and Marcel Broodthaers), photographs with words (Barbara Kruger), neon signs (Jenny Holzer)—the list could go on and on and the names of other practitioners almost endlessly added.[1] Numerous art movements generated within the past two decades are also defined by their use of language: Conceptual art, Narrative art, Discussion art, and Performance art all include programs for using language as a primary material. Since the 1960s, language has become as important to many artists as the brushstroke has remained to others.

It was Conceptual art, reacting against formalism and carrying the Duchampian aesthetic into our time, that "ushered art into the non-space of the text" (Ratcliff, "Robert Morris" 107). Largely regarded as the turning point between modern and postmodern aesthetics, or as one reviewer put it, "the straw that broke the Modernist camel's back" (Roberta Smith 82), Conceptual art continues to shape many of the forms art takes in our day. If it was neglected and scorned by a public who found it inaccessible, overly intellectual, troubling, and, in spite of its own goals, elitist, it nevertheless had a major impact on artists themselves. Even those movements that were defined in opposition to Conceptualism, like Narrative art, were still greatly indebted to it, and much art that differs widely from it today still has sources in its style. Laurie Anderson, for example, whose work is emotionally loaded, popular, sensory, and commercial (all of the things Conceptual art was not), studied with Sol LeWitt and actively practiced a Conceptual art in her early work.

All of the artists to be discussed here have some relation to Conceptual art. Duchamp and Johns are major forerunners, prefiguring in their own work some of the major trends towards philosophy and literature that recur in later art. Joseph Kosuth is a mainstream Conceptualist, a "visual" artist whose sole material is language and whose linguistic experiments follow closely "after philosophy." This artist works not with vision or form but with meaning and language instead. Art and aesthetics are inextricably tied in his work, as the discourse on art becomes part of the art itself. Because of their purposeful confusion of theoretical and artistic practice, Robert Smithson's essays are linked to Concept art. But the literary component of his work, its experiential

and emotive force, its extensive exploration of the relation of word and image, and its incorporation of earth works and earth materials all differ from Kosuth's cool, cerebral, and verbo-centric art. At the furthest extreme from mainstream Conceptual art are the multimedia extravaganzas produced by Laurie Anderson. Even here, however, it was Conceptualism, the integration of theory and language in art, that, at least in her view, paved the way for contemporary Performance art. Thus she tells an interviewer:

> This is my half-baked theory about performance art and live art—my theory is that it began with this kind of heroic, gestural, physical situation, artists who said, "I paint because I like paint. That's why I paint." Then you get guys like Barnett Newman, who was very smart. And he's a person who's sitting in the same bar talking to the people who write about art. And he's been painting a blue painting, and he's talking about the *meaning* of this blue paint. An extremely articulate guy who is capable of saying things like "Aesthetics is to me what ornithology is to birds." Now, in fact, he didn't really believe that, because much of his work was about talking about the edge, the field, and the tension, and this and that. Much of his art is about the language that surrounds it. . . . And that's, I believe, the generation ahead of what's called live art, which is people *really* standing next to blue in real time, saying "Blue is . . ." They come out of a tradition which has been very *talky*. The theory has bound itself into the work so tightly that it in fact generates another form. That's my own half-baked theory. (La Frenais 267)

Despite the slang of Anderson's "talk," she is making an important point: in the 1960s, when language entered the visual arts not as a supporting discourse supplied by critics for a formalist art but rather was manipulated, investigated, and controlled by artists themselves, the whole art field changed, generating not only the new forms of performance art that we witness today, but also entirely original interdisciplinary "systems" like Robert Smithson's. Post-formalist art is characterized in many cases by this implosion of language into art.

What is most distinctive in the art of this time, then, is the way in which the visual debate concerning art's possibilities, limits, and

boundaries becomes a verbal one. Words are used not only in the production of art (Kosuth, Weiner, Barry, and Huebler), but also in the production of theories which become inseparable from it.[2] Traditionally, artists create objects and leave critics free to formulate the conceptual implications of their art. "As such," Kosuth says, "the traditional artist functions like the 'valet's assistant' to his marksman master (the critic)" ("Introductory Note" 100). The Art and Language Group (Kosuth, Buren, Smithson, and Beuys) are just some of the artists who appropriate the critic's role and create critical discourse as an essential part of art; they generate the ideas through which the artistic objects and actions are viewed, or present theoretical discourse as the substance of art. Each artist manipulates the relation of theory and art in a slightly different way. Members of the Art and Language group write essays that are presented as "visual" art.[3] Smithson intertwines art criticism and art forms, sustaining a shifting balance through a constant interplay of verbal and visual components. Theory becomes performance in Beuys's *How To Explain Pictures to a Dead Hare*, itself a poignant commentary on the necessity and the futility of talking about art.[4] Kosuth places priority on theory; his visual "forms of presentation" are secondary manifestations of his ideas; nevertheless, they constitute *procedures* essential to his art.

The prevalent use of language in contemporary visual art is just one manifestation of the whole orientation of postmodern culture towards language. "The sixties," writes Julia Kristeva, "witnessed a theoretical ebullience that could roughly be summarized as leading to the discovery of the determinative role of *language* in all the human sciences" (*Desire in Language* vii).[5] Structuralism in general "turned to language as a model for understanding all cultural phenomena" (Steiner, *Colors of Rhetoric* 51). As Barthes put it in *Elements of Semiology*, "The world of signifieds is none other than that of language. . . . We shall therefore postulate that there exists a general category language/speech, which embraces all the systems of signs; since there are no better ones, we shall keep the terms language and speech, even when they are applied to communications whose substance is not verbal" (11, 25). W. J. T. Mitchell observes that semiotics in general failed to provide an adequate theory of the image, even when individual theorists (Eco, for example) did not subscribe entirely to Barthes's "linguistic imperialism" (*Iconology* 56). Viewed in this context, the prioritization of language in conceptual art, where the "texts themselves have become the

art" (Battcock, "Documentation" 42), was not an aberration of art history so much as the fullest expression of the intellectual thought of its time. It is not a coincidence that one of the most important texts on the postmodern style was titled *The Language of Post-modern Architecture* and that Charles Jencks asked us to attend to architectural "syntax" and "semantics" (39).

A shift has occurred since the sixties to modify this view of language, on the part of both theorists and artists. Language and image are now frequently presented without priority, and there is a concern for the interplay of sign systems rather than any hierarchy between them. Smithson, Anderson, and other artists like Jonathan Borofsky set image and text in constantly changing relations to one another; these artists would concur with Mitchell's observation that the real task—not only of theory but of artistic production—"is not to renounce this dialogue" between word and image (*Iconology* 46).

The problematic term "postmodernism," then, is not problematic when we consider such developments within the visual arts. As many scholars have noted, the term itself implies an undeniable continuity with a modern past. The controversy centers on whether or not the present age has produced anything substantially different from and qualitatively equal to its modern forebears. More than a decade has passed since William Rubin made the following observation:

> Perhaps, looking back 10, 15, 30 years from now, it will appear that the modernist tradition really did come to an end within the last few years. . . . If so, historians a century from now—whatever name they will give the period we now call modernism—will see it beginning shortly after the middle of the nineteenth century and ending in the 1960s. . . . Perhaps the dividing line will be seen as between those works which essentially continue an easel painting concept . . . and, let us say, Earthworks, Conceptual works and related endeavors. . . ."

Clearly Earthworks, Conceptual works, and "related endeavors" have not replaced painting as a viable activity for the artist; witness, say, hard-edged realism, photo-realism, and neo-expressionism. But just as clearly, such artists as Kosuth, Smithson, and Anderson all produce

work that calls into question and effectively tests the conventional boundaries of art.

These artists all create works which incorporate the objectives, media, or strategies of "outside" disciplines in significant ways. Not only is the modernist aesthetic of an autonomous art object rejected within this art, but also, along with it, the notion of art as itself autonomous and separate from other disciplines. As Mitchell has observed, "The period of involuted specialization in which disciplines turned in upon themselves seems to be coming to an end" (*Language* 295). Although the breaching of artistic boundaries is not confined to any historical period (Mitchell, *Iconology* 98), I would argue that it *has* surfaced with tremendous force and great variety in our own time.[6]

It is probably true that most great art breaks generic categories: Tzvetan Todorov, for example, argues that only subliterary texts obey the rules of genre, while literary texts do not (Kent 1). In *Art and Illusion*, E. H. Gombrich describes as distinctively human ("the dignity of man"), the capacity "to extend the classes of things beyond their rational groups" (102). "Similes, metaphors and the stuff of poetry no less than of myth," he says, "testify to the powers of the creative mind to create and dissolve new classifications" (313). The strategies of contemporary art can be viewed as part of this more general dynamic of creativity; however, postmodern art shifts this process in a significant way from the level of genre to the level of disciplines. David Antin's remarks on this subject articulate the working assumptions of numerous artists and writers working today: "If we are to do something meaningful," he says, "we may have to begin by eliminating the genres that have helped to trivialize our art. By this I don't mean 'sub-genres' like 'painting' or 'sculpture.' I mean the distinctions between the arts in general" ("It Reaches a Desert . . ." 66).

Lucy Lippard's bibliographical history of the Conceptual art movement, *Six Years*, concludes with an editorial statement in which she proposes that idea art failed in its stated efforts to break through disciplinary boundaries (263f). Rethinking this same issue in light of more recent conceptually-derived forms like Smithson's art, I reach a quite different conclusion. The works considered here, like Smithson's "Quasi-Infinities" and *The Spiral Jetty* or Anderson's *United States*, really do, I think, straddle the lines between "literature" and "visual art," between the literary and the physical, or, in Anderson's case, between the literary, the pictorial, the musical, and the theatrical.

Such disciplinary crossovers, moreover, are now a cross-cultural phenomenon and are pursued as actively by some poets as by these artists. The mixing of performance contexts can tell us as much about this determination to mix disciplinary categories as the artistic products do. David Antin, for instance, is a performance poet who has participated in conceptual art shows[7] and has performed alongside such artists as Kosuth and Beuys.[8] A film produced by Ron Mann in 1982, *Poetry in Motion*, focuses on the performance strategies of contemporary poets and shows, in one segment, John Cage reading a passage from *Empty Words*, and, in another, Allen Ginsberg "howling" a poem, accompanied by a rock and roll band.[9] Anderson regularly situates her work between art, poetry, and rock and roll, and she performs both with and alongside the writer William Burroughs. This mixing of performance partners and contexts parallels the mixing of the arts which occurs within their work. As Michel Benamou once asserted, performance is the "unifying mode of the postmodern" (3), postmodern, I would argue, because it is part of a much larger and more widespread practice of confusing and fusing the once separate disciplines.

I will be looking here at hybrid art, liminal works which intersect or balance precariously between disciplinary modes. If, as I am assuming, there is a literary dimension to Smithson's art and to Anderson's, the work demands a modified notion of "literature," even as it requires a modified notion of "art." Smithson's "Monuments of the Passaic" offers an exemplary case here, for it can be read as the documentation for a Conceptual art activity (a walking tour of Passaic, New Jersey) *and* as a "literary" essay: Smithson's allusions mark his essay as an Odyssean journey that takes place within a literary tradition from Homer, to Williams's *Paterson*, to Borges's "The Immortal." The essay also includes photographs and other "reproduced reproductions," further complicating its ambiguous disciplinary status. "Textual art" is an appropriately ambivalent term for work such as this, because it suggests a link with literature (all of which is "textual art"), but not claiming for it all of the traditional values or elements that the term "literature" entails. These works are simply something "in between," "odd" objects that are neither one thing or another but many things in new combinations.

Interartistic comparisons are problematized and to some extent subverted by interartistic art of this kind. The analogies drawn by scholars to create connections between the "irrevocably separate" arts (Steiner,

Colors 4) are now generated by the artists themselves within their work. Smithson's mirrors are emblems for the (mirror) *displacements* which occur between word and thing within his art ("Incidents of Mirror Travel to the Yucatan").

Other *intra*artistic analogies would be those that the artists create for the disciplinary displacements and category confusions that the art itself entails. Indeed, as Kim Levin observes, the map appears again and again in contemporary art as an appropriate metaphor for its own boundary breaking strategies:

> If the grid is an emblem of modernism, as Rosalind Krauss has proposed—formal, abstract, repetitive, flattening, ordering, literal—a symbol of the modernist preoccupation with form and style, then perhaps the map should serve as the preliminary emblem of postmodernism: indicating boundaries beyond the surface of the artwork and surfaces outside art, implying that boundaries are arbitrary, and flexible, and man-made systems. (93)

The image of the map inevitably reflects an artist's particular style and sensibility: Johns's *Maps* are blurred with paint, Kosuth's mappings refer to art, Smithson's demark geological change, and Anderson's maps undergo innumerable distortions, until in *O-Superman* we witness a globe with the map, and hence political boundaries, effaced. In all cases, the distortions, confusions, and crossings of boundaries portrayed within the art mirror the way the art itself crosses, merges, and confuses disciplinary and artistic boundaries.

In what follows, I will be relating this effort to break down disciplinary boundaries to Wittgenstein's later theory and his sense of the fluidity and variability of conceptual boundaries. *Philosophical Investigations* is both symptomatic and causative in the larger cultural trend to question the boundaries of concepts and categories. Kosuth, Anderson, and Smithson themselves refer to *Philosophical Investigations* and incorporate some of its ideas into their work, albeit in different ways. Also pertinent to this study of the arts is the merging of disciplinary boundaries that occurs within the "paraliterature"[10] of our time, the confusion of theoretical and creative practice by philosophers like Derrida and Wittgenstein, and critics like Barthes. The widespread reading of language philosophy of contemporary visual artists is itself

significant, producing a fitting commentary on the whole orientation of contemporary thought toward language.

This study, however, is not a comprehensive survey of contemporary "language works" or "textual art." Surely numerous other artists could have been included, and much remains to be said. The decision to "read" Kosuth, Anderson, and Smithson was in large part determined by the differences among them: Kosuth is a Conceptualist, Smithson an Earth artist, and Anderson a Performance artist. While these three artists all use language, they do so in extremely different ways. Part of my purpose here is to convey a sense of the variety of textual works produced by artists in our time.

Finally, one assumption that informs this study is that changing styles in art reflect real changes in our lives, whether the art is "representational" or not. As Joseph Kosuth writes,

> In our time we have an experientially drastically richer environment. One can fly all over the earth in a matter of hours and days, not months. We have the cinema, and color television, as well as the man-made spectacle of the lights of Las Vegas or the skyscrapers of New York. The whole world is there to be seen and the whole world can watch a man walk on the moon from their living rooms. (137)

Whether the artist chooses to present far fewer sensory stimuli than in previous art (as in Kosuth's work), or presents far greater complexity of sensory experience (as in Anderson's), in either case the art is a response to life in our time. From Johns's *Flags*, to Kosuth's definitions, to Smithson's tour of Passaic, to Anderson's acute sense of the power of technology and the complexity of everyday talk—like Wittgenstein's "language games," all are drawing our attention to and increasing our awareness of ordinary language and everyday sights and sounds.

Kosuth, Anderson, and Smithson create an art of process, an art in which the product gives way to actions and procedures. Books, films, tapes, and essays all document an original performance or activity that is lost to time. Radically temporalized, the art object is always already destroyed. The rejection of object-based art decenters individual oeuvres, emptying them from the inside, so that every work is, as Smithson once described his own, a "fragment of a greater fragmentation." This is the "esthetics of impermanence" that Harold Rosenberg

once discussed at length, and his conclusion should, perhaps, be seriously pondered: "Perishable materials," he said, "will not prevent artists from achieving immortality" (*Anxious Object* 78). He was referring, in part, to Marcel Duchamp.

Duchamp: Artificer of the Uncreative

Jasper Johns once recounted a dream he had in which Duchamp, lying down dead, suddenly cracked a joke and laughed (Crichton 52). The dream seems to be a clear case of wish fulfillment: Johns confers immortality upon Duchamp, who had been ignored by the art establishment for the past fifty years. Johns, however, did not just dream this wish for Duchamp's immortality but played an active role in making it a real possibility: with Rauschenberg and Cage he "discovered" Duchamp in the fifties, and they brought the Duchampian aesthetic into our time. By the late sixties, not only individual artists but entire art movements were taking their points of departure from ideas proposed or explored by Duchamp.

The sixties, in fact, can be characterized by the number of neo-Duchampian works produced within it. Both before and after Duchamp's death in 1968, almost every artist of the decade created some *hommage à Marcel*: Rauschenberg's *Erased de Kooning* (1953), *Portrait of Iris Clert* (1961), and *Trophy II for Teeny and Marcel Duchamp* (1960); Jasper Johns's *According to What* (1964); Bruce Nauman's *Wedge* (1968); Acconci's *Seedbed*; Robert Morris's *Card File* (1962); Arakawa's *Diagram with Duchamp's Glass as a Mirror Detail* (1963–1964); Cage's *Chess Pieces* (1944), and *Not Wanting to Say Anything about Marcel* (with Calvin Sumison, 1969).

By the sixties, Duchamp had found his proper audience in other artists, and at long last could create some alliances among them. In the performance piece *Reunion*, Teeny and Marcel Duchamp played chess with John Cage on a board electronically wired for sound (Toronto, 1968). In *Walkaround Time*, the Merce Cunningham Dance Troupe performed with a decor designed after the *Large Glass* by Jasper Johns (Buffalo, N.Y., 1968). Duchamp died at precisely the time in art history that artists were finally ready for him. The Conceptual art movement, at least according to Lucy Lippard's chronology, *Six Years*, began in the same year of Duchamp's death—1968. By then, argues Calvin

Tomkins, "he had supplanted Picasso as the most influential artist of the century" (*Off the Wall* 272). One might even conclude that Johns's dream was prophetic: idea art, body art, Performance art, and Pop art were all indebted to Duchamp's aesthetic in some way, and perhaps in terms of art history Duchamp did have the "last laugh" after all.

Direct connections can be drawn between Duchamp's art and that of his followers, and scholars have been making such connections for years. Duchamp's interest in chance inspired Cage's own use of the aleatory in musical composition.[11] At the same time, the readymades inspired a new literalism and encouraged many artists, especially Pop artists, to use commonplace images and objects in their work. It was this aspect of Duchamp's style, in fact, that led Robert Smithson to call him the "artificer of the uncreative," and some of this aesthetic of the commonplace operates in Smithson's own work. Just as the quotidian is fabricated in Johns's *Painted Bronze*, so it is fabulated in Smithson's "Monuments of the Passaic," an essay that calls our attention to commonplace suburban sights. The strategies of simplicity and artlessness practiced throughout Duchamp's work were carried not only into such enigmatic gestures as Cage's *4′33″*, but also inspired the resistence to craftsmanship that was prevalent throughout the sixties in "idea art." The radical questioning of artistic value operative within Duchamp's oeuvre was played out repeatedly in works like Robert Morris's *Litanies*, which not only alluded to the cynical "litanies of the bachelors" within the *Large Glass*, but included a "Statement of Aesthetic Withdrawal" (Nov. 15, 1963), in which Morris divested his work of aesthetic value.

In his study *Postminimalism*, Robert Pincus-Witten outlines a variety of different relations between Duchamp and his artistic "heirs." He notes, for example, that Johns's plaster casts of body parts may have been influenced by Duchamp's use of the same technique in, for example, *Étant Données*. Of more importance, perhaps, is Pincus-Witten's discussion of the relation between Duchamp's "Rrose Sélavy," or *L.H.O.O.Q.*, and that group of artists (Lynda Benglis, Vito Acconci, Chris Burden, and Robert Morris) who have at one time or another toyed with transvestism in their work. "Despite the sensationalism in such imagery," Pincus-Witten writes, "the real interest lies in the maintenance of the Duchamp tradition" (181). Albeit more subtle than in some of these cases, Laurie Anderson's transvestism can be placed in this tradition along with, say, Vito Acconci's *Conversion Piece*. Anderson's own mixing of sexual styles and appearances in *United States* sug-

gests that this aspect of the Duchamp aesthetic has carried over into the art of the 1990s.

As is widely known, Concept art was in general indebted to Duchamp's ideas; it was an active working out of the implications of his artistic enterprise. Pursued by hundreds of artists throughout the world, "idea art" took its point of departure from Duchamp's radical rejection of the "retinal" aspect of art; art as idea became as legitimate as art as product or object. "The ideas in the Glass," Duchamp once said, "are more important than the actual realization" (Schwarz 7). Duchamp's effort was in all cases "to get away from the physical aspect of painting. I was interested in ideas, not merely visual products. I wanted to put painting once again at the service of the mind" (Cabanne 11). His use of ephemeral, bare, and reductive objects was carried into the style of concept art. Scripted proposals, like those in the *Green Box* ("copy out all the 'abstract' words in the dictionary"), appeared again and again with innumerable variations in the work of later artists.[12] Duchamp was practicing Concept art long before Conceptual artists did: "Everything," he said, "was becoming conceptual, that is, it depended on things other than the retina . . . if I had the chance to take an anti-retinal attitude, it unfortunately hasn't changed much; our whole century is completely retinal" (Cabanne 39, 42–43). If Duchamp's work did not change anything in his own time, it has certainly changed everything in ours.

One reason Duchamp's ideas were accepted so readily in the sixties is that they indicated a way out from the formidable influence of abstract expressionism and the formalist aesthetic it had inspired in paintings by Noland, Olitski, Newman, and Stella, for example. As Anderson suggests, formalism revealed, in a particularly acute way, the reliance of art upon a theoretical discourse that it repressed or denied.[13] Yet this relation of art and theory, the visual and the discursive, was actively played out within Duchamp's oeuvre. His ideas pertained primarily to art: they were aesthetic ideas, or, perhaps more accurately, aesthetic questions posed (as in the readymades) in a way that provoked but did not provide answers. Contemporary artists responded to this relentless toying with the boundaries of art, in many cases pushing even further the confusion of theoretical and artistic activities. Duchamp's work inspired the radical questioning and testing of limits that occurs, for example, in works by Cage, Johns, Kosuth, Buren, Irwin, and Smithson, among hundreds of others.[14]

Hence the most important aspect of Duchamp's work for this study is his use of language, his "determination to take words as the source of his pictorial experiments" (Lebel 7).[15] His inspiration derived from literature (Laforgue, Roussel, Mallarmé, and Rimbaud), and all of his artistic products have a verbal, textual dimension. Richard Hamilton once said, "Duchamp's involvement with words is extensive—as unique in itself as it is uniquely integrated into his art" (Duchamp, *Bride* 67). John Tancock writes, "For those . . . whose interest lay in the cross-fertilizing of the various media, he became the most conspicuous touchstone. The early work of Robert Morris, Bruce Nauman, and Walter de Maria is virtually a commentary on certain issues raised by Duchamp . . . they began producing objects that enmeshed visual and verbal information in the most curious manner" (173).

The use of language within art is, of course, hardly new. Early fusions of the verbal and the visual occur in Egyptian hieroglyphs, Chinese ideograms, and Mayan Glyph writing. Illuminated manuscripts, seventeenth-century Emblem books, pattern poetry (from George Herbert to the present), and Blake's mixed art are among some of the diverse and "curious" combinations of media and arts that predate our time. The most immediate and important context for a discussion of contemporary "language works," however, is modern art, in works by such artists as Juan Gris, Stuart Davis, Severini, and Carlo Carra that also includes words.

Braque's *The Portugues* (1911) was the first Cubist collage to include lettering, and it paved the way for numerous canvases with words used as elements in the composition. As Douglas Cooper suggests, the fragments of verbal material in a Cubist painting serve a double function: they operate as mimetic elements, heightening the representational aspect of the work, while at the same time foregrounding the two dimensionality of the canvas (53–54). However, as Richard Kostelanetz proposes, "as artful as many of these paintings with image-plus words are, they represent not an intermedium, where one element is entwined with the other, but rather a complementary art, like opera, where even at best a libretto can viably be separated from the music" (184).

In order to better understand the distinction made by Kostelanetz between a complementary and an intermedial art, consider Juan Gris's painting *Still Life with a Poem* (1915, Fig. 1.2). Variously colored planes are juxtaposed upon a flat two-dimensional surface. The view of a table from a multitude of perspectives is typical of analytic Cubism.

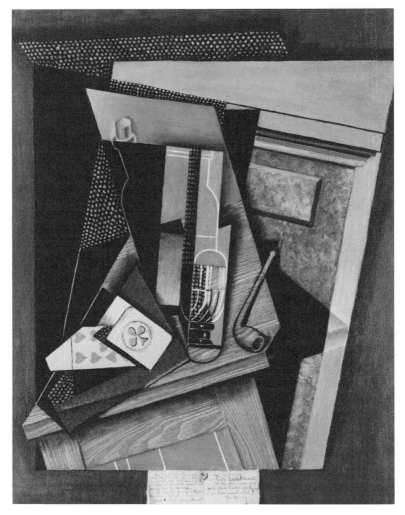

Figure 1.2. Juan Gris, Still Life with a Poem, *1915*. Oil on canvas. Norton Simon Art Foundation.

There is depth in the overlapping of planes, but a depth that is subordinated to the surface play of colored patterns and linear design. Like the repeated newspaper fragments included throughout Cubist collages, the poem here is simply another object—pipe, cards, bottle, table—incorporated within a predominately visual composition. The use of realistic details is subordinated to the construction of a visual artifact, a

set of relations, perspectives, planes, volumes, and colors. "My aim," said Gris, "is to create new objects which cannot be compared with any object in reality" (Kahnweiler 104). Containing referential elements, the Cubist aesthetic is nevertheless intent on presentation, establishing the painting as a self-contained, self-sufficient, and autonomous art object.

Although Reverdy's poem is presented as part of Gris's work, it shows just how clearly Cubism maintained the distinction between poetry and painting. The integrity, the identity, of neither is called into question, and we can make the same kind of comparisons between this poem and this painting that Cubism in general allows.

> Se tiendrait elle mieux
> sous ton bras ou sous la table?
> Le goulot dépassait d'une poche
> et l'argent dans la main moins
> longue que la manche.
> On avait gonflé le tuyau
> de verre et aspèré l'air.
> Quand celui qu'on attendait
> entra, les premiers
> assistants s'attablèrent.
> . . . Et la flamme qui
> luit dans leurs yeux
> d'ou leur vient-elles?

The poem allows us to draw just the kind of parallels that are so common in comparative studies of the arts. A typical analysis might go something like this: Both the painting and the poem employ simple, everyday images. These images serve no symbolic function, and their referentiality is undercut by foregrounding the metonymic relations established among them. Poem and painting both present disconnected fragments and varied perspectives. In the poem, as in the painting, fragments are edged next to each other, producing relations that are essentially ambiguous (who is the "elle" of the poem?). The sequence of actions within the poem defies logic, just as the images in the painting defy (logical) perspective. Images, in both cases, arise from and recede into absences, silence, emptiness, and gaps. The poem in no

way totalizes the painting, nor does the painting resolve any of the poem's ambiguities. Poem and painting on some levels interrelate ("tuyau," "goulot," "table"), but in doing so, each merely extends the other's untotalized aspects. The artworks, too, are set in metonymic relation, interacting with each other and creating unique interconnections. But the relation in no way confuses the two, in no way contaminates the autonomous integrity of the separate artifacts.

Duchamp's work operates quite differently from this. *The Bride Stripped Bare by Her Bachelors, Even*, is first of all not a canvas but a construction of glass, two glass panels, in fact, which are now cracked (Fig. 1.3). It is not, like Gris's painting, beautiful to look at; there are no bright colors or painterly textures, and the composition strikes one as peculiar and bare. If we just look at it, and for a moment forget that it is part of a larger work, the *Glass* alone looks decidedly dull. At the top (left) is a strange image with a cloud formation floating above. The bottom panel includes more mechanical contraptions constructed with glass and lead wires. Among this array of unfamiliar mechanical forms is one recognizable image—a chocolate grinder—and what, we may well wonder, is it doing here? More empty glass than imagery, Duchamp has constructed this work so that we must look both at it and through it, so that what is most distinctive about it is not only its retinal but its conceptual "transparency."

The *Green Box* includes Duchamp's fragmented narratives, drawings, and anecdotes for *The Bride Stripped Bare by Her Bachelors, Even*. When the images are seen "through" this text and the text, as it were, seen "through" the Glass, *The Large Glass* as a whole is suddenly animated, lively, intriguing, and even, in a strange way, beautiful.[16] Suddenly the mechanical images are comically humanized and implicated in a complex love story, an erotic encounter with an indecisive conclusion. The top panel is the Bride, "who instead of being merely an a-sensual icicle, warmly rejects, (not chastely) . . . the bachelors' brusque offer . . . Here the desire-gears . . . occupy less space than in the Bachelor Machine.—They are only the string that binds the bouquet." In contrast, the Bachelors (below) are "fat, lugubrious," and autoeroticism is one of the "principal cogs in the Bachelor Machine." Even though the "desire motor" of the Bachelors is separated from the Bride ("by an air cooler"), some kind of stripping nevertheless takes place:

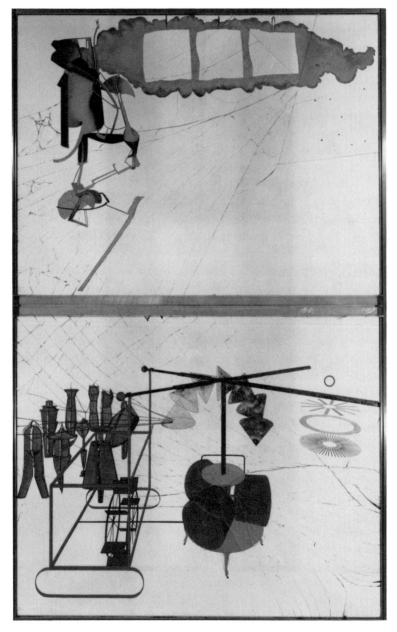

Figure 1.3. Marcel Duchamp, The Bride Stripped Bare by Her Bachelors, Even (The Large Glass), *1915–1923. Oil, lead wire, foil, dust, and varnish on glass. Philadelphia Museum of Art: Bequest of Katherine S. Dreier.*

The bride accepts this stripping
by the bachelors, since she supplies
the love gasoline to the sparks of this
electrical stripping; moreover, she
furthers her complete nudity by adding to
the 1st focus of sparks (electrical stripping)
the 2nd focus of sparks of the desire-magneto.

Blossoming.

Duchamp's notes continually create verbal and visual relations such as this; we can now identify the cloud formation as the "blossoming" of the Bride. And when we have followed through on all such correspondences, as the work invites us to do, it finally makes no more logical sense than it did before. The obvious questions still remain: Why so many bachelors? Is the "electrical connection" made or "short-circuited"? How does the Bride "reach the goal of her desire" when the Bachelor "grinds his chocolate alone?"

This grand spoof on sexual processes nonetheless contains a lyricism of its own. It is a portrait of a young girl "blossoming" into desire, caught by Duchamp in a moment of transition and transformation: "This cinematic blossoming is the most important part of the painting (graphically as surface) . . . the painting will be an inventory of the elements of this blossoming, elements of the sexual life imagined by her the bride desiring."

Why, we might ask, is the Bride's "Blossoming" more "important" to Duchamp, say, than the Bachelors' "shots" and "splashes?" Perhaps because it embodies what is most important to him about *The Large Glass* as a whole: her "blossoming" is not just physical but also mental, occuring at two different levels and "unanalyzable by logic."

1st blossoming into the stripping by bachelors. This blossoming-effect of the electrical stripping should, graphically, end in the clockwork movement (electric clocks in railway stations) . . . develop expressing indeed the throbbing jerk of the minute hand.

2nd blossoming into the stripping voluntarily imagined by the Bride-desiring. This blossoming should be the refined development of the arbor-type.

Thus the "wedding" in *The Large Glass* is not between the Bride and the Bachelors, but between the physical and mental elements that generate erotic desire. In Duchamp's work eroticism and art become metaphors for each other, since both combine mental and physical processes. The structure of the work demands a unique interplay of reading and seeing, presenting as Duchamp once said, "a wedding of mental and visual relations" (Cabanne 11).

The Large Glass is thus a hybrid work, neither purely visual nor purely verbal, neither "pictorial" nor "literary" in any conventional sense of the terms: "My research," Duchamp said, "was in the direction of finding some way of expressing myself without being a painter, without being a writer, without taking one of those labels" (Schwarz 7). *The Large Glass* effects a unique interdependence or interconnection between verbal and visual elements. It is a perfect example of what Kostelanetz would call an "intermedial" art.

Moreover, the difference between a "combinatory" and a "hybrid" art has some important consequences within both the history of art and the history of ideas. For the Cubists, words were somehow "out there," outside in the café scene, in the newspapers, calling cards, and sheets of music that were eventually brought into the collage. In contrast, Duchamp's work implies that words are not just "out there," but somehow "in here," in our minds, constituting the scene itself. Language not only affects the way we seen a particular object like *The Large Glass*, but affects visual perception in general. It is not surprising that for the past three decades artists have been wrestling in varied ways with the implications of these ideas, because contemporary theorists, too, have taken the relation of language and sight as a central subject. In "The Photographic Message," for instance, Roland Barthes says,

> If, as is suggested by certain hypotheses of Bruner and Piaget, there is no perception without immediate categorization, then the photograph is verbalized in the very moment it is perceived; the image—grasped immediately by . . . language itself—in actual fact has no denoted state, is immersed for its very social existence in at least an initial layer of connotation, that of the categories of language. (*Image-Music-Text* 29)

While they do not necessarily accept these premises, the interplay of language and vision has come to occupy the artists of our time, and this is true even of artists like Robert Irwin, whose work explores the nature of sight. [17] Contemporary artists carry on the Cubists' investigation into perception by investigating the relation of sight and language.

The Green Box begins with a "kind of subtitle/Delay in Glass":

> —but "delay in glass" does not mean "picture on glass"—
> It's merely a way of succeeding in no longer thinking that the thing in question is a picture—to make a "delay" of it in the most general way possible, not so much in the different meanings in which "delay" can be taken, but rather in their indecisive reunion "delay"—a "delay in glass" as you would say a "poem in prose" or a spittoon in silver.

"It was the poetic aspect of the words that I liked," he said, describing this passage in *The Green Box*; "I wanted to give 'delay' a poetic sense that I couldn't even explain" (Cabanne 40). Arturo Schwarz has called *The Green Box* "a body of poetic prose," and Jerome Rothenberg included passages from it within his 1974 collection of poetry, *Revolution of the Word* (32–34). Duchamp's language, however, is purposely "uneasy" literature, if it can be called "literature" at all. He was himself doubtful that the term applied: "The fact that it has been called literary is not really relevant, since the word 'literary' has a meaning that is vast" (Schwarz 7). *The Large Glass* is simply a strange combination of elements from more conventional art forms, an unusual mixture that anticipates the hybrid works of Smithson and Anderson.

Duchamp's games with titles may not constitute "literature" ("with a meaning that is vast"), but his puns are nevertheless marginally related to literary practice. "Titles in general interested me a lot," said Duchamp; "at that time, I was becoming literary" (Cabanne 40). His "*morceaux moises*" or "Wrotten writtens" (Sanouillet) have continued to acquire new meanings and inspire interpretations throughout the years. Like the Bride, Kozloff suggests, his "readymades" are "ready maids" (27); his *L.H.O.O.Q.*, ("elle a chaud au cul"), not only has a "hot rump" but asks us to "look." The nonsense adverb *même* is actually a pun on *m'aime* (Schwarz), humorously placing the artist within the love story that *The Large Glass* recounts and calling attention to the

narcissism within it. Like the story of the Bride and the Bachelors, Duchamp's language is always humorous, playful, ironic, satiric, and parodic. It is filled with nonsense, nonsequiturs, ambiguities, spoonerisms, and scatalogical puns.

Playful in effect, Duchamp's linguistic dissociations nevertheless have serious implications. As Toby Mussman observes, his puns "cast ironic doubt on the ability of any written sentence to make conclusive sense" (151). They "exalt and then deflate the power of language to convey stable, clear meaning," concurs Octavio Paz (5). The puns express Duchamp's prevailing linguistic pessimism, a skepticism he shares with many other modernists:[18] "Language is just no damn good," he once said; "I use it because I have to but I don't put any trust in it" (Tomkins, *Bride* 31–32).

We are faced, then, with this grand paradox: language enters Duchamp's work with more force and frequency, more power and effect than in any previous art, and yet the artist himself distrusts words and builds that distrust into his art. The same paradox operates in, for example, Beckett's trilogy, where the subject is the inadequacy of language, but words flood in nevertheless. Perhaps the paradox, if not resolved, can be explained in this way: the same linguistic pessimism expressed in the artist's verbal style is also applied to the category terms of art. In this grand analysis of semantic slippage, the meanings of words like "painting," "poem," "art," "sculpture," and "novel" slip as well. The confusion of genres in Beckett's work and the confusion of "art" and "literature" in Duchamp's are expressions of a prevailing pessimism. The art not only describes but also produces semantic slippage. Words no longer "fit" and objects—including works of art— become "unnamable."[19]

Duchamp was the first artist, but certainly not the last, to present a "deconstructive" art that called into question the premises of all preceding art (art as beautiful, valuable, and visual). In what would become an exclusively verbal art, Conceptual artists continued Duchamp's project of using language to explore (or explode) the boundaries of art. If Idea art, Body art, Performance art, and Pop art all had sources in Duchamp's work, so did a very different, rational, methodical, and intellectual trend develop from his "pioneering" experiments. Johns did not pursue a hybrid or intermedia art, nor did he practice art as a "deconstructive" maneuver of any kind, but he did generate a

proto-Conceptual art "of ideas" that inspired a new interest not only in Duchamp's work but in Wittgenstein's later writings as well, and these two interests were not unrelated.

Duchamp himself had read the *Meaning of Meaning* (Tomkins, *Bride* 32), a book by I. A. Richards and C. K. Ogden that incorporated a (very) few Wittgensteinian ideas, without, however, grasping the full implications of Wittgenstein's thought, as Wittgenstein told Ogden in correspondence with him.[20] In a way that is very different from *Philosophical Investigations*, the book by Richards and Ogden nevertheless includes a discussion of the relation of meaning and context. We might pause for a moment to consider how involved with context Duchamp's work really was. Harold Rosenberg says, "The principle of defining art by its art historical or museum context was established fifty years ago by Duchamp" (*Artworks* 14–15). *The Large Glass*, too, was an act of contextualization, placing a pictorial object in the context of verbal information. It is unlikely that Duchamp's work was inspired by his reading of language philosophy, but it is interesting to note that the issues correspond in this way. Johns's reading of Wittgenstein may have been merely another *hommage à Duchamp*, on the order of, say, the inclusion of images from *Tu'M* within his own *According to What*. But, as we shall see in the following discussion, Wittgenstein's philosophy addressed many of the same questions that Duchamp had raised within art, ideas specifically concerned with context, meaning, sight, and language.

Here is part of the "Appreciation" Jasper Johns wrote for Duchamp in 1968:

> Marcel Duchamp, one of this century's pioneer artists, moved his work through the retinal boundaries which had been established with Impressionism into a field where language, thought, and vision act upon one another. There it changed form through a complex interplay of new mental and physical materials, heralding many of the technical, mental and visual details to be found in more recent art.
>
> He said that he was ahead of his time. One guesses at a certain loneliness there. Wittgenstein said that "'time has only one direction' must be a piece of nonsense." (Cabanne 109)

Johns and Wittgenstein: The Echo of a Thought in Sight

Jasper Johns's fascination with Wittgenstein began in the early 1960s, but his interest in language and its relation to vision began much earlier.[21] From the outset of his work, he created paintings that were not only richly visual but verbal and intellectual as well. Following Duchamp's lead, his art created a field of force where "language, thought, and vision act upon one another." Johns dates the influence of Wittgenstein upon his work from the painting *Fool's House* (1962),[22] but a brief overview of his prior painterly concerns will help to show why he found *Philosophical Investigations* so intriguing.

Johns's early *Flag* (1954–1955), shows him using a simple, everyday, and conventional object as the subject of his work (Fig. 1.4). A commonplace image is flattened out, made co-extensive with the canvas, and, most importantly, shifted out of its familiar context. The use of a readymade image and the shifting of contexts is an obvious carryover from Duchamp (*Fountain*, for instance). But context and its relation to meaning is a central concern for Wittgenstein as well. "Every word has a different meaning in a different context," says Wittgenstein, and the meanings of objects and images, too, are defined by what surrounds them (*PI* p. 181, p. 188, 583, 525, 686):

> I see a picture which represents a smiling face. What do I do if I take the smile now as a kind one, now as malicious? Don't I often imagine it with a spatial and temporal context which is one either of kindness or malice? Thus I might supply the picture with the fancy that the smiler was smiling down on a child at play, or again on the suffering of an enemy. (539)

> I can imagine some arbitrary cipher—this, for instance:

> to be a strictly correct letter of some foreign alphabet. Or again, to be a faultily written one, and faulty in this way or that: for example, it might be slap-dash, or typical childish

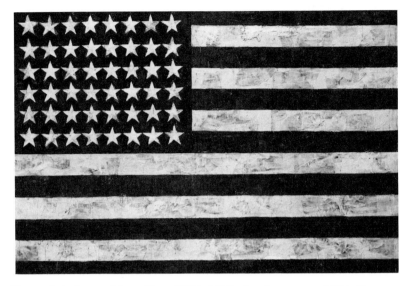

Figure 1.4. Jasper Johns, Flag, *1954–1955; dated on reverse 1954. Encaustic, oil, and collage on plywood. The Museum of Modern Art, New York: Gift of Philip Johnson in honor of Alfred H. Barr, Jr. Copyright © Jasper Johns/VAGA New York 1990.*

> awkwardness, or like the flourishes in a legal document. It could deviate from the correctly written letter in a variety of ways.—And I can see it in various aspects according to the fiction I surround it with. And here there is a close kinship with 'experiencing the meaning of a word.' (p. 210)

The readymade aesthetic, one might say, was toying with related ideas: What does it mean to de-contextualize an image? What is the meaning of a urinal (Duchamp) or two beer cans (Johns) in a gallery?

The focus throughout *Philosophical Investigations* is on ordinary language and its use. The words Wittgenstein analyzes are common and familiar terms, and he investigates their use in everyday language. "What *we* do," he says, "is to bring words back from their metaphysical to their everyday use" (*PI* 116, 97). Like Poe's Dupin, Wittgenstein is concerned with what is already familiar.[23] "The aspects of things that are most important for us are hidden because of their simplicity and familiarity. (One is unable to notice something—because it is always

Figure 1.5. Jasper Johns, False Start, *1959. Oil on canvas. Copyright © Jasper Johns/VAGA New York 1990.*

before one's eyes)" (*PI* 129). Both Johns and Wittgenstein take as their central subjects the most simple and familiar objects, images, and signs of everyday life; the operations performed with these familiar objects combine innocent and naive observation with sophisticated and subtle analyses.

In *False Start* (1959), Johns is already exploring the relation of word to thing (Fig. 1.5). A canvas explodes with expressionistic patches of color, but the painting is not an abstract expressionist work so much as an exploration of the relation of color to color terms. The obvious mislabelings suggest a disjunctiveness of words and things, and the painting marks a pointed irony: the words seem to, but do not, operate as labels.

In *By the Sea*, (1961, Fig. 1.6), Johns creates a painting that explores the conceptual basis of perception (*PI* pp. 193–210). A new variation of a series of previous works (entitled *Out the Window*, Fig. 1.7), *By the Sea* now foregrounds the relation of perception and interpretation. In addition to the three panels that read (from top to bottom) "red," "yellow," and "blue," Johns has added a fourth fusing and confusing all three. In the bottom panel, the words "red" and "blue" are hidden in the word "yellow," and one can literally "see" them only if one thinks of looking for them there. Wittgenstein discusses at length the way in which different conceptual contexts provided by a viewer can change and alter sight:

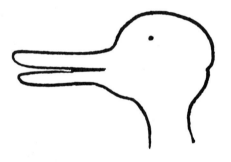

(p. 194)

> What I perceive in the dawning of an aspect is not a property of the object, but an internal relation between it and other objects.

> Do I really see something different each time, or do I only interpret what I see in a different way? I am inclined to say the former. (p. 212)

> It is almost as if 'seeing the sign in this context' were an echo of a thought. "The echo of a thought in sight"—one might say.[24]

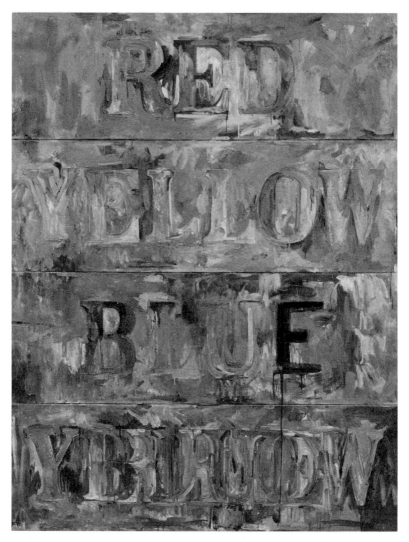

Figure 1.6. Jasper Johns, By the Sea, *1961. Encaustic and collage on canvas. Copyright © Jasper Johns/VAGA New York 1990.*

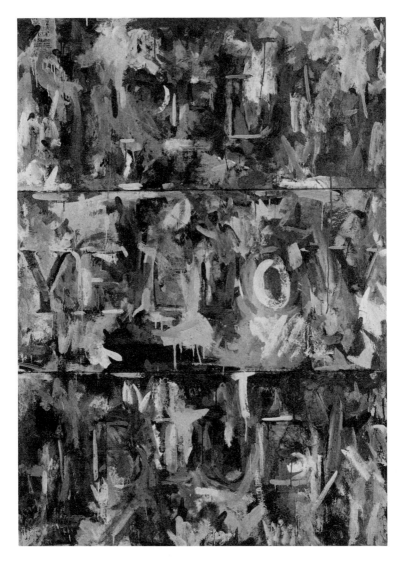

Figure 1.7. Jasper Johns, Out the Window, *1959. Encaustic and collage on canvas. Copyright © Jasper Johns/VAGA New York 1990.*

By the Sea operates like this picture puzzle: it is the context of the series of paintings *Out the Window* that leads us, in *By the Sea*, to look for, and finally see, the words in the bottom panel of the painting.

Max Kozloff is the only scholar to explore in any depth the influence of Wittgenstein upon Johns (39–41), and he compares Wittgenstein's notion of perpetual change of meaning through varied usage to Johns's notebook entry:[25]

<div align="center">

Take an object

Do something to it

Do something else to it

" " " " " " " " "

</div>

In the following reading of *Fool's House*, I intend to explore in more detail this connection between Johns's work and Wittgenstein's notion of "use." My conclusion however, will be quite different from that of Kozloff, who asserts that Johns "takes special pleasure in dismantling all semantic possibility." This phrase may have been appropriate for Duchamp, but it does not, I think, apply to Johns. Duchamp's extreme skepticism regarding language was more radical than that of either Johns *or* Wittgenstein. An analysis of Johns's reading of Wittgenstein will show that Johns, like the philosopher, wants to investigate but not to destroy "semantic possibility."

It was during the period when Johns was reading Wittgenstein that he began attaching real objects to his canvases (Crichton 49). Attached to or hanging within *Fool's House* (Fig. 1.8) are a number of simple objects: a broom, a towel, a cup, and a painter's stretcher. The canvas itself is covered in varying shades of blue and bluish gray (an allusion to *The Blue Book*, perhaps), and the objects are all splattered or covered with paint. Irony functions at various levels in this painting. Only a "fool" (like the artist himself) would live with this combination of household and painterly objects and tolerate this messiness of paint. Though the stretcher is a common tool for a painter, in this context all of the objects (including the broom and the cup) become tools for the creation of a painting.

But in addition to the broom, the towel, the stretcher, and the cup, the painting employs other tools as well—namely, the words "broom," "towel," "stretcher," and "cup." Johns is comparing words to instruments or tools in the same way that Wittgenstein does: "Think of

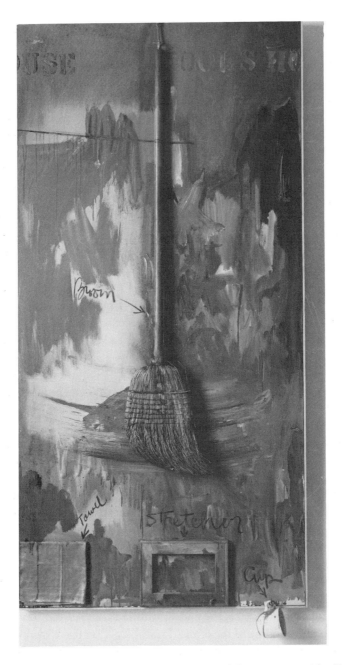

Figure 1.8. Jasper Johns, Fool's House, *1962. Oil on canvas with objects.*
Copyright © Jasper Johns/VAGA New York 1990.

words as instruments characterized by their use" (*BB* 67). "Think of the tools in a toolbox: there is a hammer, pliers, a saw, a screwdriver. . . . The functions of words are as diverse as the functions of these objects" (*PI* 11). "If we had to name anything which is the life of the sign," says Wittgenstein, "we should have to say that it was its *use*" (*BB* 4). In Wittgenstein's view, then, the meaning of a word is not an object or a concept that corresponds to it, nor is meaning an occult mental process; rather, the meaning of a word arises from its multiple and varied uses in actual conversation (*PI* 39–43, 383; *BB* 4–5). In order to fully explore the fluid and shifting nature of language, Wittgenstein examines numerous and diverse uses of specific words.

That Johns is "using" Wittgensteinian ideas (of "use") within *Fool's House* is emphasized by the way in which the title appears in the canvas, cut off, with letters displaced so that the word "use" is legible in the upper-left-hand corner. Indeed, the context provided by *Philosophical Investigations* leads us to literally see the painting in new ways. The title is painted in an intentionally ambiguous way, so that it can be read as "use tools," "tool's use," or "fool's house."

The obvious subject of this painting is the relation of words to things. What seems to be a redundant naming of objects might also be an ironic commentary on the naming or labeling function of words. Having read Wittgenstein (and/or because of his own sensitivity to language), Johns knows that the meanings of his words do not reside in the objects adjacent to them. Just as "we do not derive the meaning of the word brown from a particular color impression" (*BB* 73), neither do we derive the meaning of the word "broom" from this particular hanging object. Our understanding of this word ("broom"), like our understanding of any word, arises from our whole conceptual scheme derived from its interrelated uses. What gives the word meaning is not the object to which it corresponds, but our shifting use of the word in our system of language. "Now we could easily imagine ourselves to be impressed by merely seeing a label on a thing and to forget what makes these labels important is their use," says Wittgenstein (*BB* 69). This *is* a "fool's house," then, to the extent that the viewer believes the meanings of the words arise from the objects on the canvas, rather than from the viewer's previous understanding of the terms. It is "foolish" to think that words operate solely as labels for things (as foolish, say, as looking for an object *exactly* like this one the next time someone asks for a "broom").

Wittgenstein's purpose in comparing words to tools is to stress the

infinite variety of uses to which they might be put. ("The functions of words are as diverse as the functions [of the tools in a toolbox].") The fact that you might not want (any longer) to use Johns's well-worn broom to sweep your kitchen floor, does not mean that the broom has no use. Indeed it *is* being used to manipulate paint and to constitute a painting. Critics like Barbara Rose and Max Kozloff view Johns's displacement of the normal functions of objects as pessimistic; his "collection of functional objects deprived of their normal functioning constitutes a depressing catalogue of frustrations," suggests Rose ("Graphic Work" 66; Kozloff 21, 40). From a Wittgensteinian perspective, however, there is no "proper" use of an object or a word, there is only use, and use is always varied. Thus a hammer can be used to drive a nail or a peg into a board, it can be used to smash something, or it can be used as a paperweight (*BB* 58). ("The picture of the cube did indeed *suggest* a certain use to us, but it was possible for me to use it differently" [*PI* 139].)[26] The variable uses of objects and words is stressed by Wittgenstein in order to show that actual usage is unbounded, and we draw conceptual boundaries and definitions where we wish (*BB* 19–20, 25, 62; *PI* 69, 71, 76, 499).

It was also in the early sixties that Johns changed his own treatment of boundaries, and this change is either coincidental with or an expression of his reading of Wittgenstein. "In my earlier pictures," says Johns, "the gestures have to conform to the boundaries. That's the only thing they have to do, stay within the lines. But in the paintings of this time, there was an attempt to find a way that the gestures would make an image: the gestures would determine the boundaries" (Crichton 41). In contrast to the earlier flag paintings, Johns's boundaries now become progressively blurred. In paintings like *Map* (1961 and 1968), Johns toys with notions of pictorial and geographic borders. For a decade, the sixties, he creates images with blurred outlines or with objects and canvases jutting out from the edge of the picture plane.

The following passages are just two examples from innumerable similar comments made by Wittgenstein on the fluid boundaries of word usage and concepts:

> We are unable to clearly circumscribe the concepts we use;
> not because we don't know their real definition, but because
> there is no real 'definition' to them. To suppose that there
> *must* be would be like supposing that whenever children

> play with a ball they play a game according to strict rules.
> (*BB* 19, 25, 27).
> To say "This combination of words makes no sense" ex-
> cludes it from the sphere of language and thereby bounds
> the domain of language. But when one draws a boundary it
> may be for various kinds of reason. If I surround an area
> with a fence or a line or otherwise, the purpose may be to
> prevent someone from getting in or out, but it may also be
> part of a game and players be supposed, say, to jump over
> the boundary. . . . So if I draw a boundary line that is not
> yet to say what I am drawing it for. (*PI* 499; 68, 71, 76,
> 79, 99)

Indeed, one remark in *Philosophical Investigations* seems to apply
equally well to Johns's work at this time. "If someone were to draw a
sharp boundary," says Wittgenstein, "I could not acknowledge it as the
one I too always wanted to draw or had drawn in my mind. For I did not
want to draw one at all" (76). In the same way that Johns's boundaries of
this period are made up from the inside, from his gestures in painting,
so Wittgenstein's "definitions" are made up by examining concrete
cases of use; in both cases, boundaries and borders are left irregular
and indefinite.

Throughout Wittgenstein's discussion of unbounded concepts and
the uncircumscribed nature of usage, he stresses that such unbounded
words can still be used; indeed, words (like "game") are always used in
this way. Therefore, when Johns "bends his blue" in paintings like
According to What (Fig. 1.9), he expresses a notion of linguistic and
conceptual change that closely parallels Wittgenstein's. Michael
Crichton, I think, misses the implications of Johns's "bent blue." He
says: "Blue is a word referring to a color: its referent is a concept that
cannot be said to be bendable, but Johns has bent *his* blue" (53). In
Wittgenstein's theory of language, however, the concept "blue" *is*, like
all concepts, flexible, variable, and "bendable." He says:

> Should you say we use the word "blue" both for light blue
> and dark blue because there is a similarity between them?
> [133]. . . . We could also easily imagine a language (and
> that means again a culture) in which there existed no com-
> mon expression for light blue and dark blue, in which the

Figure 1.9. Jasper Johns, According to What, *1964. Oil on canvas with objects. Copyright © Jasper Johns/VAGA New York 1990.*

former, say, was called "Cambridge," and the latter "Oxford." If you ask a man of this tribe what Cambridge and Oxford have in common, he'd be inclined to say "Nothing" [134–135]. To say that we use the word "blue" to mean 'what all these shades of color have in common' by itself means nothing more than that we use the word "blue" in all these cases. (135; 133–140)

In this discussion, Wittgenstein examines various ways in which the concepts "blue" and "similarity" might undergo change. In effect, he shows that both our usage and our concept of "blue" *can* be "bent." It may be interesting to note here that *According to What* is as many scholars have noted, more obviously a compendium of Duchampian images, producing another case, as in Johns's "Appreciation," where allusions to Duchamp and Wittgenstein are combined.

Johns is, in short, a much more careful reader of Wittgenstein than most critics have supposed. One entry in his notebook reads:

Time does not pass
Words pass

This cryptic note directly reflects his reading of *The Blue Book* and it helps to explain the allusion to Wittgenstein included in Johns's "Appreciation" for Duchamp:

> "Where does the present go when it becomes past, and where is the past?" . . . this question most easily arises if we are preoccupied with cases in which there are things flowing by us,—as logs of wood float down a river. In such a case we can say the logs which *have passed* us are all down towards the left and the logs which *will pass* us are all up towards the right. We then use this situation as a simile for all happening in time and even embody the simile in our language, as when we say that the "present event passes by." (*BB* 107)

Here, Wittgenstein warns us, a false "picture" is created by a misleading analogy: "we are led into puzzlement by an analogy which irresistibly drags us on" (*BB* 108). What seems to be a metaphysical problem about time is, for Wittgenstein, a grammatical or linguistic one. Johns condenses and focuses the philosopher's point by shifting the analogy to words: "Time does not pass/Words pass."

Johns had indeed, as Calvin Tomkins notes, "become deeply immersed in the philosophy of Ludwig Wittgenstein" (*Off the Wall* 197). The philosopher's notion of "family likenesses" may, in fact, be an appropriate term for describing the structure of Johns's oeuvre as a whole. What ties the varied uses of a word together, according to Wittgenstein, is not one stable, essential quality or element, but the fact that the uses have a "family likeness," a network of many overlapping similarities and differences. Wittgenstein's notion of "family resemblances" seems an appropriate term for the interrelatedness of Johns's works. The artist continuously creates paintings in series—flag, target, device circle, watchman—that overlap and interconnect. The dominate image of one series will be contained or referred to within paintings from another, so that apparently dissimilar works actually do relate. Just one example is the already mentioned series which includes *Out the Window* (1959), and *By the Sea* (1961); the concepts, words, and colors red, yellow, and blue from this series are also included in such diverse paintings as *Periscope (Hart Crane)* (1963), *Studio* (1964), *Harlem Light* (1967), *Weeping Women* (1975), and

others. Widely divergent paintings, therefore, may share a "family likeness" and are related because they contain variations of this motif.

While aesthetics seems to be outside the scope of *Philosophical Investigations*,[27] Wittgenstein, in fact, repeatedly returns to problems of art within it (*BB* 166–167, 178; *PI* 219). In the following passage, he poses an ontological problem that is "solved" by addressing an aesthetic issue:

> 518. Socrates to Theaetetus: "And if someone thinks mustn't he think *something?*"—Th: "Yes, he must."—Soc: "And if he thinks something, mustn't it be something real?"—Th: "Apparently."
>
> And mustn't someone who is painting be painting something—and someone who is painting something be painting something real! Well, tell me what the object of painting is: the picture of a man (e.g.) or the man that the picture portrays?
>
> 522. When I look at a genre picture, it "tells" me something, even though I don't believe (imagine) for a moment that the people I see in it really exist, or that there have really been people in that situation. But suppose I ask: "What does it tell me then?"
>
> 523. I should like to say "What the picture tells me is itself." That is, its telling me something consists in its own structure, in *its* own lines and colors."

Wittgenstein's answer to Socrates is never stated directly; the readers are forced to draw conclusions of their own from the analogy with painting. In this case the analogy operates to deflate Socrates' assumption that the reality status of the thought is determined by the reality status of its content, for the reality status of a painted canvas is (more obviously) not determined by the reality of what it represents.

Such considerations are not as distant from Johns's work as they might at first appear. The reality status of painted objects has been a subject for artists throughout history, and our century is no exception. Consider, for example, Magritte's *The Treachery of Images* (Fig. 1.10). The point, of course, is that this is not a pipe ("Ceci n'est pas une pipe") but a painting of a pipe instead.[28] Johns produces super-realistic

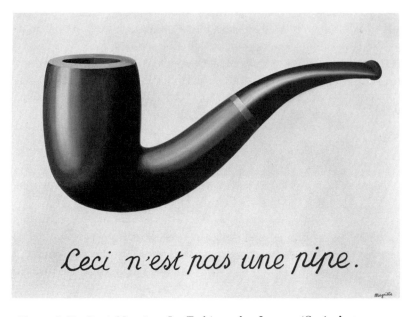

Figure 1.10. René Magritte, La Trahison des Images (Ceci n'est pas une Pipe). *(The Treachery [or Perfidy] of Images [This is not a Pipe]), 1928–1929. Oil on canvas. The Los Angeles County Museum of Art: Purchased with funds provided by the Mr. and Mrs. William Preston Harrison Collection.*

images (*Flag*, 1954–55) and objects (*Painted Bronze*, 1960, Fig. 11) in order to make a similar point. What is realistic about his art is not its heightened mimetic quality but the art object itself.

The same issue is treated even more paradoxically in *Fool's House*, where real objects are included in the work. The fact that the cup hangs outside the picture frame suggests that Johns wants to sustain a certain ambivalence regarding the reality status of his objects. Is the cup "real" because it can be taken off the canvas and used for drinking? Or is it "real" because it is part of a real painting? Certainly Johns is toying with notions of realism, and one might say, with Wittgenstein, that what is real in *Fool's House* is really the painting itself, regardless of how abstract or, in this case, how "real" the elements within it are.

Comparisons for similarities and differences receive extensive analysis by Wittgenstein, and they form a central concern for Johns as well. Johns's double and mirror images in works like *The Dutch Wives*

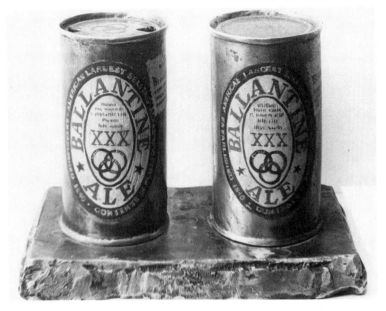

Figure 1.11. Jasper Johns, Painted Bronze (Two Ale Cans), *1960. Museum Ludwig Köln, Sammlung Ludwig. Copyright © Jasper Johns/VAGA New York 1990.*

(1975, Fig. 1.12), *Corpse and Mirror* (1974), *Painted Bronze* (1960, Fig. 1.11) and *Field Painting* (1963–1964) all reflect his interest in notions of identity and similarity. Not only can the two parts within a given work be compared for similarities and differences, they can be compared to other related pieces by Johns, and often to real objects as well (flags or beer cans). Johns places these enigmatic objects before the spectators and simply presents them to view. The viewers, in turn, remain free to draw conclusions, to define tautologies, identities, similarities, and differences as they wish. Wittgenstein frequently does the same thing by drawing our attention to ambiguities that he does not, and would not, want to resolve. For example,

> It is all right to say: "I do *two* things with this hammer: I drive a nail into this board and one into that board." But I could also have said: "I am only doing one thing with this hammer; I am driving a nail into this board and one into that board." . . . The man who says, "surely these are two

Figure 1.12. *Jasper Johns*, The Dutch Wives, *1975. Encaustic and collage on canvas. Copyright © Jasper Johns/VAGA New York 1990.*

different usages" [or images] has already decided to use a two-way schema, and what he said expressed this decision." (*BB* 58; 136–40)

By refusing to resolve ambiguities, in this case concerning notions of similarity and difference, Wittgenstein and Johns foreground interpretation and its varied possibilities.

Moreover, neither Johns nor Wittgenstein resolve the contradictions and paradoxes of their work. "It is the business of philosophy," says Wittgenstein, "not to resolve a contradiction . . . but to get a clear view of . . . the state of affairs *before* the contradiction is resolved." A number of seeming contradictions, in fact, shape Wittgenstein's later theory: the meaning of a word is fluid and undefinable, and yet it can still be used. Language is entirely conventional, yet linguistic conventions are not arbitrary.[29]

Johns's work throughout sustains contradictions related to painting.[30] Like *Fool's House*, *Periscope (Hart Crane)* responds in detail to sources "outside" the canvas, even as in a contradictory movement, the

rich and sensuous surface calls attention to itself as focus. There is a continuous tension sustained between allusiveness (allusions to philosophy, poetry, and life), and self-referentiality (the powerful surface painting that many critics have called entirely autotelic). Johns's art is completely doubled in this way. There is, in fact, an unresolved ambivalence as to which is serving which: the painting as a vehicle for ideas, or the ideas as vehicles for painting. "I am just trying to find a way of making pictures," he once said (Crichton 9), but the pictures are made out of these unresolved stresses between the world of painting and the world of ideas.

In terms of art history, also, Johns's work is completely Janus-faced, looking "back" to abstract expressionism, while at the same time providing a link to a Conceptualist future. In contrast both to Duchamp and to the Conceptualists whose work his inspired, Johns himself never relinquishes painting and the painter's craft, "la patte," the artist's paw, the artist's hand, the artist's touch. But his work does, nonetheless, like Duchamp's "break through the retinal boundaries" to engage the mind. It is inspired by and inspires thought. Indeed one might argue that Johns's painting takes the postmodern turn where he questions the modern aesthetic and its valuation of the self-contained and entirely self-referential work,[31] and instead produces a "proto-Conceptual" art shaped by ideas.[32]

It is the very tension between eye and idea, between modern formalism and postmodern Conceptualism, that makes Johns's work so engaging, and so important within the history of art. His work is purposely ambiguous and contradictory. Like *Philosophical Investigations*, it can be read in a variety of conflicting ways, and it is much more paradoxical than it at first appears to be.[33] This art of blatant, straightforward images belies the artist's subtlety of thought. Even in a photograph by Richard Avedon, Johns faces the camera with a deadpan expression; is this an angry, an ironic, or a comic pose? The photograph, like Johns's art in general, conceals more than it reveals. But the importance of this fact is that we *see* it according to our interpretation (*PI* 193–212); the image does not change, but our interpretations and our perceptions can.

Johns has created a powerful body of work which shows that not only philosophy but art as well can change our way of seeing. Both Wittgenstein and Johns, in their separate ways, "discovered a new way of looking at things" (*PI* 401). "Don't take it as a matter of course," says

Wittgenstein, "but as a remarkable fact that pictures give us pleasure, occupy our minds. ('Don't take it as a matter of course' means: find it surprising)" (*PI* 524).

Johns was not the only visual artist in the 1960s to seriously consider Wittgenstein's work. Artists as diverse as Richard Serra,[34] Arakawa,[35] Robert Irwin,[36] and Robert Smithson all responded in varying degrees and in distinct styles to his later writings. Robert C. Morgan also proposes that "speculations on art theory by Kosuth, LeWitt, Weiner were realized on the basis of Wittgenstein's later work" (8). Joseph Kosuth, in particular, generated an art informed and formed by his reading of Wittgenstein.

However, in contrast to aesthetic theorists of the time, (Elton et al.), who found confirmation of their own new critical/formalist views reflected in *Philosophical Investigations* (the autonomous, self-defined object; the separation of the various arts), Kosuth is much closer in his reading to recent deconstructive interpretations like that of Henry Staten. Already wrestling with the problem of mixed media art in Futurist and Dadaist performances, and the radical questioning of the boundaries of "life" and "art" posed in Duchamp's work, Kosuth found Wittgenstein doing in the sphere of philosophy what his fellow artists were doing in art: investigating conventions, questioning definitions, and transgressing conventional boundaries. For Kosuth, as well as for others, Conceptual art was more than a series of "anti-establishment" gestures, more than an assault on "commodity-based" art. It was not a purposeless subversion of established conventions so much as a serious exploration of the nature and meaning of the conventions themselves. In short, it was a "deconstructive" art responsive to changes in the philosophy of our time.

MARGINALIA AT THE CENTER

2 TEXT AND CONTEXT

Reading Kosuth's Art

What counts is no longer the artist, or his feelings, or holding a mirror up to mankind, or man's labor, or any of the values on which our world is built. . . . Yet art is nevertheless an inquiry, precise and rigorous.

MAURICE BLANCHOT

The "true" repetition of Wittgenstein would catch, not his results, his arguments, his "models," but his deconstructive movement.

HENRY STATEN

When Henry Flynt defined "Concept art" in the Fluxus book *An Anthology*, he described the artistic activity that would dominate the decade: "Concept art is first of all an art of which the material is concepts, as the material of eg. music is sound. Since concepts are closely bound up with language, concept art is a kind of art of which the material is language." Among others, Conceptual artists Lawrence Weiner, Robert Barry, and Douglas Heubler create just this sort of art, an art in which language subsumes object making, where ideas concerning art materials and actions (Weiner), mental processes (Barry), and social and political phenomena (Weiner and Huebler) become the substance of art.[1] Each artist develops a distinctive style, yet all employ the Conceptual style of "scripting,"[2] the use of brief, prosaic, verbal propositions for mental or physical activities to be completed by the artist or audience. Like many of Duchamp's proposals in *The Green Box*, the *idea* of the artistic product or process becomes the art, whether or not the artist or viewer chooses to enact the activity described.

In approaching the work of Joseph Kosuth, it is important to note its

relation to this larger movement and to stress its difference from it as well.[3] His use of the book format for his five-volume *Art Investigations and "Problematic" Since 1965* reflects the resurgent interest at this time in the inexpensive, mass-produced artist's book.[4] Like other concept artists, Kosuth employs the technique of scripting, particularly in "The Fourth Investigation" where instructions for art procedures are typed out in simple form on mailing labels (for example, "Look up the word 'abstract' in the *Oxford Concise Dictionary* and consider the information"). The use of the imperative (do this, do that) is used not only by concept artists Kosuth, Weiner, Heubler, and Arakawa but appears repeatedly in *Philosophical Investigations*, where it is used to activate the audience and in Wittgenstein's words, "stimulate them to thoughts of their own" (*PI* Preface). *Art Investigations* further shows that Kosuth's work belongs in the tradition of *arte povera*, poor art that uses simple and available materials, is minimal in style and content, not sensorially pleasing, de-aestheticized, and purposely devoid of craft (Celant). In addition, Kosuth's art, like most "idea art," simply looks "dumb" (Lippard, *Changing* 257). His dictionary definitions and clips from the thesaurus offer no information with which we are not already perfectly familiar. But "this disarming pretense of idiocy," does, as Richard Kostelanetz proposes, "mask deeper speculative concerns that may not be immediately or even intrinsically evident" (150).[5]

Joseph Kosuth's work is a form of Conceptual inquiry. It uses art institutions, galleries, media, photography, language, and objects in order to investigate the limits, meaning and boundaries of one concept: art. If his products—reductive, minimal, bare—leave spectators bored, Kosuth replies that they are not excited enough by the idea of art: "Non-artists need that physical excitation along with the art to keep them interested. But the artist has that same obsessed interest in art that the physicist has in physics and the philosopher in philosophy" (Arthur R. Rose 23). It is important to stress Kosuth's commitment to art at the outset because he subjects it to such radical "deconstruction," emptying it of all traditional value in his exploration of its limits and boundaries. Like the artists Daniel Buren, On Kawara, Robert Irwin, or Mel Bochner, Kosuth does not produce aesthetic objects so much as employ extremely simple strategies for disengaging and activating our whole conceptual framework concerning art. This kind of work extends the experiments of Duchamp's readymades, Cage's *4'3"* and Rauschen-

berg's *Portrait of Iris Clert* into an entire artistic mode. The artist, how-ever, remains deeply committed to art, even as traditional values and definitions are dislocated and destabilized. As Daniel Buren says, "One should not take neutral painting for uncommitted painting" (1972, 66).

"The 'purest' definition of conceptual art," as it is practiced by Kosuth, "would be that it is inquiry into the foundations of the concept 'art,' as it has come to mean" ("AAP" II: 160). It is a "working out, thinking out of all the aspects of the concept 'art.'" ("Introductory Note" 104). Kosuth's central concern is with this investigative process, not with the artistic product, and not with the "subject matter or the structures used" (*Function*). "Being an artist now means to question the nature of art," he says; "if you make paintings you are already accepting (not questioning) the nature of art" (Arthur R. Rose 23).

> The function of art, as a question, was first raised by Marcel Duchamp. In fact it is Marcel Duchamp whom we can credit with giving art its own identity. . . . With the unassisted Readymade, art changed its focus from the form of the lan-guage to what was being said. Which means that it changed the nature of art from a question of morphology to a question of function. This change—one from "appearance" to "conception"—was the beginning . . . of "conceptual" art. ("AAP" I: 135)

In contrast to contemporary painters like Johns or Arakawa, who continue the "morphological" tradition in art even as they extend its conceptual concerns, Concept art in general rejects the "retinal" or "perusal" tradition in art.[6] It purposely deprives its images of beauty, decoration, and taste. In Kosuth's work in particular, the reliance on verbal signs is designed to render an "iconic grasp" difficult (*AI* 3: 70), to thwart both visual and mental imaging.[7]

Kosuth's earliest Conceptual pieces (1965) include a variety of allu-sions to Duchamp and show his own interest in "putting art once again at the service of the mind." Like Duchamp, Kosuth uses glass in a vari-ety of works because it contains so many traditional associations with painting: "Alberti first suggested the idea of considering a painting as a window through which we look at the visible world. It was Leonardo da

Vinci who gave substance to this idea by suggesting that "perspective" is nothing else than seeing a place behind a pane of glass, quite transparent, on the surface of which the objects behind the glass are to be drawn" (Gombrich 299).

As contemporary artists abandon painting as the proper medium for the visual arts, they become increasingly aware of its metaphoric associations. Thus Robert Smithson writes, "The rational category of 'painting' was derived from the visual meaning of the word 'window' and then extended to mean 'wall.' The transparency of the window or wall as a clear 'surface' becomes diseased when the artist defines his art by the *word* 'painting' alone. . . . 'Painting' is not an *end*, but a *means*, therefore it is linguistically an out-of-date category" (*Writings* 47). Like *The Large Glass*, to which it may be alluding, Kosuth's *Leaning Glass* ("Any five foot square sheet of glass leaned against any wall") also empties the commonplace metaphor (of art as a window) by its rejection of realism and painting. Another early work by Kosuth contains a simple wood crate with the word "GLASS" stencilled on it (Fig. 2.1). A commonplace object frequently used for the transportations of paintings, the object is also a visual pun that alludes to Duchamp's verbal play: *boîte vert (verre)*—green box (glass). Kosuth's earliest pieces, then, function like Duchamp's in primarily a linguistic way. However, while Duchamp assaults linguistic meaning by using dissociative and nonsensical verbal ploys, Kosuth explores the meaning potential of language and uses prosaic and discursive verbal strategies instead. His *boîte verre* is part of a "Protoinvestigation" that questions definitions of words like "box" and "glass."

As in the case of other contemporary artists, Kosuth's concern for the problem of art's definition also leads to an interest in Wittgenstein's writings. Here, however, the influence is both profound and pervasive. Kosuth's three-part essay "Art After Philosophy" quotes Wittgenstein ("the meaning is the use"), as well as other philosophers referring to him (G. H. Von Wright and J. O. Urmson). For Kosuth, Wittgenstein's work signals the end of metaphysics in philosophy; the philosopher's inquiry into the meaning and boundaries of concepts is the point of departure for all of Kosuth's work, which examines the concept, nature, and boundaries of "art." Texts by and about Wittgenstein are alluded to and used in the production of Kosuth's own *Art Investigations and Problematic* (Garth Hallet, *Wittgenstein's Definition of Meaning as Use*, for example, in "The Eighth Investigation"). Kosuth's work uses art in

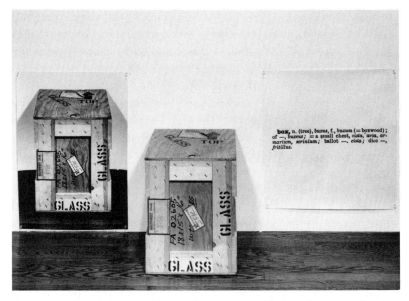

Figure 2.1. Joseph Kosuth, "One and Three Boxes," 1965. Photograph, photostat, and object. Art Investigations *1:27.*

many ways to explore issues also central to Wittgenstein's later work—the relation of word to thing and of meaning to context, the limits of logic, and the fluidity of conceptual boundaries. Kosuth's conceptual inquiry (into the nature of art) is also fundamentally grammatical (non-metaphysical, non-empirical, and even non-visual). Although its overriding purpose is to question "the language of art," it also uses words to investigate meaning.[8]

Kosuth believes that art is essentially (and not secondarily) linguistic: "Fundamental to this idea of the arts is the understanding of the linguistic nature of all art propositions, be they past or present, and regardless of the elements used in their construction ("Introductory Note" 104). This rather shocking view of the "visual" arts as centrally linguistic was shared by the Art and Language Group with whom Kosuth was associated in the 1960s. Throughout his essays Kosuth describes art as a "language" and works of art as "propositions" in that language ("AAP" I: 135–36). Diametrically opposed to traditional notions of art as visual, sensory experience, this attention to the Conceptual and linguistic aspect of art was also voiced by at least one critic at

the time. In his essay "Art and Words", Harold Rosenberg wrote: "Regardless of the Anti-Art character of modern paintings, their verbal ingredient separates them from images and things merely seen and removes them to a realm founded on the intellectual interrelation among works of art" (*De-Definition* 58).

The conceptual framework of art, or the "language of art," is an explicit theme in Kosuth's work. "The value of cubism," he says, "is its idea in the realm of art, not the physical or visual qualities seen in a specific painting." Artists are praised by Kosuth not for the particular objects they produce, but for "what they add to the conception of art." Any physical thing, Kosuth suggests, can be considered an *objet d'art*, aesthetically pleasing or tasteful, but *art* is necessarily concerned with the nature of art (hence his notion of art as tautology).[9] For Kosuth, the best art of the century (Malevich, Mondrian, Pollock, Reinhardt, Johns) is not about life (a "synthetic proposition"), but about art (an "analytic proposition"); great artists recognize the Conceptual basis of art and modify, change, or advance it in some significant and "logical" way ("AAP" I: 135–36). For Kosuth, the artist is an "analyst" concerned with how art is capable of conceptual and not just formal or morphological growth.[10]

The "verbal ingredient" of art is therefore laid bare in Kosuth's work and (like the emperor's new clothes) exposed as that which, though unrecognized and unacknowledged, had all along been a definitive aspect of art. The separations between the arts, Owens reminds us, are as much a product of words as the "facts" they are meant to describe":

> Although such distinctions were made in the name of establishing the relative merits of each of the arts, and while there may have been differences concerning the superiority of either the visual or verbal arts, the aesthetic hierarchies which followed were without exception based upon this verbal/visual polarity, and thus upon an ultimately *linguistic* criterion. ("Earthwords" 126)

Mel Ramsden (of the Art and Language Group) agrees that this focus on the "linguistic nature of art is a way of getting at . . . cultural categories, ie. to regard these categories as 'arbitrary' conventions. Not as part of 'nature'" (*AI* 1: 92). Thus the prominent use of words in Kosuth's art—his dictionary definitions, for example—make explicit

the role of words in the definition of art, the verbal and discursive component that constitutes art as a conceptual sphere.

At the same time, Kosuth's definitions are also used to de-define art, to upend the traditional function of the "visual" arts by substituting verbal operations for visual ones. This "de-definitional impulse," says Christian Hubert, "is perhaps the most powerful aspect of Post-Modernism in the arts. New areas of artistic activity have emerged—such as performance and earth art—which resist definition in terms of traditional media" (4). In his book appropriately titled *The De-Definition of Art*, Rosenberg suggests that the "best art of this century belongs to a visual debate about what art is" (12). Some contemporary artists (Robert Irwin, for example) are as concerned as Kosuth with the "de-definition" of art, yet they continue to use visual strategies in the process of questioning its boundaries. Kosuth's art is noteworthy for its degree of self-consciousness, for the way in which it focuses contemporary trends and by means of verbal techniques presents art as an activity of definition.

From 1965 to 1968, Kosuth used photostats of dictionary definitions in a variety of ways within his work, and they became a trademark for it. These images were selected from dictionaries rather than being created by the artist, in a process of transferring rather than producing information that Craig Owens defines as a distinguishing feature of postmodernism in the arts ("Postmodernism" 8). As in the work of other artists (Sherrie Levine, for instance), photography plays an important role in this art of "appropriation" and "confiscation." Rather than executing the works himself, and in order to further dissociate himself from the activity of fabricating objects, Kosuth had the photostats made rather than producing them himself. The industrially derived surfaces create a sense of the impersonal and mechanical; all the definitions are square, all are black with white lettering. They are analytic, anonymous, "neutral" (like Buren's stripes), austere, detached, and cold.[11] Designed to subvert vision rather than to engage it, Kosuth ceased the definition series when the photostats became confused for paintings: "I never wanted anyone to think that I was presenting a photostat as a work of art," he said ("AAP" III: 212).

The dictionary definition was first employed by Kosuth in the "Protoinvestigation" that juxtaposes a chair, a black-and-white photograph of a chair, and a photostat of its dictionary definition. The extremely mundane object in this work and others in the series is associated by

Terry Atkinson (Art and Language artist) with the use of the quotidian by Johns and Wittgenstein (*AI* 1: 12). "One and Three Chairs" fits neatly, as Jack Burnham and Peter Weibel suggest, into Wittgenstein's theory in the *Tractatus*. [12] In this theory, language and reality share the same logical form (Staten 5), so that "proposition, language, thought, [and] word stand in line . . . each equivalent to each" (*PI* 96). Because words are immediately correlated with things in the *Tractatus*, "Speaking the name of a thing in the physical presence of that thing, or pointing to it and saying 'this,' seems to provide an unimpeachable model of the relation between language and 'reality'" (Staten 68–69). Indeed, Kosuth seems to be pointing to objects in this way, if not uttering the words "this is . . ." (itself "the formula of the ostensive definition" [*BB* 69]), certainly making that gesture. In "One and Three Tables" (Fig. 2.2), the bare presentational style and the sense of redundancy do in fact suggest a sequence of object, image, and word "each equivalent to each." If, as Peter Weibel suggests, Kosuth had the *Tractatus* in mind when creating these "Protoinvestigations," then the artist has indeed succeeded in creating a suitable "picture" of this (picture) theory of language.

Kosuth also includes definitions in his *Notebook on Water*, a random collection of black-and-white photographs, definitions, sketches, maps, and postcards published in a manila envelope (by Multiples, Inc.) and also included in the *Art Investigations*. He describes the work as follows:

> I got interested in water because of its formless, colorless quality. I used water in every way I could imagine—blocks of radiator steam, maps with areas of water used in a system, picture postcard collections of bodies of water, and so on until 1966, when I had a photostat made of the dictionary definition of water, which for me at that time was a way of just presenting the *idea* of water. ("AAP" III: 212)

Here, again, artistic activity is a process of selection and accumulation, producing in the *Notebook* an endless collage of images and words without stable boundaries, without a frame. In keeping with idea art as a whole, there is no aesthetic quality to contemplate, no craft exhibited in this assortment of reductive images. Non-objective art, as Philip Leider observes, becomes non-object art (Weschler 81); the refined, aesthetic

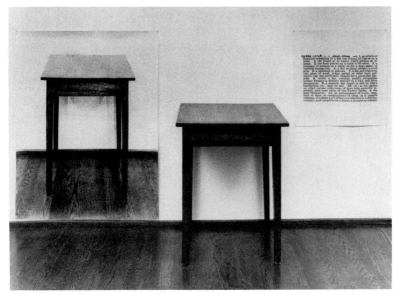

Figure 2.2. Joseph Kosuth, "One and Three Tables," 1965. Photograph, photostat, and object. Art Investigations *1: 11.*

object is "dematerialized" (Lippard) and generally reduced to a sequence of bare and minimal images. Both the materials of the art and its subject are ephemeral and insubstantial.

As in Barry's "Inert Gas Series" (1969), Art and Language's "Air Show" (1967), and Morris's "Steam" (1967), the emphasis in the *Notebook* is on formlessness (Fig. 2.3). Kosuth's melting ice cubes (in one case, humorously labeled "Present Whereabouts Unknown") subvert objecthood, as do the shifting states of physical materials in more recent works of Performance art—Joseph Beuys's *Fat Corner*, for example, or Laurie Anderson's *Duets on Ice*. Not stable objects but temporal processes are the subjects of this art.

The temporalization of the object, moreover, relates to the de-definitional impetus of contemporary art: objects in transformation elude stable definition. Here is Robert Irwin posing the problem in visual, painterly terms:[13]

> There is simply no real separation line, only an intellectual one, between an object and its time environment. . . . How

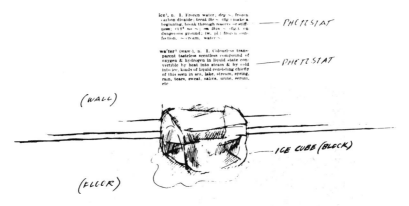

Figure 2.3. Joseph Kosuth, "Mock-up for Ice/Water piece using Time as a Variable," Photostat. 1965–1966. From Notebook on Water.

> can you separate the line in a painting by Barnett Newman
> from the rods that hold the painting up? You can, in a sense,
> just not see it; in other words, you can just dilate it right out
> of your visual range. (Weschler 108, 148)

Now contrast this attention to the impossibility of drawing boundaries
around things, to the necessity in classical philosophy for stable form
and definition:

> For Aristotle, the concept of form is inseparable from unity
> and self-identity . . . he is . . . "fighting against the flux,"
> looking for a principle that will make a thing be a "definite
> abiding something," the same as itself and different from
> anything else. . . . Form is the *horismos*, or boundary of
> definition, that makes an object be what it is and not any-
> thing or everything else, the bulwark that holds it together
> against the indefinite. (Staten 8–9)

"The boundary of definition" is precisely what is at stake in the "de-
materialization" of the contemporary arts. In "Air Show" (*Art & Lan-
guage* 20), Terry Atkinson and Michael Baldwin speculate on the
difficulty of drawing a "boundary" around a fog bank, and the virtual
impossibility of visually demarcating a "column of air." The implica-
tion seems to be that the possibility of such a boundary is a function of

language; we can conceive of such a boundary (because of the words "a column of air"), but we cannot draw one in actual fact.

In the case of Kosuth's *Notebook*, not only the material (water) but also the *idea* of the material is presented as shifting and fluid. Just as in "Air Show," the Art and Language artists stress the various ways of conceiving and conceptualizing air (as matter or, thermodynamically, as energy), so the *Notebook* presents the "multiple aspects of an idea."[14] Not just the object, but the various ways of seeing, conceptualizing, and defining it are the subjects of this art. This is not, however, just a repetition of modernist concerns for the conceptual basis of perception, but rather an extension of them which focuses on the role of language in conceptualizing processes (Figs. 2.4, 2.5). Thus Kosuth's transformations in form (water, ice, steam) correspond to conceptual transformations, and these in turn relate to the shifting definitions of water included in the work (hard water, soft water, heavy water, drinking water, rain water, ground water, spring water, limewater, mineral water, steam, vapor, ice, ice cream, icing, ice age, oxygen, hydrogen, etc.).[15] There is not one stable definition of water so much as a multiplicity of overlapping and related uses and definitions of it. ("We find that what connects all the cases [of water, say] is a vast number of overlapping similarities and as soon as we see this, we feel no longer compelled to say that there must be some one feature common to them all" [*BB* 87].)

By 1968, and probably before, Kosuth was using his dictionary definitions in a very peculiar and slyly ironic way. The only exhibition of these definitions occurred in that year: twelve dictionary definitions of the word "nothing" taken from twelve different dictionaries. The reviewer for *Arts Magazine* caught part of the irony: "The concept of the show is ironically provocative—how can nothing remain nothing when there is so much of it that must be dealt with as something?" (Terbell 61). It is ironic, too, that the work currently exists as "nothing" but an idea. But the irony extends to Kosuth's use of definitions as well; while they seem to be static and definitive, they in fact operate the opposite way. By compiling numerous definitions for one word, the viewer shifts between various definitions (or "aspects of an idea") in time, and no single definition achieves priority or authority. When Kosuth says that the definition was a way of presenting the "idea" (of "water" or "nothing"), the mode of presentation and the multiplicity of varied but related definitions, suggest that the idea is not stable and definite (as in Platonic idealism), but fluid and shifting (like water). Therefore these

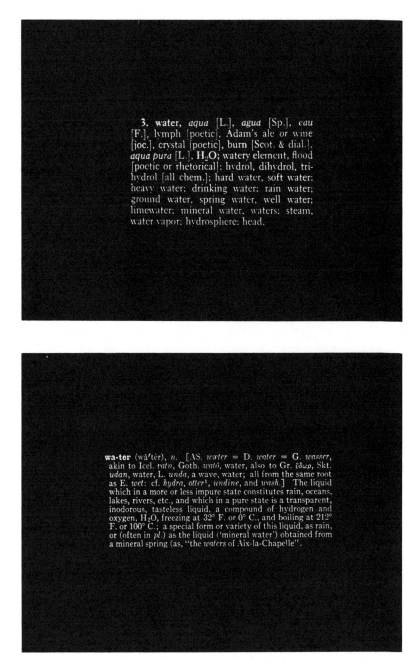

Figure 2.4. Joseph Kosuth, Photostats (Definitions), 1965–1966. From Notebook on Water.

ice (īs), n. [AS. īs = D. ijs = G. eis = Icel. íss, ice.] The solid form of water, produced by freezing; frozen water; the frozen surface of a body of water; hence, some substance resembling this; esp., a confection made of water and fruit-juice or of variously flavored cream, custard, etc., sweetened and frozen; also, icing. —**ice age**, the glacial epoch (see *glacial*).

ice (n, hence adj and v), **iceberg, icicle, icy;**
Iceland, Icelandic (adj, hence n).
　Ice derives, via ME *is, iis*, from OE *īs*, akin to OFris, OS, OHG-MHG *īs*, G *Eis*, MD *iss, isse*, D *ijs*, ON *iss*, prob also to Av *isav-*, frosty. The cpd *iceberg*, lit 'mountain of ice', ult of Scan origin, perh comes imm from MD *ijsberch* (D *ijsberg*); cf BERG. Similarly *Iceland* is 'Land of Ice', the native name being *Ísland*; hence *Icelandic*. *Icicle* derives from ME *isikel*, a f/e extn of OE *gicel*, icicle, with ME *is* (OE *īs*) added superflu-ously; cf ON *jökull*, icicle. *Icy* represents OE *īsig*.

Figure 2.5. Joseph Kosuth, Photostats (Definitions), 1965–1966. From Note-book on Water.

works in which the ostensive definition is so prominent are not defining essences. As Terry Smith proposes regarding the "Protoinvestigations," "If 'Clock (One and Five)' is about defining 'clockness' and 'One and Three Chairs' is about defining 'chairness' and so on, then the Protoinvestigations would be merely illustrations of the tritest Platonic idealism" (*AI* 4: 28). [16]

I have been suggesting that somewhere in this process of using definitions Kosuth became increasingly aware of Wittgenstein's later work. After all, it is not the *Tractatus* but Wittgenstein's later writings that are alluded to throughout the artist's work. It is even possible, I think, to read "One and Three Tables" (Fig. 2.2) both in terms of the *Tractatus* and in terms of Wittgenstein's later theory, where the philosopher retains a picture theory of language, "We said that if we wanted a picture of reality the sentence itself *is* such a picture (though not a picture by similarity)" (*BB* 41), but the connecting principle of stable logical form gives way to changing and variable use as the nexus of meaning.

If we look more closely at "One and Three Tables," what we find is a pun that subtly turns the "equivalence" (of word, object, and image) into an "equivocation" instead. A "table," as the definition itself informs us, is an orderly arrangement of words; all of Kosuth's definitions are tables, then, including this one. Previously it seemed as though the object was the center of the work and the words served merely to repeat (in different symbolic form) the same meaning, but now we are faced with (at least) two separate and irreconcilable kinds of "tables," two different meanings that do not relate at all except in the arbitrary coincidence of their sounds. Now this undercutting of the dictionary definition makes more sense if we recall that the "ostensive definition was the centerpiece of the concept of definition against which Wittgenstein was writing in *Philosophical Investigations* (Staten 68). Wittgenstein's argument against the ostensive definition is, in fact, that it "can be misinterpreted in every case" (*PI* 28); it contains ambiguities that are not usually recognized. Kosuth's pun produces an irreconcilable ambiguity within his "definition" as well: which table, the verbal or the visual one, is being defined? Rather than asserting the validity of the ostensive (dictionary) definition, then, "One and Three Tables" is ironically undercutting it.

That Kosuth at some point became or was aware of this ambiguity within "One and Three Tables" is suggested by what he goes on to do, "the use he makes of the word" (*PI* 29) in later works. "The meaning of

the expression depends entirely on how we go on using it," says Witt-
genstein [*BB* 73–74]). Indeed, Kosuth employs the same pun repeat-
edly. The "Synopsis of Categories" from the thesaurus ("The Second
Investigation") is exactly a "table" of words; "The Third Investigation"
focuses attention on the "table" of contents of three books (on time).
"The Eighth and Ninth Investigations" contain real tables with texts on
them; the texts are coordinated by numbers to clocks so that the clocks
become "tables" for reading the texts (Fig. 2.6). Wittgenstein dis-
cusses many such tables for the reading and interpreting of signs (*PI*
53, 86). In one of Kosuth's versions, "the linkage is between the two
numbers pointed to by the hands of the clock, and the correspondence
of those numbers in the text (Zettel)" (*AI* 4: 23). The important point is
not how often Kosuth employs verbal tables, or exploits the pun ("truth
tables" "timetables"), or even his allusion to *Zettel*, but that for Witt-
genstein (and I think for Kosuth as well), tables for reading signs ex-
emplify multiple contexts and possibilities for interpretation, and puns
exemplify the multiplicity of uses and hence meaning possibilities for
each and every word.[17] Consequently, "One and Three Tables," like
the ostensive definition itself, can be interpreted in a variety of ways;
multiplicity and ambiguity undercut the stable and "definitive" mean-
ing that it seems to offer.

Another important aspect of Wittgenstein's philosophy for Kosuth,
as for Johns, is the notion of use, and thus the relation of meaning to
context. In the same way that *Fool's House* decontextualizes real objects
(broom, cup, canvas) and uses them for entirely different purposes
within painting, so in "The Second Investigation," Kosuth wrests the
"Synopsis of Categories" (Fig. 2.7) from its "proper" place in the the-
saurus and uses it for purposes entirely of his own.[18] Creating his own
margins and boundaries, Kosuth, in his pencilled notes, turns the
"Synopsis" into a personal mapping of his own extensive travels and
shows. In the process, he also creates a series of jokes playing on cul-
tural stereotypes: (AFFECTIONS: "Spain"; VOLUNTARY ACTION:
"Denmark"; INTELLECT: "Oxford University"), and a sequence of
in-jokes concerning other artists as well: (ORGANIC MATTER: "Dwan
[Gallery], R.[obert] S.[mithson] Language Show"; RELATION: "2-man
show with R. Morris"). Overlaid with Kosuth's handwriting, the "Syn-
opsis" ceases to be a linguistic system and becomes a geographic and
temporal map instead. As geographic boundaries are crossed, so too
are the boundaries of "art" and "life." Sections of the "Synopsis" are

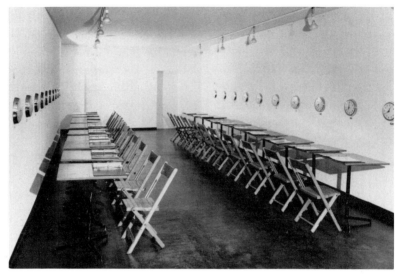

Figure 2.6. Joseph Kosuth, "The Eighth Investigation, Proposition 5," 1971. Tables, chairs, and propositions. Art Investigations 4:27.

scattered out into newspapers (London, New York, Melbourne), buses (Halifax), street signs (Turin), and billboards (Portales, Pasadena, Bern). Finally, as these geographic and "art/life" boundaries are crossed and confused, so are the boundaries of the accepted locations for art. Within Kosuth's work, all "boundaries are 'givens' and function in a 'game-like' arena with changing *use* and *meaning*" (*Function*).

This kind of work expands the art context in obvious ways; yet it leads to art which ironically threatens to disappear altogether. The effort to treat the environment and to expand art into life results in work that is easily overlooked (Kosuth's category terms; Buren's stripes), that disappears intermittently (Smithson's *Spiral Jetty*), or that is designed not only to be peripheral but invisible as well (Irwin's prismatic columns). One literally does not see the work unless one knows where to look for it or has "advance information about it" ("AAP" I: 137). The art functions as an extreme manifestation of the interest throughout the century in the interdependence of perception and conception (in Cubism, Futurism, Dada, and Op art). But in Conceptual art, what we know not only determines *how* we will see the art, but *if* we will see it at all.

The billboards and newspapers of Kosuth's "Second Investigation" are particularly interesting, because they are virtually meaningless for

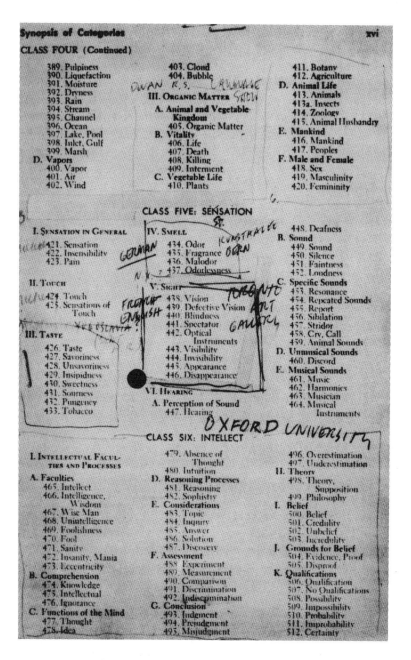

Figure 2.7. Joseph Kosuth, from "Synopsis of Categories," 1968. Art Investigations *2: 6.*

any viewer unfamiliar with their place in Kosuth's gambit. In Kosuth's work, every artistic form has relational value and none operates separately as an autonomous object.[19] "Each unit," he says, "has no more inherent value or meaning anywhere along the line than does another" (*Function*). His works are presented in sets ("Investigations") without center or hierarchy, and the individual piece (minimal, reductive, bare) only "works" as a function of that set (*AI* 3: 70). Indeed Robert Morris defines this "relational structuring" as a distinctive characteristic of contemporary art: "In this 'new work,'" he says, "the specific art object is simply a component or part of a larger substantive whole, . . . it resists the confines of the specific-object framework" (Atkinson 148).[20] A set of stripes by Buren, a pile of rocks by Smithson, a "Synopsis" excerpt by Kosuth are not presented for the edification and contemplation of the viewer, so much as they are designed to shift the viewer's attention from the object itself towards its relations to other objects and ideas (Smithson's site/non-site relation, for example). This displacement of value from the thing itself to its role in a larger system relates in a general way to contemporary theories of language (from Wittgenstein to structural linguistics) which stress the meaning of a word as its role in the entire system of language.[21] "In modern theory," says Wendy Steiner, "thinking is understood as a set of relations rather than as a common substance inhering in a group of phenomena" (*Colors* 38). Viewed as parts of a larger system, the objects, images, and gestures of art are also in this way temporalized, 'inscribed in a sequence,' deriving their meaning from a 'before' and an 'after'" (Staten 72, 87). "*This* scene here means nothing by itself. It is like a picture in a series of pictures which tell a story in a picture language, and the single picture makes whatever sense it makes only in the sequence" (*PI* p. 54n, 536–39; Staten 147).

In Kosuth's "The Second Investigation," meaning resides not only in the way the individual signs relate back to the "system of signs," the "Synopsis of Categories"; it also is generated anew in each new physical context. The "Investigation" might best be viewed as a visual and verbal form of "dissemination":

> We can see the convergence between Derrida and Wittgenstein in this notion of continually different contextualized meaning as the focus of investigation . . . the limitless iterability of the sign, its capacity to appear again and again in

new contexts where its meaning differs, however slightly, from its meaning in any previous context . . . means that in order to understand each appearance in its difference we must study its context or syntax. (Staten 25)

Kosuth's "The Second Investigation" examines shifts of meaning and function in response to variations in the surroundings, the physical contexts of words. Such shifts in Kosuth's "Investigation" do not lead, as they do in *Philosophical Investigations*, to an exposition of confusions and category mistakes in philosophy (Staten 95), but they do produce some unexpected juxtapositions which call attention to the relation of context to meaning. For example, like all of Kosuth's signs, one stands oddly out of place in its setting; located near a busy street in Turin, it contains the category terms associated with heat (Fig. 2.8):

327. calore
328. rescaldamento
329. cottura
330. combustibile
331. incombustibile
332. freddo
333. refrigerazione

The photograph included in *Art Investigations* shows the sign surrounded by cars—"combustion" engines. Another sign, in Pasadena, contains terms related to electricity, and the photograph of the piece includes a nearby lamppost. It is difficult to tell in the street signs and billboards if such coincidences are accidental or controlled. But in the use of media advertisements, Kosuth's procedures are clearly aleatory; he submits the "Synopsis" fragments to newspapers and magazines, and his data surfaces arbitrarily in their pages.

Jack Burnham aptly describes "The Second Investigation" as "the essence of data dispersion" (35). As information is dispersed physically outward into various locations, accidental juxtapositions also generate and "disseminate" meaning. Gregory Ulmer shows that Derrida's "signature effect" disseminates or "engenders meaning beyond authorial intent"; it calls attention to the unmotivatedness of language by following networks of meaning unanticipated by the writer himself and located in the accidental, aleatory coincidences of sounds in language

Figure 2.8. Joseph Kosuth, from "The Second Investigation," 1969. Street sign. Art Investigations 2: 14.

(*Applied Grammatology* 25, 45–46). Kosuth's method is not homonymic but semantic; as "his" (already appropriated and cited) texts appear accidentally in a newspaper or magazine, they too produce unanticipated coincidences that "disseminate" meaning out beyond the control of the artist.

Kosuth's dissociative strategy, therefore, produces some surprising and comic semantic connections. The thesaurus category COMMUNICATION OF IDEAS is accidentally juxtaposed with a headline that reads: "Sir Henry Loses His Voice" (Fig. 2.9). The category term ORDER, with its subheading ASSEMBLAGE, surfaces in the art section of the *New York Post*; the newspaper page is itself an assemblage (of ads, reviews, and listings) and at least one famous assemblagist, Robert Rauschenberg, is mentioned on the page (Fig. 2.10). In another instance, the words REPRESENTATION and MISREPRESENTATION are surrounded by line drawings from cartoons and advertisements (visual "representations"). Even more, one of the ads offers a garage "tilt a door" at the bargain rate of $287 (with "no worry terms") so that the term MISREPRESENTATION begins to resonate with familiar meaning (Fig. 2.11).

To make too much of these coincidental meanings would be a mistake of over-interpretation, but to miss that some such accidental connections occur would be to miss the point entirely. "The Second Investigation" is a "real life" collage or assemblage in constant transformation and change. That Kosuth "produces" the verbal component and allows the visual elements to accumulate accidentally around his signs constitutes an ironic inversion of the traditional role of the "visual" artist. The most important issue for Kosuth, as for deconstructive philosophy, however, is that ever-shifting contexts generate meanings in constant transformation and flux, even as the wrested or cited texts retain associations with their former context (Ulmer 58–59). It is this preoccupation with the relation of meaning to context that distinguishes the work of Joseph Kosuth and the Art and Language Group from most other Concept art of its time. "There is an attempt in Art and Language," Atkinson explains, "to go for the contextual questions not the object questions" (164).

The term "context" then is multivalent: it includes the system of signs ("The Synopsis of Categories"), the specific spatial and temporal situation in which the sign appears, and also the conceptual context(s) supplied by each reader or viewer.

Figure 2.9. Joseph Kosuth, "III. Communication of Ideas," from "The Second Investigation," 1969. Newspaper advertisement, The Sun, *Melbourne, May 11, 1969. Art Investigations 2:46.*

...ase its effectiveness as social nifesto.

'he devices he has absorbed right out of the avant-garde k. There are passages as in and abstract as minimal lpture and as big as most of examples one sees around, iough in a work as overelming in its dimensions as Siqueiros mural, thier im- t as pure form hits the visi only after patient looking.

✳ ✳ ✳

'here are sculptural passages expressionistic as the snarl metal-and-canvas three di nsioral "targets" of Lee Bon- ou, or the mystical metal la- inths of Herbert Ferber.

'he overall book of the mural lirectly in line with the pop ists' credo: be big as a build , obvious as billboard, garish a neon sign. The difference 'hat the pop-artists say noth plainly and directly. Rather

proletarian revolution must and will continue, until the oppressors are eventually vanquished.

Meanwhile he works in his magnificent studio behind his garden, bright with bougain villaea reflected in the swimming pool alongside his handsome house.

Some 20 assistants jumps to do the master's bidding, as he puts final touches on a stupendous project paid for by a Mexican industrialist and builder, Manuel Suarez. Mr. Suarez has also constructed and paid for the auditorium which will house the work.

It is a situation which embarrasses Siqueiros not at all, any more than did his accepting from Mexican President Gustavo Diaz Ordaz the National Prize for the Arts, highest award granted by the government which had put him in jail.

In the bright mid-day sun of

heralds his genius at devising, compositions of thrusting, rushing forms that make the Italian futurists, from whom he learned much, seem static in comparison. It affirms his unwavering belief in man's esthetic, if not their political or social ideas.

But it also announces to the world that Siqueiros, last of the great Mexican muralist triumvirate—the others, of course, were Rivera and Orozco —knows no more about color than he ever did, that he has still not learned how to rein in his compulsive cataracts of details, ant that his taste remains as unrelievedly dreadful as it has always been.

Revolutions, perhaps, have no need for taste. What Siqueiros doesn't see is that art isn't much use to them, either. His tycoon-patron, on the other hand, seems to understand this very well.

Figure 2.10. Joseph Kosuth, "IV. Order," from "The Second Investigation," 1969. Newspaper advertisement, The New York Post, *New York, April 1, 1969.* Art Investigations *2: 29.*

Figure 2.11. Joseph Kosuth, "III. Communication of Ideas," from "The Second Investigation," 1969. Newspaper advertisement, The Sun, *Melbourne, May 11, 1969.* Art Investigations *2: 47.*

> And when we write or speak, or when we act out scenes, we
> are essentially exposed to having someone else repeat what
> we have done or said while "grafting" it into a new context—
> say, in order to mock us. This essential possibility is the
> positive condition of being able to say or do anything mean-
> ingful, but it ensures that . . . meaning will be illimitably
> torn and carried away into an illimitable spread of new con-
> texts. (Staten 147)[22]

Kosuth's work turns such interpretive contexts into one of its many sub-
jects. "The Eighth Investigation" asks us, for example, to consider the
various ways of reading clocks (*PI* 266), and the various kinds of time
senses; yet it also lists the various "levels" or contexts in which it can
itself be read. We are asked to consider the Second and Third Proposi-
tion of "The Eighth Investigation" in some of the following ways: the
formal "hardware" elements of the proposition; the proposition in the
context of "The Eighth Investigation"; the proposition in the context of
all eight "Investigations"; "The Eighth Investigation" in the context of
the Guggenheim International, where the work was exhibited (1971);
all eight "Investigations" in the context of modern art, in the context of
postmodern art, in the context of our notion of twentieth-century art,
and in the context of Kosuth's notion of twentieth-century art. This is
the permutational exhaustion of possibilities seen in LeWitt, Dar-
boven, and Johns applied to the possibilities for "reading" and inter-
preting "art." Moreover, it is a *verbal* list of alternatives that calls
attention to "contextualization" as a process of "textualization" as
well. Consider the following illustration from *Philosophical Investiga-
tions*, which also stresses "context" as a kind of "text" surrounding
an image:

You could imagine the illustration

appearing in several places in a book, a text-book for in-
stance. In the relevant text something different is in ques-
tion every time: here a glass cube, there an inverted open
box, there a wire frame of that shape, there three boards
forming a solid angle. Each time the text supplies the inter-
pretation of the illustration.

But we can also *see* the illustration now as one thing now
as another.

—So we interpret it, and *see* it as we *interpret* it. (p. 193)

Kosuth's "Eighth and Ninth Investigations" include texts that oper-
ate exactly like Wittgenstein's "text-book," leading us to both see and
interpret (clocks, propositions) now in one way, now in another. Thus
the artist does not only present objects but also controls some of the
contexts or texts (including theoretical texts) through which they are
viewed.

In the same way, then, that he blurs the boundary between the theory
that generates the art and the art itself, so Kosuth also blurs the bound-
ary between the art and the viewer's response to it. In the Introduction
to *Function*, he says, "This book is actually only segment one . . . and
segment two is necessarily supplied by the reader." Because of his per-
mutational list of possible contexts for reading "The Eighth Investiga-
tion," there is not much that the viewer can do that is not already
subsumed as part of the art itself. The scripting techniques of Concep-
tual art in general operate to make the viewer an active participant not
only in the interpretation of the work but also in its production. The
boundaries are now purposely confused. Artist becomes theorist,
viewer becomes "artist" as the roles overlap and intertwine. Since each
viewer will perform these operations in a slightly different way, not only
is the art enacted by the audience, but its meaning "is illimitably torn
and carried away into an illimitable spread of new contexts."

Because Kosuth's logical exhaustion of possibilities does not result
in stable meaning so much as expand into varied and multiple pos-
sibilities for interpretation, the "logic" of the procedure is itself under-
cut. The artist is following LeWitt's dictum: "The logic of a piece or
series of pieces is a device that is used at times only to be ruined" (80–
81). Kosuth's *Function* is a small book in which the "art works" are just
spoofs on logic, a series of pseudo-syllogisms:

Premises:
1) Children are illogical
2) Nobody is despised who can manage a cobra
3) Illogical persons are disliked

Answer:
Children cannot manage cobras

Solution:

$$1 \quad\quad 2 \quad\quad 3 \quad\quad\quad 1 \quad\quad 3 \quad\quad\quad\quad\quad\quad 2$$
$$b_1 d_0 \; \dagger \; ac_0 \; \text{ß} \; d'_1 c'_0; \quad \underline{bd} \; \dagger \; \underline{d'}\,\underline{c'} \; \dagger \; a \; \underline{\underline{c}} \; \Vdash \; ba_0 \; \dagger \; b_1, \; \text{i.e.} \; \Vdash \; b_1 a_0$$

The answer does not follow from the premises, the premises are them-
selves "illogical," and the entire joke seems to be that logic can supply
answers, but it can offer no (comprehensible) solutions.[23] Similar
pseudo-mathematical sentences also serve as the "solutions" to a series
of riddles posed in "The Fifth Investigation." "If it takes twice as long
for a passenger train to pass a freight train after it first overtakes it as it
takes the two trains to pass when going in opposite directions, what
would be the question and what would be the answer?" Kosuth's art
functions in many ways like this riddle: the answer to the question of
what kind of art he is creating is simply the questioning (of art) itself.
There is no closure, no resolution, no "solution" to this riddling, unset-
tling, and even at times annoying "process of questioning the nature of
art."[24] Describing Kosuth's work, Mel Ramsden said, "It may be that
we are in a situation where there is no logical connection between
'meaning' and 'certainty'" (*AI* 2: 75; 4: 1). As it tests the values, limits,
and boundaries of art, Kosuth's work remains essentially "investiga-
tive" and interrogative, despite the techniques and the terminology of
logic and mathematics that it employs.

If the meaning of a word is its "use," then the meaning of *Function*,
say, or the "Investigations" is not contained within them, but in how
Kosuth uses them to dislocate or "deconstruct" the "visual arts" by ac-
cess to another system—language.[25] The purpose of such de-
construction is to show that concepts (like art) are not bounded and sta-
ble (like an "ostensive" definition), but fluid, changing, capable of
growth and variation. Mel Ramsden observes:

> One problem Joseph Kosuth did come across at a new angle
> was the conventional nature of art. Once you regard art as a

> social and cultural activity and not something merely trace-
> able to antediluvian "talent," "genius," etc., then you be-
> gin to see that this social "art context" must . . . be subject
> to articulation/revision and not simply the art "works"
> within it. (*AI* 1: 39, 56)

The deconstructive operation is simple enough, but it produces
anxiety-provoking questions concerning our fundamental values in art.
Kosuth's work is built on a series of negations. It does not function as
entertainment or decoration ("AAP" I: 137). Even within the frame-
work of "idea art," Kosuth's work is extreme in its refusal to present
visual and other kinds of experience. According to Kosuth, art cannot
compete with contemporary life experientially ("AAP" I: 137) and
should not strive to be a "human ordered base for perceptual kicks"
("Introduction" 100). Although space and form are founding principles
in the "visual" arts, they too are excluded from his (primary) concerns.
Except, perhaps, for the sense of loss which accompanies the negation
of traditional values, feeling is also an essential aspect of art that seems
to be eliminated here. (Even Malevich's extreme abstraction preserves
and sustains feeling in paintings that strive to "reach a desert where
nothing can be perceived but feeling".) Kosuth's art is the most exten-
sive exploration of what it means for a visual artist, in the words of
Duchamp, "to make works which are not works of 'art'" (*Large Glass*
80). "The Fifth Investigation" includes the following outline:

> forms of presentation
> 1. non-composition
> 2. non-esthetic
> 3. valuelessness
> 4. definition of intensions (*AI* 3: 24

The term "intensions" is adopted from logic and refers to the total num-
ber of characteristics that a thing must possess so that a particular term
can be applied to it. The question posed by Kosuth's work thus seems to
be, if one subtracts composition, aesthetics, and value from art: Is it
still "art"?

Kosuth creates work that is "willfully problematical" (Ramsden, *AI*
1: 28), that purposely increases the difficulty of comfortably classifying
it as art. As such, it includes imagery of classification systems within it,

all of which are associated with language in some way: the "Synopsis of Categories," (a classification system of language in language), file cabinets accompanied by the classification system of the Library of Congress (Fig. 2.12), and two "Information Rooms," or library reference rooms, one of which is orderly, the other in a state of disarray (Fig. 2.13). Kosuth's "Investigations" are themselves arranged in orderly fashion; his own texts are separated ("logically") into different "propositions" and "levels" within them. Thus a paradoxical tension is sustained in an art that uses systems of orderly and logical classification as part of its visual and verbal techniques, and the de-definitional impulse of the work to render classifications impossible or irrelevant.

This double tension toward and against categorization exists within language as well. Words enable us to classify; "even to use language at all is already to idealize, to classify," says Henry Staten (24). But language sometimes also misleads us into believing that stable classifications and distinctions can be made when they cannot (*PI* 47–48, for example). The "Synopsis of Categories" itself embodies this duality. It implies that language is capable of being ordered, categorized, and systematized. However, synonyms in general suggest the "slipperiness" of language, the networks of interrelated meanings that cannot be so easily categorized in actual usage.

Philosophical Investigations centers upon words whose meanings merge and overlap (like "seeing" and "knowing"), where the flexibility of actual usage produces unresolvable conceptual problems (contradictions), which in turn render clear categorization and classification (of concepts) impossible. Not all words, just some, pose these kinds of conceptual difficulties. ("There are words with several clearly defined meanings. It is easy to tabulate these meanings. And there are words of which one might say: They are used in a thousand different ways which gradually merge into one another" [*BB* 28].) Kosuth's *Information Rooms* provide an interesting visual analogy for this distinction between "things" (words, concepts, books) which are easily classified (in an orderly library room), and other "things" which are not easily categorized at all. Deconstructive philosophy, as Staten describes it in *Wittgenstein and Derrida*, in general sustains this double perspective on classification and categorization: "The point of departure of deconstruction from philosophy is thus quite subtle. The value and necessity of pure concepts and categories are not denied, but they are no longer the last word. We no longer simply note and then set aside the factual or empirical contamination of our unities, but see that they are impure always and in principle" (19).

Figure 2.12. Joseph Kosuth, from "The Seventh Investigation," 1971. Photograph of file cabinets. Art Investigations 3: 77.

It is fitting, then, that Kosuth places his own *Investigations* among the clutter of philosophical texts in the disorderly *Information Room* (Meyer xi). His art properly belongs in this room (or conceptual space) where clear classifications have not and perhaps cannot be made. His central subjects—the limits of logic, the relation of meaning to context and of word to thing, the boundaries and definition of concepts—are normally "philosophical" rather than "artistic" concerns. Throughout his work, Kosuth treats art as "philosophy by analogy" (Rose 23), using art to explore the kinds of questions concerning language and meaning that contemporary philosophers ask. As it investigates its own boundaries and limits, art now parallels philosophy as that "discourse which has taken as its object its own limit" (Ulmer 30–31). As a result, Kosuth's work not only includes definitions as visual material and as subject, it also becomes a problem of definition itself; the logical consequence of his definition of art produces a conceptual riddle or puzzle of its own: Is this artist employing philosophical subjects for the creation of art? ("Art indeed exists for its own sake," he says in "Art After Philosophy".) Or is he using art for the purpose of conceptual

Figure 2.13. Joseph Kosuth, "Information Rooms," 1970. Photographs of li-brary reference rooms. Art Investigations *3: 79.*

investigations ("philosophy")? It is possible to give "both remarks a conceptual justification" (*PI* p. 203), for his effort is directed at sustaining the ambiguity: "The elements I use in my propositions consist of information. The groups of information types exist often as "sets" with these sets coupling out in such a manner that an iconic grasp is very difficult, if not impossible. Yet the structure of this set coupling is not the "art." The art consists of my action of placing this activity (investigation) in an art context" (*AI* 3: 70).

Neither "philosophy" nor "art," the work contains aspects of both; because Kosuth practices art as conceptual inquiry, it is impossible to separate what is "philosophy" from what is "art" within it. The disciplinary categories intentionally merge and blur as part of a process (investigation) that tests the limits and boundaries of concepts (like art). "Deconstruction," says Staten, "probes the boundaries of our concepts, and the sense that these concepts have within these boundaries becomes questionable *at* the boundaries" (158). Kosuth's art is art *at* the boundary between "art" and "life," "art" and "non-art," "art" and "philosophy."

In "Art After Philosophy," Kosuth wrestled with terminology and used the term "philosophy" when he meant "metaphysics," but he nevertheless grasped one of the most forceful developments in recent culture: "The twentieth century," he says, "brought in a time which could be called 'the end of philosophy and the beginning of art'" (I: 134). Indeed the shift towards aesthetics within nonmetaphysical philosophy may be one of the most significant changes in the thought of our time. Both Wittgenstein and Derrida practice philosophy as a kind of poetry, shifting the boundaries of their own discipline to include art. Gregory Ulmer shows that Derrida deconstructs metaphysics not only in his theory but also in his writing practice, which in *La carte postale* includes "verbal-visual" techniques and the Conceptual style of scripting as well (xii–xiii 48). Ulmer explains:

> There is a general shift under way, equally affecting the arts and the sciences, in which the old classifications organizing the intellectual map into disciplines, media, genres no longer correspond to the terrain. The organizing principle of the current situation is the collapse of the distinction (opposition or hierarchy) between critical—theoretical reflection and creative practice. Derrida's promotion of a fusion

between philosophy and literature is just one symptom of this hybridization. (225)

Henry Staten agrees:

> That is what makes Derrida so difficult to read *well*, neither simply as poetry, nor simply as philosophy. . . . There is nothing more difficult than trying to read something that violates the form we try to apply to it. It may be said of Derrida's work, as Wittgenstein wrote of his own, that "one cannot even compare the *genre* (Art)" it belongs to "with that of earlier works." (48, 85–86)

Staten, moreover, stresses how important it is to attend to Wittgenstein's *style* ("a form of poetry or collage, word collage"), in order to understand the destabilization of conventional concepts that is one "aspect" of his theory.

Thus Kosuth's peculiar shift towards philosophy within art can be viewed as a mirror reflection of the same (but opposite) development within philosophy to include literary/artistic modes within it. The most important point is not that Kosuth was reading philosophy but that it was this "deconstructive," interdisciplinary philosophy that he was reading. His art, like *Philosophical Investigations*, "continuously violates the form we try to apply to it"; it examines conceptual boundaries and transgresses them at the same time; it enacts through disciplinary hybridization the theory of (transitional) definitions that it describes. Kosuth's work is a visual and verbal analysis of art that merges theoretical and creative practice. Importantly, it "investigates" the role of language and texts in shaping how we see and how we define art.

Philosophy, then, is one of the (many alternative) contexts in which to view not only Kosuth's work but Conceptual art as a whole. As classical metaphysics gives way to "deconstructive" philosophy, the focus of attention shifts from things (the being of the thing) to words and concepts for them. "The subject matter of conceptual investigation is the meaning of certain words and expressions—and not the things or states of affairs themselves about which we talk. . . ." (G. H. Von Wright quoted by Kosuth in "Art After Philosophy"). "This invocation is necessarily the bringing into play of a concept and not of an unequivocal transcendent something to which the concept refers" (Staten 156). This

shift from the thing to the sign of the thing, from the object to the concept of the object is the hallmark of non-metaphysical philosophy in our time: "Derrida's conclusion is that the sign confounds the categories of ideality and materiality. This conclusion, all by itself, may not seem like much. But to make the nature of the sign the focus of thought [is] to open out a meditation that is no longer that of classical metaphysics, which is no longer a meditation on the thing" (Staten 49).

Viewed in this context, then, it is not quite as surprising that artists should cease to be object-makers and become "idea-makers" instead, manipulating words and concepts rather than portraying and fabricating *things*.

: 3 WORDS *EN ABÎME*

Smithson's Labyrinth of Signs

The work is conceived from the beginning, slow stroke by slow stroke, like some prehistoric, age-long upheaval in natural things, driven by natural forces.

EZRA POUND

Masterpieces are only beautiful in a tragic sense, like a starfish lying stretched dead on a beach in the sun.

WILLIAM CARLOS WILLIAMS

The decay that begins immediately on completion of the work was now welcome to me. Dirty man with his dirty fingers points and daubs at a nuance in the picture. This spot is henceforth marked by sweat and grease. He breaks into wild enthusiasm and sprays the picture with spittle. A delicate paper collage of watercolor is lost. Dust and insects are also efficient in destruction. The light fades the colors. Sun and heat make blisters, disintegrate the paper, crack the paint, disintegrate the paint. The dampness creates mold. The work falls apart, dies. The dying of a picture no longer brought me to despair. I had made my pact with its passing, with its death, and now it was part of the picture for me.

JEAN ARP

And it is the spectator who is the real sculptor in the void, who reads the book between its lines.

JEAN-PAUL SARTRE

A gallery exhibit by Robert Smithson is strange and disconcerting. The space is filled with rocks piled into crates, gravel dumped on mirrors, and dead trees lying on the floor. For artistic sensibilities shaped by the rich painting of Cubism or abstract expressionism, this "art" certainly seems to have gone too far, or perhaps

not far enough. Instead of "talent," "craft," and "craftsmanship" Smithson offers his viewers heaps of cinders, rubble and rock (Fig. 3.1). However, since the publication of *The Writings of Robert Smithson* in 1979, and Robert Hobbs's *Robert Smithson: Sculpture* in 1981, we are beginning to better understand and appreciate the quality of Smithson's artistic sensibility. We are finding that his raw materials participate in a larger system of meanings and metaphors, and once we enter this labyrinthian network of signs and symbols, Smithson's rocks suddenly look quite different. Never before, in fact, have such debased and dirty materials spoken so eloquently within art.

In 1966, Nancy Holt took a snapshot of Robert Smithson climbing a wire fence into a "No Trespassing" area of the Great Notch Quarry in New Jersey (Fig. 3.2; Hobbs 42).[1] The photograph suggests Smithson's persistence in exploring abysmal geological sites and offers a fitting emblem for his continuous crossing of limits and boundaries. It is also a picture of transgression with ties to poststructuralist theory:

> The concept of limit is one of the fundamental issues, not only for Derrida, but for that group of writers currently identified as "poststructuralist." As Foucault notes in a 1963 article on Bataille, limit and transgression are interdependent: "Perhaps one day [transgression] will seem . . . decisive for our culture. . . . But in spite of so many scattered signs, the language in which transgression will find its space and the illumination of its being lies almost entirely within the future." (Ulmer 30)

Transgression "finds a space" in Smithson's art. His tactic is not to obliterate limits ("Art is concerned with limits," he says, "and I am interested in making art"),[2] but to cross margins, multiply, dislocate, dislodge, and expose them. He transgresses the museum structure with Earth Art, dislocates and perpetually destabilizes the relation of concept and object, word, and thing, fuses and confuses fact and fiction, and upsets the boundaries between his writings and other texts. He trespasses into numerous outside disciplines (psychology, the physical sciences, literature, and anthropology, among others) in order to appropriate strategies, forms, and textual materials for his art.

The work itself is a network of images and themes that accumulate and proliferate through varied media: Earthworks, sites,[3] sculptures,

Figure 3.1. Robert Smithson, Eight Unit Piece, *1969. Mirrors and earth material. Courtesy Estate of Robert Smithson.*

film, conceptual proposals and procedures, drawings, essays, photographs, and art criticism. The artist keeps not only his media but also his disciplinary tactics in constant transformation and change. No single approach (philosophical, psychological, critical, sculptural, or literary) masters the system;[4] they all interact in fluctuating and continually changing relations. As a result, the oeuvre is interdisciplinary without priority; the different methods and modes do not synthesize or

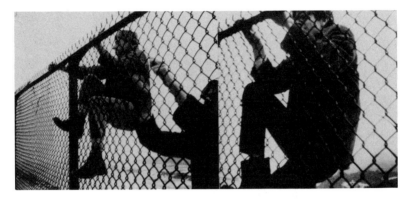

Figure 3.2. Photograph of Robert Smithson and Robert Morris climbing a wire fence into a No Trespassing area of the Great Notch Quarry. Courtesy Estate of Robert Smithson.

resolve into a unity, but continuously shift in relation to one another, "creating an oscillation—vertigo once more."[5]

The verbal and the visual, the fictional and the factual, site and non-site, presence and absence, object and concept, nature and culture, sight and non-sight, center and circumference—in short, all that constitutes Smithson's "art of unresolved dialectics" (Hobbs 23), resists mastery, unity, and closure. Both the Nonsites and the Sites contain presence and absence at the same time (*WRS* 115, 169; Norvell 88), sustaining an endless dialectic that parallels Derrida's theories. Smithson's "unresolved dialectics" can be related to post-structuralism, where dialectics are not resolved so much as continuously displaced, where as Mark Krupnick says, "displacement almost always figures as an alternative to the Hegelian *Aufhenbung*, the sublation by means of which contradictions are transcended. Under the new (post-Hegelian) dispensation, in the reign of difference (as opposed to identity), there will be no more grand claims, no more leap-frogging beyond stubborn conflicts to false reconciliation. . . . There can be no raising up, or sublation of contraries" (Krupnick 2, 12).

Similarly, Smithson's different disciplinary approaches overlap, fuse, differ, alternate, creating both coherence and disjunction. The effort is not towards totalization and synthesis, a *Gesamkunstwerk*, in which variety and diversity are finally reconciled and unified. Smithson keeps his disparate elements (word and thing, for example, or concept

and object) at the "edge of interaction" (Childs 73), in constant transformation and change.[6]

The following discussion will explore in detail how Smithson's interdisciplinary tactics operate within two works, "Quasi-Infinities" and *The Spiral Jetty*, and why Smithson adopts them. His art is comprised of extraordinary chasms and depths—boundless abysses of nature and the self. "Vast monuments of total annihilation are pictured over boundless abysses or seen from dizzying heights" (*WRS* 31). The unfathomable is not only described but also produced within his art as language, too, is placed by the artist *en abîme*.

> Around four blocks of print I shall
> postulate four ultramundane margins
> that shall contain indeterminate in-
> information as well as reproduced re-
> productions.

Robert Smithson's "Quasi-Infinities and the Waning of Space"[7] is a critical essay on biological forms in art, yet it is also an essay on time, a carefully crafted literary production, a cosmological fantasy, and an art manifestation as well (Figs. 3.3–3.6). It is an essay about the margins of art which subverts the margins of art. It not only transgresses generic boundaries but also includes boundaries as a prominent visual feature. The format of the essay, with its rectangular borders and its footnotes circling around the page, sets up a number of paradoxes. First, within the conventional four-sided borders of a canvas, we find a text instead of a painting. In addition, in order to read the text, the very definite margins of the essay must be continuously crossed. Though we can visually determine what is inside and what is outside the border, the opening sentence (above) paradoxically suggests that what is posited "outside" is also contained "within" the boundaries of the work. This text, therefore, "involves a certain experience of limits" (Barthes, *Image-Music-Text* 157); like Derrida's "Tympan," for example, it includes margins in order to cross them. Moreover, as in "Tympan," what is "outside" the margin of "Quasi-Infinities" and of Smithson's art in general is a text.

The boundaries of "Quasi-Infinities" are further complicated by Smithson's intertextual strategies. The essay is a visual and textual collage that mixes verbal and visual "quotations" from diverse disciplines

Figure 3.3. Robert Smithson, "Quasi-Infinities and the Waning of Space," 1966. Collage-Essay, page 1. Courtesy Estate of Robert Smithson and Arts Magazine.

11 Any art that originates with a will to "expression" is not abstract, but representational. Space is representated. Critics who interpret art in terms of space see the history of art as a reduction of three dimensional illusionistic space to "the same order of space as our bodies." (Clement Greenberg—*Abstract, Representational and so forth.*) Here Greenberg equates "space" with "our bodies" and interprets this reduction as abstract. This anthropomorphizing of space is aesthetically a "pathetic fallacy" and is in no way abstract.

12 Plate probably drawn for Spigelius (1627)

13 Willem deKooning

"Although inanimate things remain our most tangible evidence that the old human past really existed, the conventional metaphors used to describe this visible past are mainly biological." George Kubler, *The Shape of Time: Remarks on the History of Things*

nowhere

,

17

,

nowhere.

.

.

.

.

).

;

the pleasure

nowhere.

let him go to sleep

17

John Cage. *Silence.* Cambridge: M.I.T. Press

"Dr. J. Bronowski among others has pointed out that mathematics, which most of us see as the most factual of all sciences, constitutes the most colossal metaphor imaginable, and must be judged, aesthetically as well as intellectually, in terms of the success of this metaphor." Norbert Wiener, *The Human Use of Human Beings*

system is extended into mechanics. The workings of biology and technology belong not in the domain of art, but to the "useful" time of organic (active) duration, which is unconscious and mortal. Art mirrors the "actuality" that Kubler and Reinhardt are exploring. What is actual is apart from the continuous "actions" between birth and death. Action is not the motive of a Reinhardt painting. Whenever "action" does persist, it is unavailable or useless. In art, action is always becoming inertia, but this inertia has no ground to settle on except the mind, which is as empty as actual time.

THE ANATOMY OF EXPRESSIONISM[11]

The study of anatomy since the Renaissance lead to a notion of art in terms of biology[12]. Although anatomy is rarely taught in our art schools, the metaphors of anatomical and biological science linger in the minds of some of our most abstract artists. In the paintings of both Willem deKooning[13] and Jackson Pollack[14], one may find traces of the biological metaphor[15], or what Lawrence Alloway called "biomorphism[16]." In architecture, most notably in the theories of Frank Lloyd Wright, the biological metaphor prevails[17]. Wright's idea of "the organic" had a powerful influence on both architects and artists. This in turn produced a nostalgia for the rural or rustic community or the pastoral setting, and as a result brought into aesthetics an anti-urban attitude. Wright's view of the city as a "cancer" or "a social disease" persists today in the minds of some of the most "formal" artists and critics. Abstract expressionism revealed this visceral condition, without any awareness of the role of the biological metaphor. Art is still for the most part thought to be "creative" or in Alloway's words "phases of seeding, sprouting, growing, loving, fighting, decaying, rebirth." The science of biology in this case, becomes "biological-fiction," and the problem of anatomy dissolves into an "organic mass." If this is so, then abstract-expressionism was a disintegration of "figure painting" or a decomposition of anthropomorphism. Impressionistic modes of art also suffer from this biological syndrome.

Kubler suggests that metaphors drawn from physical science rather than biological science would be more suitable for describing the condition of art. Biological science has since the nineteenth century infused in most people's minds an unconscious faith in "creative evolu-

14 Jackson Pollack

15 The biological metaphor is at the bottom of all "formalist" criticism. There is nothing abstract about deKooning or Pollack. To locate them in a formalist system is simply a critical mutation based on a misunderstanding of metaphor—namely, the biological extended into the spatial.

16 *Art Forum,* September 1965. *The Biomorphic Forties*

17 A. The Guggenheim Museum is perhaps Wright's most visceral achievement. No building is more organic than this inverse digestive tract. The ambulatories are metaphorically intestines. It is a concrete stomach.

B. Guggenheim Museum

*Figure 3.4. Robert Smithson, "Quasi-Infinities and the Waning of Space,"
1966. Collage-Essay, page 2. Courtesy Estate of Robert Smithson and* Arts
Magazine.

18 The truncated ideas in *Nova Express* (Evergreen Black Cat Book BC-102) disclose in part the "heat-death" of the biological metaphor. "The Insect Brain of Minraud enclosed in a crystal . . ." M. L. von Franz in *Time and Synchronicity in Analytic Psychology* states, "Physicists studying cybernetics have observed that what we call consciousness seems to con-
sist of an intra-psychic flux or train of ideas, which flows 'parallel to' (or is even possibly explicable by) the 'arrow' of time. While M. S. Watanabe convincingly argues that this sense of time is a fact sui generis, others like Grunbaum tend to believe that entropy is the cause of time in man." See *The Voices of Time* (p. 218), edited by J. T. Fraser, New York: George Braziller, 1966.

19 Alberto Giacometti, *The Palace at Four A.M.* (1932-33)

tion." An intelligible dissatisfaction with this faith is very much in evidence in the work of certain artists.

THE VANISHING ORGANISM

The biological metaphor has its origin in the temporal order, yet certain artists have "detemporalized" certain organic properties, and transformed them into solid objects that contain "ideas of time." This attitude toward art is more "Egyptian" than "Greek," static rather than dynamic. Or it is what William S. Burroughs calls "The Thermodynamic Pain and Energy Bank"[18]—a condition of time that originates inside isolated objects rather than outside. Artists as different as Alberto Giacometti and Ruth Vollmer to Eva Hesse and Lucas Samaras disclose this tendency.

Giacometti's early work, *The Palace at Four A.M.*[19], enigmatically and explicitly is about time. But, one could hardly say that this "time-structure" reveals any suggestion of organic vitality. Its balance is fragile and precarious, and drained of all notions of energy, yet it has a primordial grandeur[20]. It takes one's mind to the very origins of time—to the fundamental memory. Giacometti's art and thought conveys an entropic view of the world. "It's hard for me to shut up," says Giacometti to James Lord. "It's the delirium that comes from the impossibility of really accomplishing anything[21]."

There are parallels in the art of Ruth Vollmer to that of Giacometti. For instance, she made small skeletal geometric structures before she started making her bronze "spheres," and like Giacometti she considers those early works "dead-ends." But there is no denying that these works are in the same class with Giacometti, for they evoke both the presence and absence of time. Her *Obelisk*[22] is similar in mood to *The Palace at Four A.M.* One thinks of Pascal's "fearful sphere" lost in an Egyptian past, or in the words of Plotinus the Stoa, "shadows in a shadow[23]." Matter in this *Obelisk*[24] opposes and forecloses all activity—its future is missing.

The art of Eva Hesse is vertiginous and wonderfully dismal[25]. Trellises are mummified, nets contain desiccated lumps, wires extend from tightly wrapped frameworks, a cosmic dereliction is the general effect. Coils go on and on; some are cracked open, only to reveal an empty center. Such "things" seem destined for a funerary chamber that excludes all mention of the living and the dead. Her art brings to mind the obsessions of the pha-

"In principle, nothingness remains inaccessible to science." Martin Heidegger, *An Introduction to Metaphysics*

"The unity of Nature is an extremely artificial and fragile bridge, a garden net." T. E. Hulme, *Cinders*

"It came to him with a great shock that not one of the robots had ever seen a living thing. Not a bug, a worm, a leaf. They did not know what flesh was. Only the doctors knew that, and none of them could readily understand what was meant by the words 'organic matter'." Michael Shaara, *Orphans of the Void*

24 A. For further edification concerning obelisks see *A Short History of the Egyptian Obelisk* by W. R. Cooper. London: Samuel Bagster and Sons, 1877. "The first mention of the obelisk, or Tekhen, occurs in connection with the pyramid: and both are alike designated sacred monuments on the funereal stele of the early empire, and also were undeniably devoted to the worship of the sun; occasionally the obelisk was represented as surmounting a pyramid, a position which it has never actually been found to occupy."

B. *The New York Obelisk—Cleopatra's Needle* by Charles E. Moldenke, New York: Anson D. F. Randolph and Co., 1891. "We know of the Obelisk of Karnak, erected by Queen Hatasu, that the apex of its pyramidion was covered with 'pure gold' . . ."

C. *Cleopatra's Needles and Other Egyptian Obelisks* by Sir E. A. Wallis Budge, London: The Religious Tract Society, 1926. Regarding obelisks in Rome: "The brass globe which had been fixed on the top of the obelisk when Caligula set it up was removed; it was empty, though many believed that it would be found to contain valuable objects."

D. *Salambo* by Gustave Flaubert, a Berkeley Medallion Book, 1966. Regarding obelisks in Byrsa: ". . . obelisks poised on their points like inverted torches."

20 The following is part of a manuscript that describes *The Palace at Four A.M.* It was dictated by Giacometti to André Breton for publication in the magazine *Minotaure* (No. 3-4, 1933, p. 42) and later translated by Ruth Vollmer into English (see the magazine *Transformation* published by Wittenborn). "This object has taken form little by little; by the end of the summer 1932 it clarified slowly for me, the various parts taking their exact form and their particular place in the ensemble. Come autumn it had attained such reality that its execution in space did not take more than one day." He also goes on to say, ". . . the days and nights had the same color, as if everything happened just before daybreak. . . ."

21 *A Giacometti Portrait*, The Museum of Modern Art

22 Ruth Vollmer, *Obelisk* (1962)

23 Quoted from *Enneads*, in *Concepts of Mass/in Classical and Modern Physics* (Harper Torch Book TB571) by Max Jammer, page 31. On the same page Jammer goes on to say, "Proclus, the other great exponent of Neoplatonism in the East, accepts Plotinus' doctrine, but with one important modification: the passivity or inertia of matter follows from its extension." The decline of the *categories* of "painting" and "sculpture" seem to be the result of this problem of spatial extension from matter. Space becomes an illusion on matter.

Figure 3.5. Robert Smithson, "Quasi-Infinities and the Waning of Space," 1966. Collage-Essay, page 3. Courtesy Estate of Robert Smithson and Arts Magazine.

C. In her *Loakoon* based on the sculpture by Pergamen? second century B.C. we discover an absence of "pathos" and a deliberate avoidance of the anthropomorphic. Instead one is aware only of the vestigial and devitalized "snakes" looping through a

lattice with cloth bound joints. Everything "classical" and "romantic" is mitigated and undermined. The baroque aesthetic of the original *Loakoon* with its flowing lines—soft and fluid—is transformed into a dry, skeletal tower that goes nowhere.

B. Pergamen? *Loakoon*

25 A. Eva Hesse, *Loakoon*, 1965

"The individual is the seat of a constant process of decantation, decantation from the vessel containing the fluid of future time, sluggish, pale and monochrome, to the vessel containing the fluid of past time, agitated and multicolored by the phenomena of its hours." Samuel Beckett, *Proust*

30 A. Don Judd has been interested in "progressions" and "regressions" as "solid objects." He has based certain works on "inverse natural numbers." Some of these may be found in *Summation of Series* by L. B. W. Jolley, a Dover paperback.

raohs, but in this case the anthropomorphic measure is absent. Nothing is incarnated into nothing. Human decay is nowhere in evidence.

The isolated systems Samaras'[26] has devised irradiate a malignant splendor. Clusters of pins cover vile organs of an untraceable origin. His objects are infused with menace and melancholy. A lingering Narcissism[27] may be found in some of his "treasures." He has made "models" of tombs and monuments that combine the "times" of ancient Egypt with the most disposable futures of science fiction.[28]

TIME AND HISTORY AS OBJECTS

At the turn of the century a group of colorful French artists banded together in order to get the jump on the bourgeois notion of progress. This bohemian brand of progress gradually developed into what is sometimes called the avant-garde. Both these notions of duration are no longer absolute modes of "time" for artists. The avant-garde, like progress, is based on an ideological consciousness of time. Time as ideology has produced many uncertain "art histories" with the help of the mass-media. Art histories may be measured in time by books (years), by magazines (months), by newspapers (weeks and days), by radio and TV (days and hours). And at the gallery proper—*instants!* Time is brought to a condition that breaks down into "abstract-objects[29]." The isolated time of the avant-garde has produced its own unavailable history or entropy.

Consider the avant-garde as Achilles and progress as the Tortoise in a race that would follow Zeno's second paradox of "infinite regress[30]." This non-Aristotelian logic defies the formal deductive system and says that "movement is impossible." Let us paraphrase Jorge Luis Borges' description of that paradox. (See *Avatars of the Tortoise*): The avant-garde goes ten times faster than progress, and gives progress a headstart of ten meters. The avant-garde goes those ten meters, progress one; the avant-garde completes that meter, progress goes a decimeter; the avant-garde goes that decimeter, progress goes a centimeter; the avant-garde goes that centimeter, progress, a millimeter; the avant-garde, the millimeter, progress a tenth of a millimeter; and so on to infinity without progress ever being overtaken by the avant-garde. The problem may be reduced to this series:

$$10 + 1 + 1/10 + 1/100 + 1/1000 + 1/10,000 + :::$$

26 Lucas Samaras, *Untitled*, 1963

27 Self-love, self-observation, self-examination, and self-awareness result in an isolated mind. This kind of mind would tend to produce a fictitious "reality" detached from organic nature. *Monsieur Teste* by Paul Valery is perhaps the greatest elucidation of Narcissism. "He watches himself, he maneuvers, he is unwilling to be maneuvered. He knows only two values, two categories, those of consciousness reduced to its acts: the possible and the impossible. In this strange head, where philosophy has little credit, where language is always on trial, there is scarcely a thought that is not accompanied by the feeling that it is tentative...."

28 In *13 French Science-Fiction Stories* edited by Damon Knight (Bantam paperback (F2817) is a story by Charles Henneberg called *Moonfishers*. "The Interplanetarians were landing in these sands. They were of many kinds. Much later, the Pharaoh Psammetichus III noted: 'They fell from the sky like the fruits of a fig-tree that is shaken; they were the color of copper and sulphur, and some had eyes.'"

29 The following book elucidates this idea: *Abstraction and Empathy* by Wilhelm Worringer, London: Routledge and Kegan Paul Ltd., 1953; translated from the German *Abstraktion und Einfuhlung*, 1908. "In so far, therefore, as a sensuous object is still dependent upon space, it is unable to appear to us in its closed material individuality." And "Space is therefore the major enemy of all striving after abstraction...."

Figure 3.6. Robert Smithson, "Quasi-Infinities and the Waning of Space," 1966. Collage-Essay, page 4. Courtesy Estate of Robert Smithson and Arts Magazine.

(physics, literary criticism, art, art history, science fiction and science fact, poetry, and philosophy). Consequently, Smithson's writing has "no clearly defined boundaries, it spills over constantly into the works clustered around it, generating a hundred different perspectives" in a way that typifies the postmodern text (Eagleton, *Literary Theory* 138). "Here various agents, both fictional and real, somehow trade places with each other" (*WRS* 81). Fictional sources (*Salammbô*) are used to present factual, art historical "information" (about obelisks); imaginary and real architectures are juxtaposed (The Tower of Babel/The Guggenheim Museum), as are literary and scientific cosmologies (Poe/Kepler). Here, too, the remote future crisscrosses the remote past, endlessly displacing one another (City of the Future/Pyramid of Meidum; Plotinus the Stoa/Shaara's *Orphans of the Void*). Not only are the conventional boundaries between the "scientific" and the "artistic" crossed, but also the distinction between "high" culture and "low" (Flaubert, Beckett/Ballard, Damon Knight). The serious mixes with the playful and in general there is a jumbling of varied attitudes, voices, and tones—the scholarly, the factual, the philosophical, and the frivolous.[8]

Many of the works cited, such as Poe's *Eureka* or Cage's *Silence*, confuse generic categories themselves, or suggest such crossing of disciplinary limits in other ways (for example, Norbert Weiner's proposal that mathematics be read metaphorically and aesthetically). In "Quasi-Infinities" Smithson is, as he said of another writer, "calling forth the assorted humors of Flaubert's Bouvard et Pécuchet, the quixotic autodidacts" (*WRS* 67). Those fictional figures are also invoked in Barthes's famous definition of a Text, for which "Quasi-Infinities" serves as an excellent example:

> A text is not a line of words releasing a single "theological" meaning . . . but a multidimensional space in which a variety of writings, none of them original, blend and clash. The text is a tissue of quotations drawn from the innumerable centres of culture. Similar to Bouvard and Pécuchet, those eternal copyists, at once sublime and comic and whose profound ridiculousness indicates precisely the truth of writing, the writer can only imitate a gesture that is always anterior, never original. His only power is to mix writ-

ings, to counter the ones with the others, in such a way as never to rest on any one of them. (*Image-Music-Text* 146)

It is particularly fitting that Smithson arranges his blocks of text around the pages of "Quasi-Infinities," for as Barthes continues, "the Text is that space where no language has a hold over any other, where languages circulate (keeping the circular sense of the term)" (*Image-Music-Text* 164). "Quasi-Infinities" is quite literally a "tissue of quotations," a space in which various disciplinary languages "circulate."

The two distinct themes of the essay, art and time, create overlappings, tensions, divergences, and correspondences in what Barthes calls "stereographic plurality" (*Image-Music-Text* 159). The themes are linked in a number of ways. Just as Eva Hesse's sculpture *Laocoön* empties out the original (Footnotes 25A and B of "Quasi-Infinities"), so Smithson's "Quasi-Infinities" can be read as a "newer *Laocoön*" that deflates that of Gotthold Ephraim Lessing. As Smithson's essay continually crosses space (spatialized language and static visual images), and time (the dynamic flow of words), it undermines Lessing's division of space and time and the classification of the arts based upon it. Relativistic space-time is a recurring theme in Smithson's work; in "Entropy and the New Monuments," he says, "Rather than saying 'what time is it,' we should say, 'where is the time?'" (*WRS* 10). Smithson also argues that all significant sculptures are temporal; the pyramids as well as the new monuments of minimalism are all "time structures." "Every object if it is art," he says, "is charged with the rush of time, even if it is static" (*WRS* 90).

Along with Lessing's *Laocoön*, George Kubler's *The Shape of Time* is alluded to throughout "Quasi-Infinities," and it, too, is a text that concerns time and art. According to Kubler, art history, rather than being linear, chronological and progressive, is "trans-historical" and intermittent. Smithson's essay draws connections between monumental art from various cultures and historical periods in a way that is theoretically consistent with Kubler's view of time. Like Kubler, Smithson deems the biological metaphor inappropriate for art history and goes further to criticize the latent anthropomorphism in abstract expressionist art.[9] Smithson also adopts from Kubler the notion of an "actual" present, the "void between events," the "dead" time which flits too quickly past for conscious perception. It is this paradoxically static time which

shapes Smithson's artistic preferences and selections in the essay (Giacometti, Vollmer, and Hesse) and informs his neon sculpture *The Eliminator* (1964) as well. While it is interlaced with the discussion of art, time is also a separate (alternative) thread that passes through the "tissue" of texts in "Quasi-Infinities" and once followed, begins to weave a fabric of its own.

The essay offers diverse perspectives on time, gleaned from various disciplines, expressed in a variety of textual voices, without ever reconciling the numerous, often contradictory systems presented. The opening paragraph, like the opening sequence of *The Spiral Jetty* film, is "charged with the rush of time." The prose paragraph moves through time and space with urgent rapidity. As in the Earth projects, where Smithson accelerates natural processes of sedimentation and deposition, here the artist catalyzes language and "steps up the action" (*WRS* 177) in words. The forward rush through words and images suggests consuming time, Eddington's "arrow of time," the irreversible flow of time (associated with the expanding universe), which leads men to build quasi-infinities—"cities and monuments, pyramids and empires which can resist the teeth of time" (Cohen 275). Space is "eliminated" and "wanes" in such entropic transformations, where "things don't go in cycles . . . [but] just change from one situation to the next," as Smithson describes it (Norvell 139).

But "Quasi-Infinities" is itself a (verbal) monument both "to and against entropy"; a constant fluctuation between eternities and entropies is established in the essay. Non-entropic systems of time are also alluded to in varied pictorial and verbal ways. The Pyramid of Meidum, for example, suggests Egyptian notions of infinity where, as Gombrich says, "time comes to a stop in the simultaneity of a changeless now":

> For the Egyptian, the newly discovered eternity of art may well have held out a promise that its power to arrest and to preserve in lucid images might be used to conquer . . . evanescence. His images weave a spell to enforce eternity. Not our idea of eternity, to be sure, which stretches backward and forward in an infinite extension, but rather the ancient conception of recurrent time that a later tradition embodied in the famous "hieroglyph" of the serpent bit-

ing its own tail. . . . The typical in its most lasting and changing form. (Gombrich 724–25).

The citation from Beckett's *Proust* alludes to yet another concept of timelessness, a "brief eternity" within time made possible by involuntary memory. As Beckett explains, "if this mystical experience communicates an extratemporal essence, it follows that the communicant is for a moment an extratemporal being. The Proustian solution consists . . . in the negation of time and Death, the negation of Death because the negation of Time. . . . Time is not recovered, it is temporarily obliterated" (*Proust* 56).

Smithson's collage of quotations forces the reader to confront varied notions of time, all distinct and contradictory when juxtaposed with one another. The continuous oscillation between "infinities" and "entropies" is perhaps focused most clearly in footnote 18. Here entropy is recalled again by the allusions to Burroughs's *Nova Express* and Grunbaum's belief that "entropy is the cause of time in man." But the essay by von Franz to which Smithson also alludes actually proposes the timelessness of the unconscious, expressed in myths, dreams, archtetypes, and the intuitions of artists and scientists. Indeed, one way to come to terms with the archaic monumentality of the Earthworks and the continuous use of archetypal symbols within Smithson's work (for instance, the inverted trees), is to view them not as symbolizing this or that idea, but in themselves time-binding or time-stopping procedures.[10] The symbol, whether archetypal or original, can, at least in Smithson's artistic vocabulary, stop time: "All the arduous efforts of all the monumental ages are contained in the ultra-instants, the atemporal moments, or the cosmic seconds. This is a return to a primitive inertia or invincible idleness that stops trains, jets and ships and transforms them into signs or symbols" (*WRS* 50). Von Franz further proposes a psycho-physical parallelism in which the timeless unconscious parallels the Minkowski "block universe," the static interpretation of relativity theory (and which may account, in part, for Smithson's "blocks" of texts).

Entropy theory also entails a vision of infinity or timelessness, and so complicates and even confuses the distinction between entropy and eternity. "A world is envisioned in which all energy or temperature differences have been removed. There are no longer hot stars radiating

energy to cooler bodies, or highly structured organisms disparate from their environment. Instead the universe has become a homogenous mixture at a dead level of temperature and uniformity" (Schlegel 511). This thermodynamic scenario informs all of Smithson's work, from "Entropy and the New Monuments" to "Monuments of the Passaic," and it can be seen in the "time structures" of "Quasi-Infinities," "devoid of organic vitality," "drained of all notions of energy," which nonetheless have a "primordial grandeur" (*WRS* 34). "This kind of time has little or no space; it is stationary and without movement, as well as being instant, and is against the wheels of the time clock" (*WRS* 10). As in the serial repetition of minimalism, or the redundant blackness of Reinhardt's paintings, "time vanishes into a perpetual sameness."

At least four distinct views of static time, therefore, are presented or suggested within "Quasi-Infinities": Kubler's "interchronic pause" of the "actual" but unobtainable present; Minkowski's "block universe," the static interpretation of relativity theory; thermodynamic inertia; and Zeno's paradox which, when applied to time, postulates not only the infinite divisibility of time (Borges 33), but also the impossibility of passage of or through it (Borges 207). One view of time contains nothing (entropy), while another contains everything (relativity theory). Despite their differences, however, the theories are all inherently paradoxical, which may be why Smithson incorporates them within his work. His writing style, moreover, exploits paradox in a way that parallels these systems of time. It is filled with oxymora ("wonderfully dismal"; "malignant splendor") and contradictions ("each painting evokes the presence and absence of time"; "shapes that evade shape"), which mirror in language the paradoxes of time Smithson describes. As his prose fluctuates continuously between the factual and the richly "adumbral," Smithson's style remains, as he said of Reinhardt's writing, "marvelously inauthentic" and contrived.

Just as Smithson is not interested in art history (as linear and singular) but in art histories (multiple, intermittent, and repeated), so too, he is not interested in locating the singular truth of time, but in presenting time as itself a multifaceted (crystalline) subject.[11] The layout of the essay itself encompasses a variety of features that connect it to time. The order of the marginal notes, for instance, lead the reader in a clockwise direction (clock time) to cycle around the page (cyclic return). But the subordinate notes often go counterclockwise (8A and B, for ex-

ample), setting up the kind of tensions sustained within the essay as a whole between irreversible and reversible time (and progressions and regressions in space as well—the Judd sculpture). The succession of pages also turns the circuit into a spiral, suggesting the numerous systems of time operating within *The Spiral Jetty*, including that view of time as a "tripartite infrastructure that extends forever into the future through the past" (*WRS* 51). The spiralling motion of square blocks (themselves "mirrors" of texts and artworks) not only relates to Reinhardt's "squares of time" but also to the "ever-receding square spiral" of the "Ultramodern," and its own quasi-infinity, "crystalline time" (*WRS* 51).

However interesting the various connections and disconnections between these diverse notions of time, the essential point is that Smithson repeatedly invokes contradictory systems of time within his work. This strategy is familiar to "readers" of *The Spiral Jetty*,[12] yet it is often overlooked in "Quasi-Infinities." A drawing for the film *Broken Circle* (Fig. 3.7) also includes contradictions: the sign of infinity, inscribed by an airplane's "cloverleaf pattern," floats over the broken circle, itself a symbol of broken eternity (*WRS* 182).

What we find in "Quasi-Infinities," then, is the poststructuralist "explosion" or "dissemination" of meanings (Barthes, *Image-Music-Text* 159).[13] Excessive signification leads to what Smithson calls, "the clashing aspect of the entropic tendency,"[14] which he builds into all of his work. If information is defined as "the ability to make non-random selections from some set of alternatives," (Reddy 303), then this theoretical fiction is designed precisely to preclude information. As contrary systems of time multiply, they also logically cancel out, leaving the Conceptual structure as empty as the sculptural forms. "Temporal continuity," Smithson says, "conceals the discrete structure of illusion, it conceals the Absolute that suggests nothing, recalls nothing, signifies nothing" (*WRS* 51). The text, therefore, becomes an elaborate tomb,[15] a crystalline lattice, a "peripheral shell, reflecting the empty center" (*WRS* 74). As in "Incidents of Mirror Travel in the Yucatan," or *The Spiral Jetty*, "Quasi-Infinities," too, practices what Barthes calls the "infinite deferment of the signified" (*Image-Music-Text* 158). What is missing from this essay is precisely the truth (of time). Yet, as Borges explains, "this imminence of a revelation which does not occur is, perhaps, the aesthetic phenomenon" (188). As each temporal scheme is

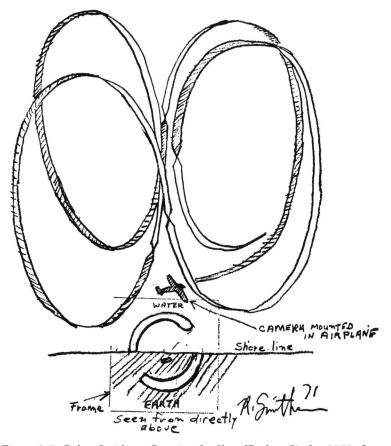

WATER

CAMERA MOUNTED IN AIRPLANE

Shore line

Frame

EARTH

Seen from directly above

R. Smithson 71

Figure 3.7. Robert Smithson, Drawing for film of Broken Circle, *1971. Courtesy Estate of Robert Smithson.*

called into question by another, the discourse on truth is hopelessly confounded with artifice and fiction. In "Quasi-Infinities," the problematic of time becomes an aesthetic of time instead.

The quaternary structure of the essay (four pages long, four separate sections, four-sided margins), clearly alludes to the fourth dimension. That the essay concludes with two elaborate jokes satirizing "progress," "creative evolution," and temporal measurement links what are actually two distinct interpretations of the fourth dimension operating within the essay: time and laughter. In "Entropy and the New Monument," Smithson explains: "[Buckminster] Fuller was told by certain

scientists that the fourth dimension was 'haha,' in other words laughter. Perhaps it is. It is well to remember, that the seemingly topsy-turvy world revealed by Lewis Carroll, did spring from a well ordered mathematical mind. . . . Laughter is in a sense a kind of entropic verbalization" (*WRS* 17).

The kind of humor Smithson describes (Carroll), admires (Borges), and creates (the "haha crystal concept" or "solid state hilarity") is entropic because it explodes with laughter the systems of measurement, classification, and definition upon which it is based: "Let us now define the different types of Generalized Laughter, according to the six main crystal systems: the ordinary Laugh is cubic or square (Isometric), the chuckle is a triangle or pyramid (Tetragonal), the giggle is hexagon or rhomboid (Hexagonal), the titter is prismatic. . . ." (*WRS* 17).

The jokes within "Quasi-Infinities" also satirize logic, order, and system: "Consider the Avant-garde as Achilles and progress as the Tortoise in a race that would follow Zeno's second paradox of the 'infinite regress' . . . the Avant-garde goes ten times faster than progress, and gives progress a headstart of ten meters. The avant-garde completes those ten meters, progress one, the avant-garde completes that meter, progress goes a decimeter. . . ." This humorous contrivance functions as part of Smithson's argument against a linear art history, but it also allows him to take his argument (so to speak) one step further. It is not just the "avant-garde" being satirized here, but all ideologies of time. Indeed the essay explores numerous systems (of time, of the fourth dimension), in order to undercut the notion of such systematization itself. According to Smithson, "System is a convenient word, like object. It is another abstract entity that doesn't exist. . . . If you make a system you can be sure the system is bound to evade itself, so I see no point in pinning any hopes on systems" (Norvell 90). [16]

Hulme's *Cinders*, fragments of which appear throughout "Quasi-Infinities," calls for the distinction "between a vague philosophical statement that 'reality always escapes a system' and the definite cinder felt in a religious way" (Hulme 243). Hulme's "cinder-principle" operates as powerfully in this essay as it does in Smithson's Nonsites and Earthworks. [17] Here the reader confronts textual and theoretical "cinders"—fragments of systems presented in brief and incomplete quotations. On one level, the fragments suggest the decay of time; as in modern poetry, temporality is built into the work. Hugh Kenner observes that "time's ellipses work at random, Pound's do not." Neither,

we might add, do Smithson's. The sentence fragments within "Strata: A Geophotographic Fiction" (Fig. 3.8) and its juxtapositions of discontinuous geological, literary, and philosophical material all suggest the wreckage of earth, language, and culture by time, as do the fragments of "Quasi-Infinities."

But the theoretical systems to which these fragments allude are also themselves incomplete and unable to "cover" the entire truth of time. Each text to which we are referred by the notes promises to offer a comprehensive scheme that will master all aspects of time, and what we find instead is that time "always escapes a system." Amidst accumulating theories, facts, fictions, and alternative schema, we begin to feel the "definite cinder." As Elizabeth Childs proposes, "paradoxically in his writing . . . Smithson invoked systematic order, both mental and physical (geological) only to project the overthrow of that order by time; he proposed structures to better observe their collapse, disintegration, and dissolution" (72). The systematic orders (of time) invoked within "Quasi-Infinities" disintegrate, too, as they accumulate in time.[18]

The symmetrical arrangement of the essay, therefore, does not establish order so much as operate like a labyrinth "compounded to confuse men; its architecture, rich in symmetries, is subordinated to that end" (Borges 110). Like Borges's "The Garden of the Forking Paths," "Quasi-Infinities" is a labyrinth of time, "an infinite series of times, in a growing dizzying net of divergent, convergent, and parallel times. This network of times . . . embraces all possibilities of time" (Borges 28), and the labyrinth of time is a text. Like Ledoux's building, Smithson's essay produces "symmetrical perplexities" unresolved by any "general theory." It "begins" and "ends" with two different kinds of labyrinth: one architectural (The Amiens Labyrinth), the other theoretical (the infinite regress). In Borges's work, as Smithson probably knew, Zeno's paradox is always "that labyrinth consisting of a single line which is invisible and unceasing" (Borges 33, 89). As the first sentence of the essay suggests, the marginal notes comprise the "obstacles" that both constitute the text as a labyrinth and impede our progress through it. Some of the "obstructions" are "dead-ends," (footnote 12), that return us immediately to the text; others lead outward (from Beckett to Proust, say, or through the spectrum of texts referred to in Borges's essays) in an infinite regress of passages from texts to texts. We might recall Smithson's preference for "The Ramble" in Central Park and his admiration for Olmstead for "creating paths that out-

STRATA A GEOPHOTOGRAPHIC FICTION

Figure 3.8. Robert Smithson, "Strata: A Geophotographic Fiction," 1972. Photo-Essay, excerpt page 1. Courtesy Estate of Robert Smithson and Dan Graham.

labyrinthed labyrinths" (*WRS* 127). The footnote to "A Sedimentation of The Mind: Earth Projects" also turns into a "dizzying maze, full of tenuous paths and innumerable riddles" (*WRS* 91).

"Quasi-Infinities" most resembles a textual labyrinth in the infinite range of possibilities it presents for reading one text through and by means of another. Filled with riddling short circuits produced by continuously strange juxtapositions, it also generates and sustains a number of unexpected connections between disparate facts and ideas. For example, the quotation from Cage's *Silence*, discontinuous with the

texts surrounding it, creates, like many of the notes, abrupt gaps and breaks in logical continuity; yet this particular quotation not only reflects the "silence" within Cage's aesthetic, but also dovetails neatly with the sculptural and Conceptual vacancies described and generated in Smithson's essay. One other example, from numerous others, is the way in which Poe's *Eureka* links up with "Quasi-Infinities"; Poe's expanding and contracting cosmology relates to the subtitle of Smithson's essay: "For many artists the universe is expanding; for some it is contracting." The centripetal and centrifugal tensions between the circumference and the center outlined within *Eureka* operate visually within "Quasi-Infinities." Both authors postulate or accept the interrelation of space and time, and both are interested in the cosmic extension of time beyond man and human history—to the extreme future and the remote past with "memories of a destiny . . . infinitely awful . . . that there was a period in which we did not exist" (Poe 257–58, 291, 305–308). "Quasi-Infinities" opens up into an infinite range of possible avenues for reading, becoming quite literally "unmasterable" in the innumerable semantic relations that can be traced through its fragments. "It is best to think of printed matter," says Smithson, "the way Borges thinks of it, as 'The universe (which others call the library),' or like McLuhan's 'Gutenberg Galaxy,' in other words as an unending 'library of Babel'" (*WRS* 15).

Thus Smithson's essay is itself quasi-philosophical, quasi-literary, and quasi-visual. It is somehow all of these—philosophy, literature, art history, art criticism, and art—and none of them, conflating genres in a way that complies with Derrida's "law of participation without membership" ("Law" 210). What constitutes this essay as a postmodern text is its confusion of the distinction between theory and art practice, the way in which the discourse on truth is contaminated by fiction, "its subversive force in respect to the old classifications" (Barthes, *Image-Music-Text* 157). "Interdisciplinarity is not the calm of an easy security," Barthes reminds us, "it begins *effectively* . . . when the solidarity of the old disciplines breaks down— perhaps even violently—in the interests of a new object and a new language" (155).[19]

Smithson's commitment to an interdisciplinary art was based in part on the collapse of the space-time divisions which sustained (for Lessing at least) the separation of artistic categories. But there were other

sources as well for the artist's use of interdisciplinary tactics, including not only his familiarity with Barthes's writings, but also his interest in Wittgenstein's later philosophy and the way it overlaps with Ehrenzweig's Freudian theory of creativity.

Like Kosuth, Smithson read Wittgenstein and acquired from *Philosophical Investigations* a sense of the fluidity of word usage,[20] conceptual categories, and disciplinary limits. The artist says: "Wittgenstein has shown us what can happen when language is idealized, and that it is hopeless to try to fit language into some absolute logic whereby everything objective can be tested. We have to fabricate our rules as we go along the avalanches of language and over the terraces of criticism" (*WRS* 88). What Smithson responds to most strongly is Wittgenstein's (eventual) rejection of a "stable," "logical," and "solid" ground for language; he refers to the philosopher's thesis in *Philosophical Investigations* that language "does not operate according to strict rules."

Additionally, Smithson, like Wittgenstein, exploits the materiality of language (and in Smithson's case the *analogy* of language as material) as a means of confusing the distinctions between critical and poetic discourse. Henry Staten, in fact, locates the aesthetic dimension of Wittgenstein's writing precisely in the philosopher's attention to the material possibilities of language, including the sensuous character of metaphor and the visual configurations of signs. In *Philosophical Investigations*, he observes, "we witness the liberation of language as material substance from the domination of meaning which we associate with modern poetry" (Staten 88–90). In *A Heap of Language*, Smithson, too, exploits the visual configuration of linguistic signs (as he does in "Strata: A Geophotographic Fiction," Fig. 3.8) and vividly presents language as "material."[21] Indeed, *A Heap of Language* (Fig. 3.9) seems almost indebted to Wittgensteinian theories. Here language is presented as (printed) "matter"; when "family relations" of overlapping and related meanings become the structuring principle of language, its "ground," rather than being "solid" (the crystalline "hardness of the logical must"), is fractured and fissured instead. "Language" nevertheless functions to construct meanings and concepts in this way.

More importantly, the result of such a view of language, for both Wittgenstein and Smithson, is that the discourse on truth is contaminated by fiction and poetry. "A Sedimentation of the Mind : Earth Projects" includes the following passage:

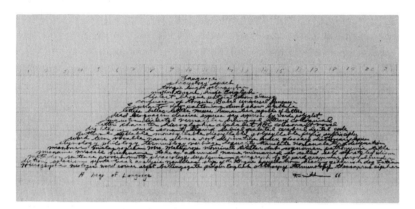

Figure 3.9. Robert Smithson, A Heap of Language, *1966. Pencil drawing. Courtesy Estate of Robert Smithson.*

> The names of the minerals and the minerals themselves do not differ from each other, because at the bottom of both the material and the print is the beginning of an abysmal number of fissures. Words and rocks contain a language that follows a syntax of splits and ruptures. Look at any word long enough and you will see it open up into a series of faults, into a terrain of particles each containing its own void. This discomforting language of fragmentation offers no easy gestalt solution; the certainties of didactic discourse are hurled into the erosion of the poetic principle. (*WRS* 87)

This writing both describes and enacts the transformation of critical discourse into poetic language, the "hurling of didactic discourse into the erosion of the poetic principle." Moreover, it is a particular view of language—as material, fragmented, shifting, and changing—which leads to this "erosion" of theoretical discourse by poetic language.[22] This view of language as "slippery" inspires Smithson's shifting styles throughout "A Sedimentation of the Mind: Earth Projects," an essay that presents constant transitions between one kind of language use (flat, informational, and scientific prose) and another (language rich in

figurative "materiality" and depth).[23] Different techniques are employed within "Quasi-Infinities" to achieve the same effect; here the materiality of language arises not from metaphor but from Smithson's manipulation of textual "material" and printed "matter." Both techniques lead to language that is constantly in change, in the words of Craig Owens "labyrinthian and abyssal" ("Earthwords" 122).

Wittgenstein's theory of language overlaps with Ehrenzweig's theory of creativity, and both provide a theoretical base for Smithson's practice of an interdisciplinary art.[24] A number of Ehrenzweig's ideas inform Smithson's artistic practice, the most important of which is the notion of the primary process as a "precision instrument for creative scanning" (Ehrenzweig 5).[25] "I'm totally concerned with making art," says Smithson, "and this is mainly an act of viewing, a mental activity that zeroes in on discrete sites" (*WRS* 174). The source of artistic creation, according to Ehrenzweig, is an experience of "de-differentiation," a breaking through of rational ego boundaries to "the low levels of consciousness" (84). This transgression of ego boundaries is always associated by Smithson with the fragmentation and unfathomable quality of the sites he selects:

> Banks of suspended slate hung over a greenish-blue pond at the bottom of a deep quarry. All boundaries and distinctions lost their meaning in this ocean of slate and collapsed all notions of gestalt unity. The present fell forward and backward into a tumult of "de-differentiation," to use Anton Ehrenzweig's word for entropy.[26] Syncline (downward) and anticline (upward) outcroppings and symmetrical cave-ins caused minor swoons and vertigos." (*WRS* 89–90)

The Spiral Jetty, as we shall see, eloquently conveys the vertigo and the contradictions of this primary process activity: "I was on a geologic [geo-logic] fault that groaned within me" (112), "I was slipping out of myself again" (113).[27]

Although his perceptions and his sensibility shape all of the art, then, the "self" within Smithson's work operates in a strangely dislocated and displaced way. The artist is the organizing principle of the work, and yet as in poststructuralist theory "it includes a deconstructed self, decentered, disseminated" (Ulmer 229). In *Enantiomorphic*

Chambers, as in the site selection process, the "self" is portrayed as an abyss: "We are lost between the abyss within us and the boundless horizons outside us" (*WRS* 105).[28] The "horizons" (*400 Seattle Horizons* or "Incidents of Mirror Travel") and boundaries of the self therefore shift continuously within Smithson's work:

> One's mind and the earth are in a constant state of erosion, mental rivers wear away abstract banks, brain waves undermine cliffs of thought, ideas decompose into stones of unknowing, and conceptual crystallizations break apart into deposits of gritty reason. Vast moving faculties occur in this geological miasma, and they move in the most physical way. This movement seems motionless, yet it crushes the landscape of logic under glacial reveries. This slow flowage makes one conscious of the turbidity of thinking. Slump, debris, slides, avalanches all take place within the cracking limits of the brain. (*WRS* 82)[29]

The most important result of Smithson's use of Ehrenzweig's theory for the construction and creation of his art is that the theory stands in marked contrast to Michael Fried's "Art and Objecthood" and its call for clear classifications in the arts. If for Ehrenzweig, the "blurring of conscious focusing is felt as a danger and a threat of total chaos," it is Michael Fried, according to Smithson, and critics like him calling for stable categories in the arts, who are most threatened by the "abyss" or "chaos" inherent in creativity. "The quality of Fried's fear is high," says Smithson, "but his experience of the abyss is low" (*WRS* 84). For Smithson, language enters the visual arts, like Tony Smith's text (describing his ride on the New Jersey Turnpike), as one of the varied ways to express an original and unbounded state of mind "in the primary process of contact with matter" (*WRS* 84). In *The Spiral Jetty*, Smithson describes the experience as itself boundary breaking: "No sense wondering about classifications and categories, there were none. . . . No ideas, no concepts, no systems, no structures, no abstractions could hold themselves together in the actuality of that evidence" (*WRS* 111). As the text intrudes into the visual arts, it breaks conventional artistic boundaries and often marks, for Smithson, a psychological experience that is itself boundary breaking.

All that is normally "repressed" and outside the stable, rational

consciousness is thus brought into this art: the unconscious, the alea-tory, the cataclysmic, and the absent. For the generation preceding Smithson, the formalists and their champion, Michael Fried, language is the repressed "constitutive outside" that is now brought into and used within art. Thus Craig Owens aptly describes the explosion of langu-age within the contemporary visual arts as occurring "with all the force of the return of the repressed" ("Earthwords" 126). Derrida's inter-est in the "constitutive outside" of philosophy—the unconscious, the female, death, catastrophe, accident (Staten 19–20)—relates to Smithson's use of language and texts within art, his inscription of ab-sences within it, his images of natural catastrophe (*Partially Buried Woodshed*, *Broken Circle*) and processes of physical dissolution (*Tar Pool and Gravel Pit*).

"An interviewer once asked Smithson: 'Are there any elements of de-struction in your work?' He replied, 'It's already destroyed'" (*WRS* 181). The extent of the destructiveness included within Smithson's art can only be understood by recognizing the monumentality of the forms he submits to decay. Comprised of boulders and rocks, *The Spiral Jetty* sculpture wound 1,500 feet into the Great Salt Lake; it was 160 feet in diameter (Fig. 3.10). Six thousand, six hundred fifty tons of earth mate-rial were moved in order to construct this self-destroying object (Hobbs 191). If Derrida says, "I will speak, therefore, of an apocalyptic tone in philosophy," both Smithson's structures and his interdisciplinary tac-tics speak of the apocalyptic within art. Here we witness not only the destruction of monolithic Earthworks, but also the "the Wreck of For-mer Boundaries" (*WRS* 84), as word and thing, text and object, "art" and "literature" become intertwined in surprisingly original ways.

Just as the labrinthian intertextuality of "Quasi-Infinities" creates an "abyss" of language as it crosses disciplinary boundaries, so too, *The Spiral Jetty* crosses the margins of art, poetry, and film, and creates an abyss of language through a very particular metaphoric mode. If, as Bachelard proposed, "the poetic mind is purely and simply a syntax of metaphors,"[30] then certainly Robert Smithson had a poetic mind, even if what he produced cannot easily be placed in any single artistic category. Regardless of how we choose to categorize or define it, *The Spiral Jetty* represents what Craig Owens defines as a distinctive fea-ture of postmodernism in the arts: "the dispersal of the literary across the entire spectrum of aesthetic activity" ("Earthwords" 126–27).[31]

David Antin observes that Smithson was "mapping metaphors" in his

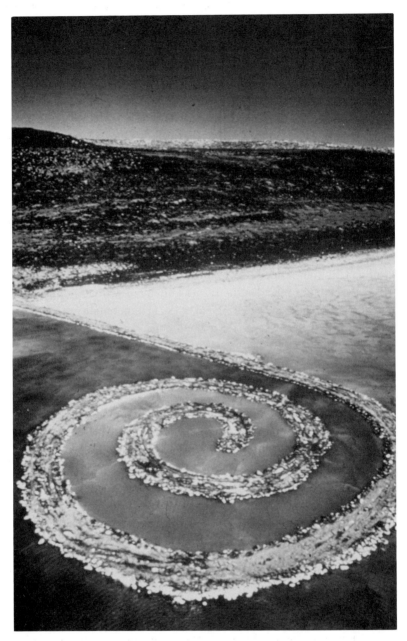

Figure 3.10. Robert Smithson, The Spiral Jetty, *Great Salt Lake, Utah, 1970. Coil 1,500′ long and approximately 15′ wide. Black rock, salt crystals, earth, red water. Courtesy Gianfranco Gorgoni.*

sculptures and Earthworks ("It Reaches a Desert" 69). As I hope to show, it is precisely the way in which the artist "maps metaphors" that leads to the laybrinthian and abyssal nature of language exposed, explored, and created in his work. Although metaphors operate within his oeuvre as passages across varied media to create connections between distinct works, nevertheless they also become vertiginous mazes of meanings in themselves.

Consider, for example, how many different metaphors are generated for language within Smithson's writings. It is a "mirror structure," (*WRS* 67) or "looking-glass babel" (*WRS* 67), a "mirror displacement" ("Incidents of Mirror Travel"), an "infinite museum" (*WRS* 67) and a "building of words": "—a brick = a word, a sentence = a room, a paragraph = a floor of rooms, etc," (*WRS* 67). Smithson's style is to create not just one stable metaphor for each idea and then manipulate it, but to multiply metaphoric meanings in a labyrinthian syntax of associations.[32] Thus language is also strata (*WRS* 129), matter (*WRS* 104), "linguistic objects" (*WRS* 44), minerals (*WRS* 87), "mountains of symbolic debris" (*WRS* 89), and earth (*WRS* 89). The following passage from "Incidents of Mirror Travel in the Yucatan" shows that even Smithson's most documentary style is loaded with metaphors. "Discursive literalness," he once wrote," is apt to be a container for a radical metaphor. Literal statements often conceal violent analogies" (*WRS* 104):

> Two asymmetrical trails that mirror each other could be called enantiomorphic after those two common enantiomorphs—the right and left hands. Eyes are enantiomorphs. Writing the reflection is supposed to match the physical reality, yet somehow the enantiomorphs don't quite fit together. The right hand is always at variance with the left. Villahermosa on the map is an irregular yellow shape with a star on it. Villahermosa on the earth is an irregular yellow shape with no star on it. . . . (*WRS* 102)

In this brief passage, writing is presented as a "trail" to be followed, a "mirror reflection" of reality, a form of enantiomorphic duplication and difference, as well as a "mapped" revision of the artist's experience. Language is also a "pyramid" (*A Heap of Language*, *WRS* 104), or as in Carl André's writings, a "grave" for metaphors and meanings

(*WRS* 68). The image of a linguistic labyrinth is therefore fitting for Smithson's own use of language:

> In the illusory babels of language, an artist might advance specifically to get lost, and to intoxicate himself in dizzying syntaxes, seeking odd intersections of meaning, strange corridors of history, unexpected echoes, unknown humors, or voids of knowledge . . . but this quest is risky, full of bottomless fictions and endless architectures and counter-architectures . . . at the end, if there is an end, are perhaps only meaningless reverberations (*WRS* 67).

In the proliferation of associations which Smithson continuously incorporates in his work, the figures "emerge and become more important than the object they name" (Ulmer 195). For Smithson, language is precisely this analogic permutation, the metamorphosis of one image into the next. His language is "matter" (*WRS* 104) or "material" which is constantly changing, shifting, dislocating, in an incessant process of transformation, a syntax to follow like a "mirror trail" or "looking-glass" labyrinth comprised of metaphoric associations in change. Language is, in fact, the road or path that leads us into and through Smithson's work, constituting, as he said of Tony Smith's infamous text on the New Jersey Turnpike, "a *whole* syntax":[33]

> In a sense the "dark pavement" could be considered a "vast sentence," and the things perceived along it "punctuation marks." ". . . tower . . ." = the exclamation mark (!). ". . . stacks . . ." = the dash (–). ". . . fumes . . ." = the question mark (?). ". . . colored lights . . ." = the colon (:)" (*WRS* 46–47)

Given the syntactic accumulation of metaphors within Smithson's style, the text by Michel Leiris affixed as the margin to Derrida's "Tympan" serves as an excellent "pretext" for a discussion of *The Spiral Jetty* (1970):

> The acanthus leaf copied in school . . . the stem of a morning glory or other climbing plant, the helix inscribed on the

> shell of a snail, the meanders of the small and the large intestine, the marblings that bloom on the edges of certain bound books . . . the steel cable . . . the corkscrewing of the vine . . . the corkscrew (itself prefiguring the endless screw of drunkenness, the circulation of the blood, the concha of the ear, the sinuous curves of a path, everything that is wreathed, coiled, flowered, garlanded, twisted, arabesque) . . . Therefore, essentially, in question is a *spiraled* name. (Derrida, *Margins* x–xxix)

Leiris's narrative presents a chain of images, a syntax of metaphors, loaded, overabundant, a surfeit of images. Derrida's text and Leiris's overlap and cross margins through the image of the tympan, in both texts the image of a margin that can be broken (Pierce-oreille/Persephone). Through this syntactic accumulation, a subversion of semantics is accomplished—not a collapse of meanings into confusion, but a multiplication of alternative possibilities of priority. Is it Persephone, really, that controls these metaphors, or the "gramaphone," which links all of the previous images (the spiral, the membranc/hymen, the voice) and extends the imagery with its inscription of the "gramme" of writing? Or is the text itself the tenor of all these metaphors, a text which spirals onward, repeating, turning back on itself, going forward, destroying one link as it creates another?

As Craig Owens proposes, Smithson's *The Spiral Jetty*—film, essay, and Earthwork—is a Barthean Text, a Text that I think has some interesting affinities with Leiris's syntactic mode and Derrida's "marginal" strategies. *The Spiral Jetty* crosses disciplinary margins and complicates them further by the use of varied media. Its margins also extend outward to include and overlap with other texts. Finally and most importantly, it, too, presents a syntax of associations, placing semantics *en abîme* amidst a surplus of significations. Like the writers discussed by Derrida in "White Mythology," or Derrida in his reading of Leiris, Smithson is also "putting into *abîme* one determined metaphor" (Derrida, *Margins* 262). Alan Bass, editor and translator of "White Mythology," offers the following explanation of *abîme*, which I use throughout this essay: "*Mettre en abyme*(to put into *abyme*) is a heraldic term for the placement of a small escutcheon in the middle of a larger one. Derrida is playing on this old sense of abyme, with its

connotation of infinite reflection, and the modern senses of *abîmer*, to ruin, and of *abîme*—abyss, chasm, depths, chaos, interval, difference, division, etc." (262n).

The Spiral Jetty is a "methodological field" that "cuts across" (Barthes, *Image-Music-Text* 157) three works by Smithson and a number of other texts as well. It accumulates meanings and associations that extend into "a meandering zone": "Here are a reinforcement and prolongation of spirals that reverberate up and down space and time. . . . So that one ceases to consider art in terms of an 'object'" (*WRS* 112). Indeed *The Spiral Jetty* is not an object but a syntax of metaphors which not only describes but also produces a "lucid vertigo"[34] by winding and unwinding images linked by rotary motions, spiral shapes, and spinning sensations as follows:

> The artist's vertigo at the site ["a spinning sensation without movement" *WRS* 111]; the vortex of the legendary whirlpool in the Great Salt Lake; the boiling rotation of the sun and its spiral explosions [in the opening shot of the film, Fig. 3.11]; the spinning wheels of the trucks, the circuitous motion of the helicopter; the circulation of the blood ["red algae circulating in the heart of the lake . . . no they were veins and arteries" *WRS* 113]; the circulation of the lake; the "churning orbs" of the artist's eyes [*WRS* 113]; the swirls in Pollock's *Eyes in the Heat* [*WRS* 113]; the helixical growth of crystals in steps ["each cubic salt crystal echoes the Spiral Jetty in terms of the crystal's molecular lattice" *WRS* 112; Fig. 3.12]; the spiral steps of the artist on the Jetty; a spiral staircase ("*scala* . . . a flight of stairs" *WRS* 112]; the windings of film footage "like intestines" [*WRS* 114]; the clockwise and counterclockwise motions of the artist, the helicopter, and the crystals (and thus the springs of a clock); a coiling serpent (drawings); the gyroscopic rotation of the earth [*Gyrostasis*, Fig. 3.13]; the film itself, a "spiral made up of frames"; the spinning of a cyclotron [*WRS* 113]; "Brancusi's sketch of James Joyce as a spiral ear" [*WRS* 112]; the "conch shell which for the South-West Indians represents the whirlwind and the word" [Gilbert-Rolfe and Johnstone 87]; "the spiral shape of cephalopods, fossils of the Jurassic Period" [maps of which are included in the film

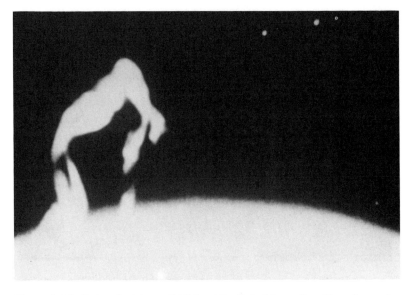

Figure 3.11. Robert Smithson, Still from The Spiral Jetty *film: The solar explosions, 1970. Courtesy Estate of Robert Smithson.*

(Childs 74)]; a spiral path ["I took my chances along a perilous path, along which my steps zigzagged resembling a spiral lightening bolt" *WRS* 113]; the scale of "centers and edges" within the essay which is itself a "muddy spiral"; the "curved reality of sense perception" [*WRS* 113]; Mandelbrot's sets in chaos theory; and a double helix ["following the spiral steps we return to our origins, back to some pulpy protoplasm" *WRS* 113; "I was dissolving into a unicellular beginning, trying to locate the nucleus at the end of the spiral"]. Thus "disparate elements assume a coherence." [*WRS* 115]

The Spiral Jetty also entails at least two structural circuits or spirals as well. Robert Hobbs observes that the film creates a circuit by ending where the audience is seated—in the screening room (196). The essay also ends describing the opening sequence of the film creating a loop or spiral between them.

Further, Smithson's spirals overlap and spill into still other spirals alluded to in the essay and quoted in the film. The reference to

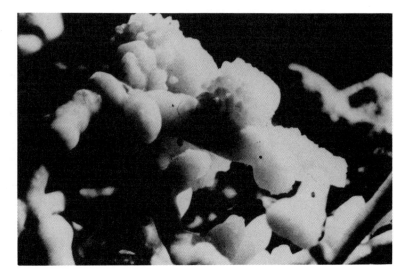

Figure 3.12. Robert Smithson, Still from The Spiral Jetty *film: The crystal formations on* The Spiral Jetty, *1970. Courtesy Estate of Robert Smithson.*

Brancusi's sketch suggests the spiralling structure of *Finnegans Wake* and Vico's cycling history. A fragment from *The Time Stream* (John Taine/Eric Temple Bell) describes the sun as a vast spiral nebulae; a bit of dialogue from *The Most Dangerous Man Alive* is heard on the voice track as well: "'Spirals,' he whispered, 'Spirals coming away.'"[35] The narration from Beckett's *Unnamable* leads us to another "traveler" caught moving in spirals: "I must have got embroiled in a kind of inverted spiral. I mean one the coils of which, instead of widening more and more, grew narrower and narrower and finally, given the kind of space in which I was supposed to evolve, would come to an end for lack of room. . . ." (39–40). The spiral is also the life cycle, or to put it in Beckett's terms, the "lifescrew": "it's not my turn, my turn to understand, my turn to live, my turn of the lifescrew, it calls that living" (176). In *The Spiral Jetty* film, we see just how brief is Smithson's own intense run on the "lifescrew."

Smithson's truly excessive compilation of spirals and spiralling motions, curves, swirls, cycles, and circuits is simply a beautiful sequence or series of mirrored images and analogies. An anecdote recounted by Stephen Jay Gould reminds us of the dangers of reading

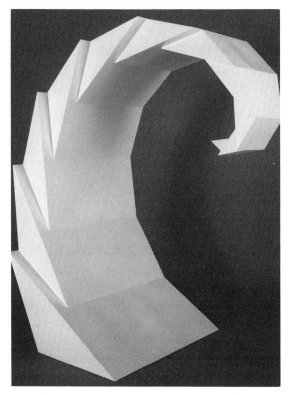

Figure 3.13. Robert Smithson, Gyrostasis, *1974. Painted steel. The Hirshhorn Museum and Sculpture Garden. Smithsonian Institution: Gift of Joseph H. Hirshhorn, 1972.*

too much into spirals. Apparently early in the century Randolf Kirkpatrick, a natural historian, began to see "the coiled form of num-milites as an expression of life's essence, as the architecture of life it-self. Finally, he broadened his claim to its limits: we should not say that the rocks are nummilites; rather the rocks and the nummilites and ev-erything else alive are expressions of "the fundamental structure of liv-ing matter," the spiral form of all existence" (Gould 231).[36] Regardless of how much like the mad scientist Smithson may be in his diligence in collecting spirals, he is not like "Crazy Old Randolf Kirkpatrick," using them to suggest some essential truth of the universe. Smithson's infinite series of analogies, in fact, is designed to do the reverse: to create meanings that cancel out and "self-destroy"—like the Jetty

itself—as they accumulate. A passage from Hulme's *Cinders* quoted in part in "Quasi-Infinities" suggests how analogies are finally employed by the artist:

> The truth is that there are no ultimate principles, upon which the whole of knowledge can be built once and forever as upon a rock. But there are an infinity of analogues, which help us along, and give us a feeling of power over the chaos when we perceive them. . . . The analogues . . . seem about to unite the whole world logically . . . But the line stops. There is no unity. . . . All language and life are made up of tangled ends like that. Always think of the fringes and of the cold walks, of the lines that lead nowhere. (223, 235–36)

Smithson's sequences of images, clusters of related metaphors, isomorphisms, and homologies ultimately lead nowhere at all. It is, as it were, the fascination of the journey itself that keeps the artist and the reader circulating through analogies without reaching any stable semantic destination; for the complex symbolic system does not "add up," does not settle down to a stable meaning, but keeps moving, accumulating, and proliferating meanings in "a network of tangled ends," in what Smithson calls "this branching mode of travel" (*WRS* 103).

As many critics have recognized (Hobbs 19; Childs 77), a number of conflicting alternative views of time are sustained within *The Spiral Jetty*, as they are in "Quasi-Infinities." "An art against itself," remarks Smithson, "would be a good possibility, an art that always returns to essential contradiction" (*WRS* 90). A number of different kinds of entropy are invoked in *The Spiral Jetty*. The destruction and disappearance of the Jetty by natural forces, fully anticipated by the artist, is an example of what Arnheim, (in *Entropy and Art*) describes as the "catabolic effect": the "destruction of shape by natural violence, crumbling, rusting, erosion, friction, in short all agents and events that act in an unpredictable, disorderly fashion, they all grind things to pieces" (27). But the orderliness of crystals is ironically the result of entropy as well, an entropy that arises from energy and tension reduction, and the visible result of physical forces establishing, under field conditions, the most balanced configurations attainable. "This is true," Arnheim continues, "for inorganic as well as organic systems, for the symmetries

of crystals as well as that of flowers" (6–7, 52). Hence the crystals that accumulate on the Jetty not only mirror its spiral structure ("each cubic salt crystal echoes the Spiral Jetty in terms of the crystal's molecular lattice" [112]), they also repeat the Jetty as a symbol of entropy. Like a mirror reflection, however, the mirror repetition also entails a reversal, for the crystals counter entropic disorder (the destruction of the Jetty), with an image of entropic order and symmetry.

Calling attention not only to the complexities of entropy theory, but also voicing his standard suspicion of categories and classifications, Smithson once quipped, "I would like to compile all the different entropies. All the classifications would lose their grids" (*WRS* 181). Communication theory, as Smithson knew very well, also generates its own version of the Second Law of Thermodynamics, and as Robert Hobbs suggests, *The Spiral Jetty* "overloads the symbolic potentialities to the point of chaos or entropy" (196).

Consequently, *The Spiral Jetty* is built not only as a symbol of entropy but of negentropy as well. Rosalind Krauss proposes, for example, that *The Spiral Jetty* outlines a Proustian "passage" in time (282–83), while Elizabeth Childs reads the spiral as a model of continuous and unifying time, including "time travel" back to primordial origins (77). These interpretations link up as time reversals or forces of negentropy sustained within the work, even as they coexist with images and actions of entropy.

Thus *The Spiral Jetty* does return to "essential contradiction" and layers up these echoing and divergent, overlapping and contradictory significations like disparate strata to be explored. We discover here what Barthes describes as "a multi-layering of meanings which always lets the previous meaning continue as in a geological formation, saying the opposite without giving up the contrary" (*Image-Music-Text* 58). Through excessive signification, Smithson's work "denies any definite meaning in the most definite way" (*WRS* 16). In this vortex of proliferating associations and contradictory meanings, the reader loses centric footing and shares at least part of the artist's "vertigo." The "center" of this work is a scene of continuous displacements, shifting thematic alternatives, for which images and metaphors accumulate like growth in a crystal, "around a dislocation point" (*WRS* 112).[37] Adopting Derrida's terminology, Craig Owens argues that Smithson's work describes that "dizzying experience of decentering which occurred at the moment when language invaded the universal problematic, the moment when,

in the absence of center or origin, everything became discourse"
("Earthwords" 122).

"Language should find itself in the physical world and not end up
locked in an idea in somebody's head. Language should be an ever de-
veloping procedure and not an isolated occurrence. Writing should
generate ideas into matter, and not the other way around" (*WRS* 133).
Words shape Smithson's choices of objects and materials throughout
his art—the "instamatic" camera in "Monuments of the Passaic," the
"helicopter" in *The Spiral Jetty* film ("from the Greek *helix, helikos*
meaning spiral)" (*WRS* 113), or the "mangrave" branches in "Incidents
of Mirror Travel in the Yucatan" (103), an essay about the death and
demise of an entire civilization. "Time turns metaphors into things,"
Smithson says (56), and as artist, that is exactly what he does. The
opening sequence of *The Spiral Jetty* film includes a literalized acting-
out of a text: "The earth's history seems at times like a story recorded in
a book each page of which is torn into small pieces. Many of the pages
and some of the pieces of each page are missing." The textbook quota-
tion (from Thomas Clark and Colin Stern, *Geological Evolution of North
America*)[38] is not only revised by Smithson to accentuate fragmentation
but also and more importantly treated as fact. In the film, ripped pages
are seen fluttering through the air and onto the ground. This technique
of literalizing metaphors recurs throughout Smithson's work. Although
in the following instances it is impossible to determine which came
first, the text or the sculptural object, nevertheless the visual/verbal
coincidences are striking:

> Hulme's *Cinders*: "The truth remains that the world is not
> any unity, but a house in cinders (outside in the cold,
> primeval)." (223)
> Smithson, *Partially Buried Woodshed*

> Borges: "I saw all the mirrors in the planet and none re-
> flected me." (quoted by Smithson, *WRS* 43)
> Smithson, *Enantiomorphic Chambers*

> Heraclitus, Fragment 124: "The most beautiful world is like
> a heap of rubble tossed down in confusion." (quoted *WRS*
> 83)
> Smithson, *Cayuga Salt Mine Project*, comprised quite liter-
> ally of rubble tossed down in confusion.

In these cases, Smithson's work discloses what Owens describes as the "absolute congruence and hence interchangeability of writing and sculpture" ("Earthwords" 123–24).

However, it is equally important to recognize that language does not always operate in this way within Smithson's work. In "Incidents of Mirror Travel in the Yucatan," language and image are described as "enantiomorphs," doubling and duplicating, as well as displacing and reversing, one another, repeating each other with differences that are never collapsed into an identity. Smithson may very well have been aware of the analysis of the relation of words and things, the visual and the verbal in Foucault's essay on *Las Meninas*:

> It is not that words are imperfect, or that when confronted by the visible, they prove insuperably inadequate. Neither can be reduced to the other's terms. It is in vain that we say what we see; what we see never resides in what we say. . . . But if one wishes to keep the relation of language to vision open, if one wishes to treat their incompatibility as a starting point for speech, instead of as an obstacle to be avoided, so as to stay as close as possible to both, then one must preserve the infinity of the task. (*Order* 9)[39]

Smithson preserves "the infinity of the task" by constantly shifting the relation of words and images, objects and ideas within his work.

In *The Spiral Jetty* Smithson presents linguistic data as solid objects. "Language tended to inform my structures," he says. "I guess if there was any kind of notation, it was a kind of linguistic notation" (*WRS* 154). Language may in fact be one of the many axes around which the verbal and visual material of *The Spiral Jetty* accumulates:

> Helix: A spiral in many dimensions, in which the Jetty "could be considered one layer." (*WRS* 112)
>
> Helicopter: "From the Greek, *helix, helikos* meaning spiral." (*WRS* 113)
>
> Helicline: A curving ramp that ascends gradually. *The Spiral Jetty* curves and it also "ascends", ("*scala* . . . a means of ascent") (*WRS* 112). *Amarillo Ramp* is also a helicline.

Heliostat: A device consisting of a mirror slowly revolved by clockwork so as to reflect the sun's rays continuously in a fixed direction. "The helicopter maneuvers the sun's reflection through the Spiral Jetty until it reached the center. The water functioned as a vast thermal mirror." (*WRS* 113)

Heliogram: Signaling by flashing sun's rays from a mirror. The water serves as a "vast thermal mirror" reflecting sunlight. All the Mirror Displacements are "heliograms" of sorts, suggesting that Smithson is more interested in sign systems than in any messages that they might convey.

Heliotypes: Printed reproductions. The "heliotyped landscape" of "Passaic" and its reprinted "Allegorical Landscape," the "reproduced reproductions" of "Quasi-Infinities" (*WRS* 32), or history seen as nothing but "copies of copies" (*WRS* 73) are all heliotypes of sorts. Smithson's work in general is presented as a series of duplications and replicas for lost and absent originals, like the documentation for *The Spiral Jetty* itself. In "Ultramodern," Smithson says, "repetition, not originality is the object." (*WRS* 49)[40]

Helios: The sun. The film begins with a shot of the sun and fictively ends in "sunstroke." The narration includes a definition of sunstroke from *Black's Medical Dictionary*.

Thus not only does the artist use language to describe *The Spiral Jetty*; he also uses the Jetty to inscribe words and ideas into matter. Not only does he shape and mold language like "material to put together" (*WRS* 104), treating language as a thing (as in "Quasi-Infinities"); he also treats objects linguistically, to produce a kind of "writing beyond the book" (Ulmer 15–16, 242).

In general Smithson is interested in etymology ("*scala*," "helix," "teratology" (*WRS* 73), because it parallels in language the "primordial return" to origins enacted within *The Spiral Jetty* as a whole.[41] It is a view of language as "ever-developing procedure," a temporalizing of words. Just as Smithson likes the aesthetic of the picturesque, because it accentuates the temporal, changing aspect of nature unaccounted for in Burke's separate categories of the beautiful and the sublime (*WRS* 118–19), so too he is interested in the effects of time upon language: "Words like trees, can be suddenly deformed or wrecked, but such de-

formation cannot be dismissed" (*WRS* 118). Smithson employs the temporal dimension of language in two ways: first, to bind the present to the past, as he does with the maps of the Jurassic period in *The Spiral Jetty*; second, to accelerate the wreckage and deformation of what he considers to be outmoded terms. In "Project for an Air Terminal Site," he calls for a new vocabulary of air travel and for a new vocabulary of art: "Our whole notion of air travel is casting off the old meaning of speed through space and developing a new meaning based on instantaneous time. . . . The same condition exists in art. . . . The categories that proceed from rational logic inflate a linguistic detail into a dated system of meaning . . . 'painting' is not an end but a means. . . . It is linguistically an out-of-date category" (41–47). Smithson wants to supplant linguistic "categories" with "linguistic sense-data" in order to engender new forms and concepts of art: "Linguistic sense-data, not rational categories are what we are investigating" (*WRS* 46).

The *Spiral Jetty* essay includes the following passages: "Size determines an object, but scale determines art. A crack in the wall if viewed in terms of scale not size, could be called the Grand Canyon . . . a room . . . the solar system. . . . Scale depends on one's capacity to be conscious of the actualities of perception (*WRS* 112).[42] The artist utilizes this notion of scale throughout his work. In the essay "Ultramodern," for example, buildings become "cosmos that dissolve into fatigued and tired distances" (*WRS* 98). The overturned rock in "Incidents of Mirror Travel" is the displacement of the entire Mayan civilization expressed on a microscopic scale; it is also "the entrance to the abyss . . . a damp cosmos of fungus and mold" (*WRS* 98). In *The Spiral Jetty*, everything is somehow everything else, except on a different scale: double helix, crystals, spiral, sun, solar system. "To be in the scale of the Spiral Jetty is to be out of it" (*WRS* 112), writes the artist, suggesting that the material Jetty was never the controlling object of the work, but simply one level or layer within its spiralling scale changes.

One result of this tactic is that, in keeping with the aesthetic of Conceptualism, the object is "de-materialized" and "de-objectified." As Smithson describes *Broken Circle*, "I don't see it as an object, what you have there are really many different scale changes" (*WRS* 179). More importantly, the scale changes within *The Spiral Jetty* produce a deflated or flattened-out system of metaphor similar to that described by Derrida in "White Mythology," which "explodes the reassuring opposition of the metaphoric and the proper" (*Margins* 270). Every

"metaphor" within *The Spiral Jetty* is both tenor and vehicle, signified and signifier. Does the spiral represent the sun? Or does the sun represent the spiral? Does the artist's spinning sensation reflect the legendary whirlpool, or vice-versa? What is the master metaphor—Helios (the sun) or helix (the spiral)? What is the tenor of all these vehicles? The artist's vertigo? The whirlpool? The Jetty? It is impossible to tell. All of Smithson's mirrored images participate in a network not mastered by any one. As in Derrida's theory, the effect is "not just a simple reversal of the figurative-proper relation—but that the very notion of the proper and familiar is put in question" (Ulmer 83).

This incessant change of scale, or metaphoric association without priority, places metaphors and meanings *en abîme*; Smithson's metaphors multiply and complicate signification; they proliferate without closure; they deny the existence of a "firm and ultimate ground, a terrain to build on, the earth as the support of an artificial structure" (Derrida, *Margins* 223–26). Indeed, the "ground" of language, of the earth, of the ego, and of metaphor as well, are shown by the artist to be shifting and changing continuously—not a firm ground, but an abyss, like the natural landscapes the artist "scans" and selects. In a way that parallels the physical processes of sedimentation that Smithson continuously incorporates in his work, *The Spiral Jetty* also includes a "metaphorical sedimentation of concepts" (Derrida, *Margins* 214), a metaphoric detour without return to a "proper" idea, an endless spiralling of relations without closure.

In "White Mythology," Derrida describes the *abîme* of metaphor as the "figurative ruination of logic as we know it, as for example when the distinction between the reflected and the reflecting falls apart" (261). *The Spiral Jetty* is also designed as an active ruination of logic. In it, Smithson writes, "the surd takes over and leads one into a world that cannot be expressed by number or rationality. Ambiguities are admitted rather than rejected, contradictions are increased rather than decreased—the alogos undermines the *logos*" (*WRS* 113). Indeed, Smithson consistently uses mirrors and mirror relations to undermine logos and logic. In his work "the mirror [keeps] changing places with the reflection. One never knows what side of the mirror one is on" (*WRS* 56). Sculptures like *Mirror Vortex*, *Three-Sided Vortex*, and *Four-Sided Vortex* (1965) all create labyrinthian visual complexities with mirrors. The Site/Nonsite dialectic is also presented as a puzzling mirror relation: "Is the site," he asks, "the reflection of the nonsite (mirror), or is it

the other way around?" (*WRS* 115). The endlessly mirrored images of *The Spiral Jetty* can be related to the abysmal confusion Smithson creates in his own mirror sculptures, and which he sees in Larry Bell's mirrored works, where "reflections reflect reflections in a Pythagorean chaos" (*WRS* 4).

In fact Smithson continuously places objects and images *en abîme* in that other sense of the term which suggests the placement of one identical image within another. In *Photostat of Five Mirrors Glued to Five Mirrors* (1968; Hobbs 82), a mirror contains an infinite regress of mirrors within it; in *Project for an Underground Cinema*, an "underground" theater (at least in theory) shows a film of the construction of the theater itself; Smithson envisions *The Spiral Jetty* film being shown on a ferry "spiralling" through the New York harbor. A mirror is described as a fact within the mirror of the concept (*WRS* 169); the Nonsites are "a fragment of a greater fragmentation" (*WRS* 90), and a "container within another container—the room. The plot or yard outside is yet another container" (*WRS* 115). In these works and others, the artist creates or contemplates an abysmal involution that recalls Dunne's *Serial Universe* and the involution of contemporary fiction with which he was quite familiar: Borges, Beckett, and Butor. What Smithson admires in the Ultramodern is that it presents "an infinite multiplication of looking-glass interiors . . . a monstrous system of mirrored mazes . . . a vain trap . . . an abyss" (*WRS* 50). The metaphors in *The Spiral Jetty*, too, create a monstrous system of mirrored relations, where we cannot disentangle the reflecting and the reflected. It is not surprising, therefore, that the last shot of the movie should show stills from the film itself, thereby placing it, too, *en abîme* (Fig. 3.14).

Smithson's *The Spiral Jetty*, therefore, helps to inaugurate a postmodern style of writing. It participates in the "grammatology" described by Gregory Ulmer which extends writing "beyond the book," in Smithson's case, becoming a picto-ideo-photographic-filmic text, which includes Earthworks and objects as well. But this new style also, like Leiris's *Biffures* (as presented and used in Derrida's "Tympan"), multiplies metaphors and meanings, so that the movement through images and associations becomes more important than the arrival at stable and definite meaning.

It is, in fact, an art of travels ("The Crystal Land"; "Monuments of the Passaic"; "Incidents of Mirror Travel"), transportation (of materials), and transits (the artist's incessant movement by foot, by bus, by car,

Figure 3.14. Robert Smithson, Last shot from The Spiral Jetty *film, including the moviola, film scraps, and a still from* The Spiral Jetty, *1970. Courtesy Estate of Robert Smithson.*

and by airplane). Roads, paths, and trails become metaphors for the art itself and the way in which the viewer/reader advances through it. The Site/Nonsite dialectic, for instance, "consists of a course of hazards, a double path made up of signs, photographs, and maps" (*WRS* 115). Most of Smithson's essays begin or end with an image of the road, creating in different ways, a sense of "rapid transit" through space-time. The artist's "voyages of discovery" produce "trails" for his audience to follow; as he says, "the rules of this network of signs are followed as you go along uncertain trails both mental and physical" (*WRS* 115). His art is constructed as traces, or tracks, or trails to follow, but the journey itself is uncertain: "The route is very indeterminate, it's an abyss" (*WRS* 169). "This is a map that will take you somewhere, but when you get there, you won't really know where you are" (*WRS* 176).

Metaphor also entails the notion of transport, (from the Greek *pherein*, to carry or transport). Derrida's essay in general questions the implicit assumption of classical philosophy that metaphor is charged with expressing or "transporting" a stable idea or truth (Derrida, *Margins*

223, 231). Smithson's *The Spiral Jetty* uses metaphor in a way that is consistent with Derrida's description of other possibilities for metaphor, in other words, opening "up the wandering of the semantic . . . the movement of the detour in which the truth might still be lost" (Derrida, *Margins* 241). Just as there is no "return" through Smithson's varied documentation to the lost originals which they describe, so too, there is no passage through his analogic system to any stable meaning, theme, or signification. There is only the passage or the journey itself. "Artists are not motivated by a need to communicate," he writes; "travel over the unfathomable is the only condition" (*WRS* 103). For Smithson, as for Hulme, "travel is education in cinders" (Hulme 245), "in tangled ends," in "lines that lead nowhere."

The opening sequence of *The Spiral Jetty* film shows a truck speeding along a dirt road, moving forward and backward in both time and space. The road is itself a scene of displacements, for the film cuts back and forth from it to scenes of the sun, a quarry, maps, and the Hall of Late Dinosaurs (in the American Museum of Natural History). The essay concludes with the following passage describing the opening sequence of the film:

> An interior immensity spread through the hall, transforming the light bulbs to dying suns. The red filter dissolved the floor, ceilings, and walls into halations of infinite redness. Boundless desolation emerged from the cinematic emulsions. . . . The bones, the glass cases, the armature brought forth a blood drenched atmosphere. . . . These fragments of a timeless geology laugh without mirth at the time filled hopes of ecology. From the soundtrack the echoing metronome vanishes into the wilderness of bones and glass. Tracking around a glass containing a "dinosaur mummy," the words of The Unnamable are heard. The camera shifts to a specimen squeezed flat by the weight of sediments, then the film cuts to the road in Utah. (*WRS* 115)

Smithson reads this passage from the *The Unnamable*:

> Nothing has ever changed since I have been here. But I dare not infer from this that nothing ever will change. Let us try and see where these considerations lead. I have been here,

ever since I began to be, my appearances elsewhere having
been put in by other parties. All has proceeded, all this
time, in the utmost calm, the most perfect order, apart from
one or two manifestations the meaning of which escapes me.
No, it is not that their meaning escapes me, my own escapes
me just as much. Here all things, no, I shall not say it, being
unable to. I owe my existence to no one, these faint fires are
not of those that illuminate or burn. Going nowhere, coming
from nowhere. . . . (7).

Like Beckett's character, who builds his composition out of decom-
position, who contradicts himself, who constructs fictions and systems
in order to destroy them, who feels profoundly that meaning has es-
caped him, who confuses the center and the circumference, who knows
the "surd" state, and who amidst endless dessication, decay, and defor-
mation does not despair (but is "urbane," "a credit to the art and code of
dying" [36]), Smithson, too "laughs" with nihilistic despair. He once
said:

As long as art is thought of as creation, it will be the same
old story. Here we go again, creating objects, creating sys-
tems, building a better tomorrow. I posit that there is no to-
morrow, nothing but a gap, a yawning gap. That seems sort of
tragic, but what immediately relieves it is irony, which gives
you a sense of humor. It is that cosmic sense of humor that
makes it all tolerable. Everything just vanishes. (Norvell
90)

Smithson, like Beckett, maintains "that cosmic sense of humor." And
like the artist, Beckett's inveterate travelers never stop moving in the
fictions he (and they) create. "I invented it all," says the Unnamable,
"in the hopes it would console me, help me to go on, allow me to think of
myself as somewhere on a road, moving, between a beginning and an
end, gaining ground, losing ground, getting lost, but somehow in the
long run making headway. All lies . . ." (36). Smithson's film depicts
two roads which contain all the power of this prose passage, for as we
see Smithson "gaining ground and losing ground" on the Jetty and as
the camera takes us speeding along the dirt road in the furious first
shots of the film, we have the sensation of advancing and "making head-

way." All lies: Everything just vanishes. The artist's early and tragic death is as much a part of the work as the Jetty's consumption by the lake. Smithson's road, too, is "going nowhere, coming from nowhere."

Both Beckett and Smithson create through de-creation, and *The Spiral Jetty* shows the effect of that "double-headed monster of damnation and salvation—Time" (Beckett, *Proust* 1). While time was destroying *The Spiral Jetty* as object, it was also enlarging, expanding, and enriching *The Spiral Jetty* as Text. Since 1970, numerous critics have contributed to our understanding of the way in which *The Spiral Jetty*, and the larger Text which is Smithson's oeuvre, work. Craig Owens observes that *The Spiral Jetty* is the *memento mori* of the twentieth century ("Allegorical Impulse" I 71). Perhaps it is. But it also testifies to the peculiar and mysterious power of metaphors to grow and accumulate in time. Two of Smithson's favorite writers, in fact, have commented on this phenomenon. In Nabokov's *Ada*, Van says, "Time is a fluid medium for the culture of metaphors" (420).[43] A passage from "Averroes' Search" by Borges explains this paradox more fully:

> Time, which despoils castles, enriches verses. Zuhair's verse, when he composed it in Arabia, served to confront two images, the old camel and destiny; when we repeat it now, it serves to evoke the memory of Zuhair and to fuse our misfortune with that dead Arab's. The figure had two terms then and now it has four. Time broadens the scope of verses and I know of some which, like music, are everything to all men. (154)

One can only hope that time will continue to broaden the scope, the meanings, and the metaphors of *The Spiral Jetty*, so that in art, at least, time the destroyer can also be time the healer, affirming that paradox of destruction and creation in time which always appealed so much to Robert Smithson.

"ALWAYS TWO THINGS SWITCHING"

4

Anderson's Alterity

"*Writing aloud* is not phonological but phonetic: its aim is not the clarity of messages, the theater of emotions; what it searches for . . . are the pulsional incidents, the language lined with flesh, a text where we can hear the grain of the throat, the patina of consonants, the voluptuousness of vowels, a whole carnal stereophony: the articulation of the body, of the tongue, not that of meaning, of language. . . ."

ROLAND BARTHES

"There is no such thing as a neutral voice, a voice without desire. . . ."

REGIS DURAND

"All the words . . . came out of another supermarket. Not a food supermarket, but another supermarket, a word bank. . . . They think it's all their own words, and their own way of thinking, but it's not. The very least one should demand of life is that you're actually saying what you're saying, and you're actually thinking what you're saying. That's not a very big demand."

LES LEVINE

In his poem "remembering, recording, representing," David Antin satirizes the formalist aesthetic and its preoccupation with the self-referential, autotelic work:

painting is embarrassed to be about anything . . . it's been embarrassed for a long time. . . . there's a grave sense of embarrassment before the possibility of being about in painting which they call being literary . . . and literary is a bad term for a painter because everyone knows that if you

paint a painting of anything its shouldn't be about anything but painting. . . .

Sympathetic with Antin's critique of the modern aesthetic, Gregory Battcock writes:

> A work of art that may be quite useless, quite impossible to understand, perhaps quite meaningless in every way, can be justified if it manages to refer specifically and exclusively to its own self. . . . It is the cornerstone of modernism. . . . However it no longer works. . . . The very profound level of artistic energy that is currently expended in the . . . performance field indicates that the major basis for modernist art is crumbling. (Nickas xxi)

Laurie Anderson's art is not afraid to be "literary," in Antin's sense, not afraid to be about something besides the "canvas," the "brush-stroke," the "line," and the preoccupation with formal technique that she once called "too rarefied . . . deadly."[1] Her subjects are wide ranging (politics, technology, the media, human relations, religion) and encompass, via satire, numerous aspects of everyday experience in the United States of our time.[2]

But Anderson's best work is literary in other ways as well. Through combinations with other forms of art (music, dance, photography, video, and film), language is crafted and manipulated to generate a new kind of verbal-visual-musical art. Spoken and written texts help to shape an interdisciplinary art that is also centrally concerned with the limits and possibilities language offers for representing the self, for communication, and for cultural identity and exchange. Her art is an art of multiplicity and plurality, an art of mixed media and mixed messages. Within this larger multiformity, Anderson also continually sets up binary relations, dialectical oppositions that sustain oscillations between opposites.

Anderson's earliest works paid homage to those movements which had already begun the assault on modernism and which were historically her immediate precursors: Conceptualism, Earth art, Fluxus, and Narrative art. Her first performance piece, *Automotive* (1972), was a Fluxus event, like George Brecht's own score for orchestrating car sounds, *Motor Vehicle Sundown Event* (1963).[3]

Duets on Ice (1974–75) was a strange and humorous Conceptual piece in which Anderson stood on street corners while wearing skates embedded in blocks of ice (Fig. 4.1). She accompanied a prerecorded tape as she played the violin. The piece, performed on tour in the United States (with music by Bach) and in Italy (with cowboy songs), was an example of "idea art" in action. It set up a series of correlations between kinds of duets or pairs: two skates, two sound sources, two blocks of ice, and two similar gliding motions (skating and violin playing).[4] The major theoretical tenets of Conceptualism were integrated within this work: the disappearance of the art object into a minimal Conceptual action, the dislocation of art from the museum and into the streets (on the order of, say, Daniel Buren), and a preoccupation with the disintegrating effect of time upon objects (Kosuth's *Notebook on Water* or Smithson's *The Spiral Jetty*). The piece incorporated the minimal and simple style that characterized the first generation of performances by artists such as Vito Acconci, Chris Burden, and Bruce Nauman (whose violin, tuned D.E.A.D., contained a continuous tape of grating noises) (Meyer xii). *Duets on Ice*, however, replaced the violence (Burden) and aggressiveness (Acconci) of their work with Anderson's own personal style: a musical performance that entertained an audience, however small. This is also the first piece to include what later became a signature for Anderson's style: the use of back-and-forth, dialectical movements, which, she said, "I find very, very interesting."

Stereo Decoy: A Canadian American Duet (1977), shows the extent to which Anderson adopted techniques and styles from prevailing modes of art and at the same time adapted them to express her own artistic sensibility and interests (Fig. 4.2). *Stereo Decoy* was a site-specific earthwork that crossed geographic and artistic borders, and so acknowledged the major tenets of Earth art in general. Yet Anderson's Earthwork, in contrast to any other, used bullhorn speakers, pianos, microphones, generators, mixers, loudspeakers, and a Canada goose decoy. The photo-documentation for this piece shows a piano being lifted by a gigantic crane. In *Stereo Decoy*, Anderson responded to the theories of Earth art and then translated them into her own personal vocabulary of sound, music, technology, and "stereo" relations.

Anderson's *Jukebox* (1977), *Handphone Table (When You We're Hear)* (1978), and *Quartet #1 for Four (Subsequent) Listeners* (1978) are varied kinds of sound sculptures. Janet Karden links *Quartet #1* to Rauschenberg's *Soundings* (1968); in both pieces, spectators' footsteps

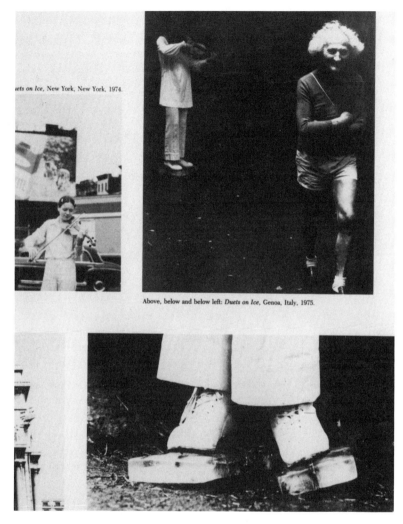

ets on Ice, New York, New York, 1974.

Above, below and below left: *Duets on Ice*, Genoa, Italy, 1975.

Figure 4.1. Laurie Anderson, Duets on Ice, *1974–1975. Courtesy of Laurie Anderson and the Institute of Contemporary Art, University of Pennsylvania.*

activate light or sounds. *Jukebox* (a real jukebox containing records made by Anderson), was exhibited as part of "Soundings," a 1982 show which documented the wide scope of sound sculptures and artworks of the century. The show included, among other works, Futurist manifestos, Duchamp's *With Hidden Noise*, Rauschenberg's *Music Box*,

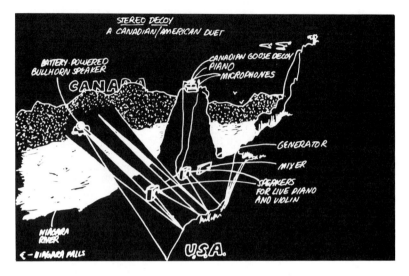

Figure 4.2. Laurie Anderson, Drawing for Stereo Decoy, *1977. Courtesy of Laurie Anderson and the Institute of Contemporary Art, University of Pennsylvania.*

Meredith Monk's *Silver Lake with Dolmen Music*, and Robert Morris's *Hearing*. Like *Revolutions Per Minute (The Artists' Record)* (1982), which includes twenty-one sound works by visual and Conceptual artists, Anderson's sound and record works attest to the growing interest on the part of contemporary artists in producing aural forms of art.

The photographs-with-texts that are part of *Jukebox* (1977) relate to Narrative art as it was practiced by Peter Hutchinson, Roger Welch, and Bill Beckley, artists Anderson has said she admired (Kardon 18). Like Conceptual art and Earth art, Narrative art was anti-studio, with the artists working in and alluding to the world beyond traditional art boundaries. Narrative art advocated a free mix and use of media: photography, film, videos, texts, tapes, drawings, paintings, and performances; it extolled "pluralism," a pluralism actively operative in Anderson's shifting media. James Collins, one of the catalysts in this movement, described Narrative art as follows: "The artists here tell 'stories,' create scenarios, written, typed, taped, and photographed. . . . Their art of people, thing and situations, embracing a wide spectrum of real and imaginary everyday life, is a humanizing ges-

ture of some significance." Reacting against the overly cerebral and theoretical concerns of Conceptual art, Narrative art brought the textual and verbal strategies of art closer and closer to storytelling. Anderson's activity as a Performance artist, she says, began with a fascination with the spoken word:

> Originally I was a sculptor. During the Seventies I did large photographs with texts. At that point I thought it's silly to have all these giant words on the wall when they have very different kinds of meanings. When you get a letter from somebody, you get a feeling of what's going on with them. But if you get a phone call and they say the same things, you get so much more information from the voice and the way they pause. So in looking at my pieces, I thought, why flatten the words out like this. Just say them. So I started giving these performances which were really just spoken stories. (Smith 61)

"Spoken stories," slides, videos, films, photographs, musical instruments, electronic devices—these elements of Anderson's singular performance in *United States* (Brooklyn Academy of Music, 1983) are, in one sense, reassuringly "Modernist." Modernism, after all, has well prepared us for this art of radical fragmentation (Cubism), for the mixing of theatrical elements in a "synthetic theater" (Futurist and Bauhaus performances),[5] for the inclusion of cacophony and noise (Bruitism, and more recently Cage), the dreamscapes and psychic discontinuity, the games, humor, jokes, and farce (Dada and Surrealism),[6] the celebration of new technology and the aesthetic of speed and suddenness (Futurism).

Yet the difference between Anderson's aesthetic and that of these precursors is important. *United States*, for example, is created under the control and direction of one artist—and, significantly, under the direction of a woman artist[7]—producing a new multimedia performance art that is not the result of a collaboration between "writers," "visual artists," "musicians," "dancers," and "composers," all contributing elements from their own circumscribed areas of expertise. As such, the boundaries between artistic disciplines are crossed not only in the artistic product (*Einstein on the Beach*, for instance) but in the creative process as well.

In addition, *United States* participates in and manifests a recent change in the relation of the artist and the audience. No longer determined to antagonize, provoke, and otherwise "cancel" its relation to the audience (as in the Satie, Picabia, Duchamp, Clair performance, *Relâche*), contemporary performance artists are determined instead to engage and entertain. Anderson's astounding commercial success is in part the result of her decision to merge high art and popular culture, fine art and mass media techniques (Smith 61).

Anderson's popularity can also be seen as an extreme case of more widespread trends in contemporary art. As early as 1969, and in response to the emergence of Pop art, Harold Rosenberg proposed that "art has entered the media *system*" (*Artworks and Packages* 13). More recently, Frederic Jameson has noted that "the line between high art and commercial forms seems increasingly difficult to draw" ("Postmodernism" 112); he continues, "even if contemporary art has all the formal features as the older modernism, it has still shifted its position fundamentally within our culture" (124).[8] The eclecticism that Charles Jencks defines as a distinctive feature of the postmodern style is also, he says, an attempt to "overcome the elitist claim [of modernism] not by abandoning it, but through the expansion of architectonic language in various directions—to the down-to-earth, to the traditional, and to the commercial jargon of the street" (*Language* 6, 8, 113).

In Laurie Anderson's work, the language of art "expands in various directions" as well, including the "down-to-earth, the traditional, and the commercial jargon of the street." Indeed, language is portrayed as a heteroglossia of conflicting foreign and social languages. This linguistic heteroglossia in turn contributes to the larger multiplicity of Anderson's mixed verbal, visual, and musical art. The meaning of Anderson's texts arises from their visual, musical, and vocal contexts, the slight intonations, pauses, and sound effects that amplify, contradict, or ironically deflate what is being said. "I want to be in a power series," she once remarked, "where the general term is an almost insignificant detail—a slight twitch, a repeated phrase" (Sondheim xxiv). Since so much depends on the performance itself, on the vocal delivery of texts, it is impossible to separate the "literary" from the "dramatic," the "visual" from the "aural" in this work. Anderson's textual vignettes are always presented in combination with other art forms (music, dance, photography, video, and film) to shape not only an intergeneric but an interdisciplinary art.

Anderson has said, "I . . . try and build [a] piece in certain visual-audio layers so that you can get conflicting bits of information, things that pull at each other" (Philip Smith 61). The piece "Stereo Song for Steven Weed" exemplifies the way in which "things pull at each other" within Anderson's work. As in *Duets on Ice* (1974–75) or *Stereo Decoy* (1977), she is preoccupied with oppositional movements. In this case, the oscillation is between the left and right motions of the head producing the gesture "No," and captured in the Janus-faced, photographic self-portrait included in *Jukebox*. "Stereo Song for Stephen Weed" expresses Anderson's continuing interest in dialectical motions, back-and-forth movements, the stereo effect between opposites: "Most of the work that I do," she said, "is two part stereo . . . so there's always the yes/no, he/she, or whatever pairs I'm working with" (Kardon 19). The important "stereo effect" within the piece is between two sign systems, the language of gesture ("no") and the meaning of words ("yes"). The version in *Jukebox* (1977) plays out these oppositions visually, by juxtaposing a musical score, a photograph, and a text, a combination of media that enacts the multiplication and the differences between sign systems which the anecdote itself concerns (Fig. 4.3).

As Roger Copeland says, "Anderson keeps the various media discretely independent, often pitting words and images against one another" (103). "If there is an image and a text," observes Janet Kardon, "there is also a *frisson* between depiction and a voice" (30). Anderson's hybridism sometimes erases, as in the Tape Bow transitions between sounds and words, or the blurring which occurs between text and music,[9] and sometimes preserves (in an active *frisson*) the boundaries between the varied artistic media which it incorporates.[10] An unresolved "dialogue" occurs between various sign systems within her work, a sustained oscillation between different genres, media, and disciplinary tactics.

The videotape of *O-Superman* (1981)[11] preserves what is most effective in Anderson's performances and constitutes an interesting "artwork" in its own right. It begins with a digital pulse which is eerie itself, and over which Anderson delivers the lyrics in a cadenced rhythm halfway between speech and song. The strangeness is heightened by the image of Anderson herself, in punk hair and black leather jacket, with a pillow light that emits a bright red glow from her mouth. Stylized and exaggerated motions of hands and arms play with and against the meanings of words, all the while producing huge shadows

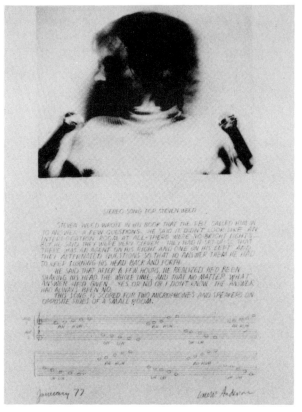

Figure 4.3. Laurie Anderson, "Stereo Song for Stephen Weed," from Jukebox, *1977. Courtesy of Laurie Anderson and the Institute of Contemporary Art, University of Pennsylvania.*

which hover over the artist in a sequence of visual messages (Fig. 4.4).

If Anderson's visual effects are uncanny, strange, and bizarre, her language in this piece, as elsewhere, is perfectly familiar. ("Hello, this is your mother, are you coming home?") New verbal combinations, musical juxtapositions, and unusual visual contexts bring the most commonplace speech into the foreground; the language which has become "invisible" because so familiar is heard again, as it were, for the first time.

O-Superman shows that the entire spectrum of possible relations of the verbal and the visual are explored and exploited within Anderson's work. At times there is a simple translation between one sensory mode

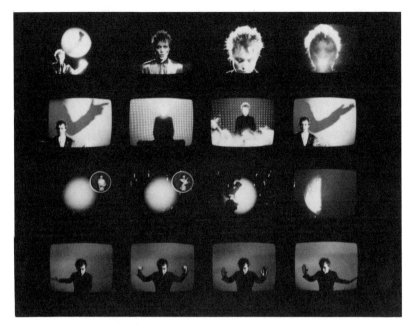

Figure 4.4. Laurie Anderson, Stills from the videotape O-Superman. *Photographs from* United States, *1984. Reprinted by permission of HarperCollins Publishers.*

and another; the verbal text is translated into sign language, into the language of familiar gestures and into images, as one sign system repeats and echoes another.

> —"Come as you are but pay as you go" is accompanied by a pointing hand;

> —"This is the hand, the hand that takes," an open palm;

> —"Smoking or non-smoking?" suddenly smoke fills the screen;

> —"Neither snow nor rain nor gloom of night shall stay these couriers from the swift completion of their appointed rounds." A circle in the upper right corner of the screen shows Anderson looking very Chinese and translating the text into sign language;

—At the word "rounds," a disk spins around;

—"There's always justice. . . ." Anderson balances her
arms to suggest the scale of justice;

—"There's always force," she makes a fist;

—The recapitulation of musical themes is accompanied
by the shadow-play of images from the oral text: the
telephone, the cigarette, the flexed arm of "force."

More interesting, however, is the way in which these different sign
systems not only translate but vary and modify each other's meanings.
"You better get ready, ready to go" is a phrase ordinarily repeated by a
mother to a dawdling child. But the shadow-image of the pointed hand
distinctly resembles a gun, suggesting that "getting ready to go" may
mean to "go" into the armed services, or even to *go*, to die and be
killed. Anderson's Chinese costume indicates that her act of signing
stands for translations between foreign languages as well. Finally, the
spinning disk turns into a spinning earth and then a spinning white
globe in which national boundaries are effaced, as they are in the open-
ing shot of the video, in which a white globe subtly "shrinks" before the
viewer's gaze. The imagery of *O-Superman*, then, adds its aura of hu-
morous literalization to the spoken text, but it also expands the text by
placing it within an international or global perspective that sheds light
on the ideological dilemma which the piece as a whole presents.[12]
 The complex switching between media within Anderson's work is re-
lated to the continuous alterity of gender which is sustained vocally
throughout her performances. She said, "In my work I strive for a sort of
stereo effect, a pairing of things up against each other and see myself as
a sort of moderator between things. Sexuality is one of those things that
I'm between" (Kardon 25).[13] Within Anderson's work there is a con-
tinuous alternation not only between images and texts, texts and music,
but also a continuous alternation between male and female voices (Fig.
4.5). Throughout her performances, Anderson either alters her own
voice with electronic devices ("Say Hello"), or presents two speakers
(male and female) whose voices alternate in presenting fragmented
monologues ("So Happy Birthday" and "New Jersey Turnpike"). The
gender oscillations present the sexes themselves in unresolved "dialec-
tical" relations. What Owens calls Anderson's "vocal transvestism"

Figure 4.5. Laurie Anderson, from "So Happy Birthday." United States, *1984. Courtesy of Perry Hoberman.*

("Discourse" 60) sets up a continuous binary opposition that fluctuates between male and female without resolution and without priority. In this case, all discourses (male and female, verbal and visual) become "other" (or alter) to each other in a way that undercuts and denies hegemony to any. Situating herself in this way "between" the sexes and the arts, Anderson transgresses both the "laws of genre" and gender.[14]

"The Language of the Future" (*United States*) contains many of Anderson's stock verbal strategies, including the reliance upon subtleties of vocal delivery, the alternations and contradictions of genders, and the satire on conventional modes of talk (for example, the stewardess's controlled delivery in the midst of a plane crash). It includes slang ("chitchat"; "wavelength"), slapstick comedy ("Put your hands on your head. Put your hands on your knees! Hey-hey"), and abrupt dissociations ("This is your Captain. Have you lost your dog?"). Like many of Anderson's other pieces, it describes eccentric characters ("Three Walking Songs"), or "normal" characters described in odd and eccentric ways. At the center of the piece is a confrontation of different and differing languages: "I realized she was speaking an entirely different language. Computerese."

Most importantly, "The Language of the Future" exploits all of the dialectical oppositions of languages, genders, and genres of Anderson's work, and it extends them even further. In addition to alternations between genders, there are also continued alternations between language and sounds, and between sounds and silence (electronic beeps). The piece is, in effect, *about* the alterity it enacts. Male and female, culture and nature, text and music, the language of the self and the language of the other, the language of the future and the language of the past are all presented as sustained dialectical opposites, like the switching of electronic or digital devices ("on and off"), sexual "currents" ("on again, off again"), and finally like the switching from life to death itself ("current runs through bodies and then it doesn't"). Given the cadenced rhythms, the anaphora, the repetitions in the conclusion, one might even argue that the piece "switches" from prose to poetry as well.

> Always two things
> switching.
> Current runs through bodies
> and then it doesn't.
> It was a language of sounds,
> of noise,
> of switching,
> of signals.
> > It was the language of the rabbit,
> > > the caribou,
> > > the penguin,
> > > the beaver.
>
> A language of the past.
> Current runs through bodies
> and then it doesn't.
> On again.
> Off again.
> Always two things
> switching.
> One thing instantly replaces
> another.

Anderson has transformed a (perhaps personal) story about an imminent plane crash into a verbal artifact with wide social appeal. "The Language of the Future" concerns both social and personal experiences of "future shock," the confrontation of our society with new technologies and their languages, which parallels at the level of society the "future shock" each individual experiences when confronting the reality of his or her own death. Anderson's comic nightmare preserves a paradoxical tension between social satire and a sense of personal terror, a continuous "switching" not only between kinds of discourses, genres, and media, but also a "switching" between personal and social experience.

Anderson's work includes language as one component of a multifarious art, but it is also about language, how we think about it and use it. One way, in fact, to come to terms with the relation of Anderson's art to that of her modern predecessors is to note her ambivalent attitudes towards language and the complexity of her linguistic uses. Anderson's art includes all of the linguistic pessimism traditionally associated with modernism (Sheppard). Assaulted as vigorously as in Dadaism or in Futurism, words frequently collapse into pure noise, garbled signals, high-pitched squeaks, and electronic sounds. Anderson's innovative technological devices—the tape bow violin, for instance—or the "Door and Wall Songs" actively transform spoken phrases into dissociated sound in a way that parallels the disintegrating effect of Duchamp's *Anemic Cinema* upon language. "I'm very suspicious of language," Anderson said in one interview; "it's so slippery, so slippery to seize."[15]

At the same time, a pervasive desire for communication can be traced throughout Anderson's art. While her work describes semantic and semiotic breakdowns and contains numerous parables of failed communication, as Craig Owens observes ("Sex and Language" 53), it also expresses the artist's own desire to communicate. "I feel a personal responsibility to communicate," she says, "not to make art that's so coded that people can't receive it."[16] Thus much of Anderson's language is just plain, straightforward talk, everyday colloquial speech turned to the task of storytelling. "I think of the work that I do as the most ancient in the world: storytelling," she says (Jarmusch 130), and her stories are told in the vernacular languages which her audiences speak. "The key to her American vision," writes one commentator, "is language and a vocabulary rooted in ordinary everyday speech" (*WGF*).

Neither Duchamp nor Marinetti would ever have said, as Anderson has, that "the most important thing is that people learn to talk to each other" (La Frenais 269). Nor would they have used the slangy, straight-forward, even prosaic language with which she constructs her narrative vignettes.

In "Language is a Virus from Outer Space," Anderson presents a spoof on language theories, satirizing, parodying, and poking fun at different views of language. In this piece, a rock and roll motif links a series of monologues spoken by Anderson in varied tones of voice. She playfully pokes fun at an obtuse and naive view of language: "You know I don't believe there's such a thing as the Japanese language . . . the sounds just synch up with their lips." The absurd and nightmarish vision of electronics salesmen (who sing, "Phase Lock Loop, Neurological Bonding") is a comic caricature of theorists, like Marshall McLuhan, who welcome the electronic advances which will effectively short-circuit language (McLuhan 123). Not thrilled by these possibilities offered by "Big Science and Little Men," Anderson's answer is an emphatic "NO": "You gotta count me out."

"Language is a Virus from Outer Space" also alludes to Wittgenstein in a variety of ways. Many of the arguments in *Philosophical Investigations* (concerning skepticism, solipsism, and forms of life) turn on the issue of whether or not we can know someone else is in pain; the "forms of life" argument, for instance, leads him to conclude, "If I see someone writhing in pain with evident cause, I do not think: all the same, his feelings are hidden from me" (*PI* p. 223). His picture puzzle of the rabbit-duck is presented as a huge shadow behind Anderson on the screen (Kardon 27), as she subjects the theory to a parodic distortion, a conscious impropriety. "And Geraldine said: You know, I think he's in some kind of *pain*. . . . I think it's a pain cry. And I said: If that's a pain cry, then language . . . is a virus . . . from outer space." The crossing of rock and roll and language philosophy mixes cultural codes in a way that is at once humorous and disturbing, producing a travesty directed not only at specific theories but at social and cultural categories in general. Anderson's song bears out Jencks's observation that the postmodern is organized like "a traffic accident or collision . . . more Schwitters's Merz than a cubist collage" (*Language* 118).

Throughout "Language is a Virus from Outer Space" Anderson translates language theories into parodic and dramatic vignettes, complete with eccentric character-types, each with his or her own verbal

style. This is no less true of the theory with which she is perhaps most sympathetic, Burroughs's notion of the parasitic economy described by him in *The Job*. "My basic theory," says Burroughs, "is that the written word was actually a virus that made the spoken word possible. The word has not been recognized as a virus because it has achieved a state of stable symbiosis with the host, though this symbiotic relationship is now breaking down" (12). This parasitic relation of virus/language and host/man is comically presented by Anderson as a guest/host relation in which the guest "eats all the grapes" and "takes the wallpaper samples," made even more odd by Anderson's use of electronic devices to lower her voice an octave: "I came home today, and I opened the door with my bare hands. . . ."

Anderson's allusions to varied theories of language exemplify the Conceptualist biases of her work.[17] At the same time, her use of theory is not as rigorous or as analytic, say, as Kosuth's, nor would she want it to be. Indeed, in *The Visitors* she directs some of her most pointed criticism at a Conceptual artist who is more intent on proving some linguistic theory than in actually communicating.

Similarly, in "Language is a Virus from Outer Space," Anderson mocks language theory in order to make a theoretical point. Throughout the song, she is rigorously, if humorously, exploring the effect of language upon people and their social relations. All of the vignettes in the song—and this is the crucial point—deal with the social dimension of language in some way. The McLuhanites err by willingly dispensing with language in favor of a translinguistic consciousness or electronic hookup. At the other extreme from an electronically unified sociality is the isolated individual talking in a void: "So I went to the park and I sat down and I said: Boy is this fun. I'm really having fun now. I can't remember having his much fun before." This speaker empties language of meaning, making a mockery not only of individual words, like "fun," but also of the social dimension of language in general. Although not attempting to generate a private language, the speaker is nevertheless using language privately; because of Anderson's controlled inflections and pointed repetitions this solitary speech seems equally ludicrous in this case. We might recall that one of Wittgenstein's major themes in *Philosophical Investigations* is the conventional nature of linguistic meaning, that the meaning of a word (like "pain" or "fun") does not arise from any interior feeling (although the feeling may be real enough); rather, the meaning of the word derives from its use in a given

culture with conventions of language and behavior, and coherent pat-
terns of natural fact. For Wittgenstein, the emphasis is always on the
relation of words to their use in a society rather than to some interior or
private feeling. [18]

But the social dimension of language is also a double-edged sword:
the same shared conventions and conceptual/linguistic schema which
enable communication can also become "pictures which hold us cap-
tive." Indeed Burroughs's view of language overlaps with Wittgenstein's
theory at precisely this point. What Wittgenstein calls a "false pic-
ture" Burroughs calls a "word-lock"; both cite the theory of the labeling
function of words as a prime example of a linguistic formula or "pic-
ture" which can "lock up a whole civilization for a thousand years"
(Burroughs 49; Wittgenstein, *BB* 69). [19] Burroughs's enterprise as a
whole can be viewed as an effort to assault conventional "word-locks"
and culturally defined "association blocks," a project which parallels
in its own way, the destabilization of linguistic and conceptual conven-
tions within *Philosophical Investigations* (Fig. 4.6). [20]

But for Burroughs and for Anderson, this is not a philosophical so
much as a socio-ideological activity. Burroughs says, "The word of
course is one of the most powerful instruments of control. . . . Now if
you start cutting these up and rearranging them you are breaking down
the control system" (33). The fact that Anderson's "Language is a Virus
from Outer Space" appears in the second section of *United States*, the
political section, [21] expresses her sympathy with what might be called
Burroughs's project of linguistic decontrol and ideological decentrali-
zation. Anderson's art, like Burroughs's, involves the use of creative
techniques for allowing the artist to dissociate, to manipulate, and
hence to gain more personal control over language, a language that
would otherwise "control" them ("a virus"). Both the motive and the
method of this artistic practice are closely tied to Dadaism, because
there is an effort in all cases to "cut up" and dismantle prevailing so-
ciolinguistic conventions. In Anderson's art, however, the disengage-
ment of language is always paradoxically doubled, for she sustains an
interest in everyday language even as she assaults it, and her art pro-
duces a sense of shared "forms of life" even though she satirically
mocks them.

Anderson met Burroughs in 1978 (Marincola 66), and in 1981, she
performed with Burroughs and poet John Giorno in Los Angeles (Hicks
4). His name appears conspicuously on the screen in her performances

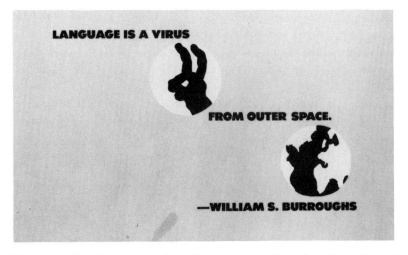

Figure 4.6. Laurie Anderson, from "Language is a Virus from Outer Space."
United States, *1984. Reprinted by permission of HarperCollins Publishers.*

of "Language is a Virus From Outer Space." In what is really a very
poignant image, Burroughs tangos through one scene with Anderson in
Home of the Brave. He narrates the "flipside," ("Sharkey's Night"), of
Anderson's "Sharkey's Day."[22] One line included in Burrough's narra-
tion (which does not appear in Anderson's text) goes: "Hey Kemosabe!
You connect the dots. . . . You pick up the pieces." It is a fitting con-
clusion (or introduction) to Anderson's work in general, because it calls
attention to the way in which her work employs Burroughs's cut-up
method and comes to the audience in "pieces." The cut-up method is
applied across media to her texts, music, and images, all of which
themselves become fragmented elements of a dynamic, multimedia
collage.

In many of Anderson's most important pieces ("O-Superman"; "So
Happy Birthday"; "Big Science") the cut-up method is combined with a
related and yet more contemporary creative procedure described by
Burroughs: "playback." Burroughs maintains that the only way to
counter the playback techniques that are used by others (personally
and politically) to control us, is through "counterrecording" and more
"playback," a procedure of repetition, manipulation, and purposeful
distortion used as a tool of analysis and aggression. The camera can be

used to play back images, as in Anderson's *Object/Objection/Objectivity*, or the tape recorder to play back language, as Burroughs describes in "The Invisible Generation" (160).

Burroughs's "playback" finds some striking parallels and ingenious variations in Anderson's original uses of tapes and recording devices. Since the late seventies, her performances have included audio palindromes (or "word droppellers") created with a "prepared" instrument,[23] used to manipulate taped words (Goldberg, *Performance* 112; Kardon 17). The tape bow modulates between nonsense and sense, and then multiplies meanings as hidden sounds and new words emerge. Convenional phrases ("Say what you mean, and mean what you say") are distorted and dismantled, their sounds and their meanings complicated to reveal that they are not really as simple as they seem.

Playback is also used in Anderson's installations; in the pseudo–phone booth *Numbers Runner* (1978), listeners become speakers and then listeners again, as they are forced to confront the words that they themselves utter. The "Door Mat Love Song" (Fig. 4.7) plays back a familiar cliché: as a door is opened and closed by the viewer, an audio head travels over a tape embedded in a doormat, producing a pointed visual pun and enough verbal dissociation to ironically deflate the cliché "You always hurt the one you love."

"I use a lot of slogans," Anderson once said, but "they are suspicious. Clichés and slogans come from a cooperative, general consensus on the world."[24] Within Anderson's art, familiar clichés function in conflicting, even contradictory ways. Although commonplace jargon, clichés, and slang allow her to communicate with her audience in a shared language, they also enable Anderson to comment critically upon the values and forms of life which that language describes and embodies. The same clichés of popular culture and mass media, through which she establishes rapport with the audience, are also cut up and used in playback processes, allowing her to disengage from the "cooperative, general consensus on the world," and, at the very least, call our attention to it.

Parody is itself a kind of playback technique, one that "reruns" or "reprocesses" another's speech with ironic and mocking distortions. It is a central stylistic strategy within *United States*, where fragments of political rhetoric ("Odd Objects"), commercial jargon ("The Stranger"), the language of cartoons ("Yankee See"), street signs ("New Jersey

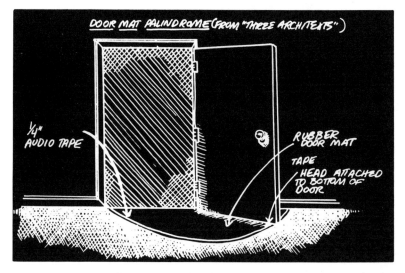

Figure 4.7. Laurie Anderson, "Diagram for Door Mat Palindrome," *1978. Courtesy of Laurie Anderson and the Institute of Contemporary Art, University of Pennsylvania.*

Turnpike"), national slogans, and popular songs are all played back and subtly mocked in new verbal and visual contexts:

Deep in the heart of darkest America,
Home of the Brave . . . Ha Ha Ha . . . You've already
paid for this. . . . ("Sharkey's Day")

Honey you're my one and only.
So pay me what you owe me. ("Example #22")

If Anderson pokes fun at social forms and institutions, she frequently directs her satire *through* the languages that people speak: the "two syllables: tops!" of TV ("Talkshow"), or the lingo of cowboy movies ("Big Science"), or the voice of the mystical prophet, Dr. J., echoed and satirized in the "prophetic" voice of her sound engineer. Just as the verbal styles of individual speakers are parodied, so the conventional performance modes of our culture (TV, lectures, sermons) and their verbal styles are replayed and "rerun" within her work ("Talkshow";

"Big Science"; "Healing Horn"), as are the verbal performances modes of other cultures ("Hey Ah"). In addition, Anderson's own performance texts are parodically reprocessed in what might be called a "meta-performative" mode: "*Hey* . . . are you talking to me . . . or are you just practicing for one of those performances of yours?" "Language is a Virus from Outer Space" concludes with a crescendo of music during which an alphabetical sequence of slang phrases is flashed in rapid-fire succession upon the screen ("T Shirt U Boat V Sign W WII X Ray Y Me"), parodying the kind of "two syllables: tops!" that enter common-place writing and everyday speech. Parody is in general a "parasitic" use of language, and hence especially appropriate for an art that presents language as a "virus."

Anderson's use of language is thus paradoxically doubled: we find both the impetus to parodically deflate and systematically disintegrate language *and* the determination to celebrate the variety and complexity of ordinary speech. One of Anderson's own slogans is "Talk Normal," a phrase that reflects back on her own verbal style and the attention it plays to commonplace speech rhythms, idiosyncrasies, slang, and slip-page. The clichés and conventions of everyday talk are re-presented and rerun with slight distortions, twists, and deformations, so that we "wake up" not only to the life we are living, as John Cage would say (12), but also to the language that we speak and hear.

Anderson's slogan "Talk Normal," however, is also subtly mocked, for her work vividly portrays the diversity of normative discourses. Craig Owens aptly observes that in Anderson's work, "language no longer exists; there are only languages, a multiplicity of different codes, dialects, idioms, and technical jargons" ("Sex and Language" 51). Despite the directness of Anderson's prose style, with its realistic portrayals of ordinary speech, her use of language is anything but simple and uncomplicated. In *United States* we hear a multitude of con-flicting, overlapping, familiar, and altogether mysterious voices: the voice, for example, of political authority ("Odd Objects"), the busi-nessman ("The Stranger"), the movies' clichéd cowboys and college students ("Big Science"), Yuppies ("New York Social Life"), and a plethora of different "average citizens" ("So Happy Birthday" "New Jersey Turnpike"). Anderson's fragments of speech represent differing and different points of view on the world, whole sets of social beliefs, values, and cultural experiences that are juxtaposed—without their

differences, tensions, and conflicts with one another resolved in any way.

While Craig Owens is correct in pointing to communications technology as the source for much of the "intersubjective deafness" that we witness throughout Anderson's work,[25] many of the failures of communication outlined within her art arise from language itself, from the multiplicity of national and social languages and the differences among them. In one comic anecdote from "New Jersey Turnpike," a whole complex network of social experience is brought to bear on the simple word "grits":

> I know this English guy who was driving around down in the South. And he stopped for breakfast one morning somewhere in Southeast Georgia. He saw "grits" on the menu. He'd never heard of grits. So he asked the waitress, "What are grits anyway?" She said "Grits are fifty." He said, "But what are they?" She said, "They're extra." He said, "Yes, I'll have the grits, please."

Here two different speakers and two different language systems collide, or slide past each other.[26] All of the voices in *United States* speak foreign languages ("Voices on Tape") or separate cultural languages that are foreign to each other. There is always an active tension between heterogeneous languages and verbo-semantic points of view, a continuous confrontation of different conceptual horizons.

The miscommunications that fill Anderson's work are expressed structurally by the strange manipulation of dialogue that occurs throughout *United States*. Despite the emphasis upon realistic speech patterns and styles, very few (if any) actual dialogues occur within this work. If people are portrayed primarily, even exclusively, as speakers, these speakers rarely, if ever, speak to each other. Dialogues are often described but never enacted in the monologues that comprise *United States*. The alternating rhythm of conversation is maintained by the two speakers of "So Happy Birthday" or "New Jersey Turnpike," but rather than talking to each other, the actors deliver a series of fragmented monologues in varied voices. The fact that the "dialogues," say, of "New York Social Life" are presented by Anderson herself in

monologue form just adds one more level of irony to this already ironic portrayal of contemporary "talk."

Within *United States* Anderson continuously gives voice to languages that are "other" to her. That she articulates or ventriloquizes "alien" discourses emphasizes her view of language in general as something alien, from the outside, "from outer space."[27] According to Bakhtin, however, this confrontation with alien discourses is an essential and inescapable fact of human linguistic experience: "It is not, after all, out of a dictionary that the speaker gets his words! . . . but rather [the word] exists in other people's mouths, in other people's contexts, serving other people's intentions: it is from there that one must take the word, and make it one's own" (294). To Bakhtin, this encounter with the discourses of others is the basis for nothing less than ideological consciousness itself (295; 345–58). An author's objective is not so much to take an ideological position (although he/she might, as he says, be biased [314]), but through heteroglossia to foreground the alternative choices involved in selecting a language or ideology of one's own.

Anderson's *O-Superman*, I think, sustains just such verbo-ideological tensions in an "unresolved dialogism." In addition to being a hybrid artistic form, it is also a "semantic hybrid" in which a number of different sociolinguistic perspectives "come together to fight it out on the territory of the utterance" (Bakhtin 360).[28] As in *United States* as a whole, varied languages or socio-ideological systems are condensed into brief utterances[29]—"Smoking or non-smoking?" "Look! They're American planes, made in America!"—which are juxtaposed without being resolved. Brief fragments of speech not only come from but also represent widely divergent social, political, and axiological systems. Anderson positions herself amidst these conflicting verbal messages, ostensibly left on her tape machine, and she attempts to locate their sources ("OK—Who is this really?") and to locate her own position in relation to them. Like the fictional situation which it describes, *O-Superman* actually does "play back" diverse and contradictory socio-ideological messages.

What we witness in *O-Superman*, and in *United States* as a whole is ideology as process: "consciousness awakens to independent ideological life," says Bakhtin, "precisely in a world of alien discourses. . . . A variety of alien voices enter into the struggle for influence within an individual's consciousness (just as they struggle with one another in the

surrounding social reality)" (8, 341, 345). Anderson's work presents precisely this intense struggle with "alien languages," languages and attitudes (about language) that "pull at each other" in oppositional ways.

The voice is an appropriate medium for this art of unresolved dialogical relations between languages, ideologies, sexes, and media, for as Regis Durand says, "The voice goes back and forth: a go-between, an intermediary. A transmitter that makes dual, dialectical relations possible, on all levels. . . . In-between, because it can only be defined as the relationship, the distance, the articulation between subject and object, the object and the Other, the subject and the Other" (102). [30]

This exploration of voice, moreover, links Anderson's work to prevailing trends in contemporary literature. All of the voices in *United States* are cut off from their sources, disengaged from characters and characterization, in a way that parallels major trends in contemporary fiction described by Barthes as follows:

> By bringing the whole narrative down to the sole instance of the discourse—or, if one prefers to the locutionary act—it is the very content of the person which is threatened: the psychological person . . . bears no relation to the linguistic person, the latter never defined by states of mind, intentions or traits of character but only by its (coded) place in discourse. It is this formal person that writers today are attempting to speak and such an attempt represents an important subversion. . . . (*Image-Music-Text* 113–14)

In *United States*, Anderson does not use language to generate characters or to represent people; indeed the reverse is the case, her "people" are simply voices who stand for and represent different kinds of language.

In this respect Anderson's *United States* is comparable to other examples of contemporary literature—David Antin's talk poems, Nathalie Sarraute's *The Use of Speech*, or Sam Shepard's *Tongues*—in which the linguistic person replaces the psychological one, [31] in which characters stand for modes of discourse. In Antin's *Tuning* and Sarraute's *The Use of Speech*, as in Anderson's *United States*, there is an emphasis upon language barriers, an inability of speakers to communicate across national or axiological boundaries. Speech is foregrounded

in the prose monologues of Sarraute, as it is in the Performance modes of Anderson, Antin, and Shepard. Anderson, like Shepard, combines verbal with "musical" forms and presents a variety of different social voices edged next to each other. In all of these cases, human speech predominates. Ironically, however, the mode of presentation is monologic, and serves as a fitting commentary on the limits of dialogue that is one thematic element of these very distinct works. Everyday and commonplace "talk," ordinary language, is a dominant aspect of their verbal style. If the authors all draw limits on the range of possibilities for communication and share to some extent modernism's linguistic pessimism, they nevertheless take everyday language as a basis for a literary style, a style that moves through the most prosaic of discourses to language loaded with poetic power. All of these works "have to do with the voice. . . . Voices traveling. Voices becoming other voices" (Shepard 300). These works, all of which toy with the relation of dialogue and monologue, all of which skew the boundaries of the disciplines in which they appear, and all of which employ simple and accessible words in prosaic, everyday language, all present language as voice, as "discourse," as a "social phenomenon—social throughout its entire range and in each and every of its factors" (Bakhtin 259). "The voice is [presented as] an in-between . . . the distance, the articulation between subject and object . . . the subject and the Other."

Moreover, in *United States*, the voice also purposely confuses the self and the Other, for the real sources of speech are always uncertain; we hear "their" words in Anderson's mouth, "her" words in "theirs," without ever, finally, being able to disentangle them from one another. When Anderson's self-referencing and self-revelation seem to be the strongest, as in "The Language of the Future" or "Yankee See," she alters her voice into the lower registers of the male speaker. The use of "actors" and electronic devices facilitate these strategies of self-diffraction, the multiplication and confusion of "vocal selves."[32] This diffraction and decentering of the "self" parallels the decentering of artistic modes and categories within *United States* and both are characteristic features of postmodernism in the arts (Foster, *Recodings* 130).

The social dimension of Anderson's work, then, is expressed not merely in its accessibility, but also in the attention paid to the social dimension and dynamics of language. The preoccupation with voice itself emphasizes the "exterior deployment"[33] of language, and the art's purposeful confusion between the voice of the self and the voice of the

Figure 4.8. Laurie Anderson, from "Frames for the Pictures." United States, *1984. Reprinted by permission of HarperCollins Publishers.*

other, the story of the self and the story of others further confuses and binds the self and society. In addition, the artist's use of dreams and dream processes can be related to the confusion of self and other, the "switching" between personal and social experience which occurs throughout *United States*.

A dream style pervades Anderson's work as a whole. There is a continuous distortion of physical sizes, from the miniature figure of *At the Shrink's* to the gigantic images Anderson presents on the film screen. A Surrealistic style is further created by the continuous displacement of ordinary functions of objects, the body used as a percussive instrument, the violin bow used as a pointer, a neon light, a record player (Viophonograph), and a "bow" and arrow ("It's Not the Bullet"). "Sharkey's Day" begins: "Sharkey wakes up and Sharkey says, if only I could remember these dreams, strange dreams, I know they're trying to tell me something." *United States* also "reruns" dream-texts from *Dark Dogs: American Dreams*, cut up and expressed by different voices in new and unusual contexts ("Big Science"; "Lighting Out for the Territories"). Anderson's reprocessing and replaying of texts is itself related to

Figure 4.9. Laurie Anderson, from "Frames for the Pictures." United States, *1984. Reprinted by permission of HarperCollins Publishers.*

dreaming, which reruns the familiar with strange distortions. One sequence in *United States* reruns narratives from *Dark Dogs: American Dreams* intercut with images that link the textual style to dreaming: the word "RERUN" is superimposed over a gigantic pillow (Figs. 4.8, 4.9). This technique also accentuates and heightens the ambiguity concerning the sources of Anderson's texts. We never know whether the dreams were told to Anderson by other people, or if they were Anderson's dreams or Anderson's fictions. Finally, *United States* as a whole concludes with a rerun of the opening sequence "Say Hello" in which Anderson, now wearing bizarre headlight goggles (Fig. 4.10), adds a new line: "You can do this in your sleep."

In his essay "Painting and *Surrealism and Painting*," Marcelin Pleynet criticizes Surrealism for not responding responsibly enough to Freudian theories. He quotes Freud's answer to Breton: "A collection of dreams, *without their associations and without knowledge of the circumstances* in which they took place, means absolutely nothing to me" (44). Anderson's work is very much in the Surrealistic tradition, especially since it presents a collection of dreams "without their associations and without knowledge of the circumstances in which they took place." We

Figure 4.10. Laurie Anderson, from "Lighting Out for the Territories." United States, *1984. Copyright © Allan Tannenbaum.*

might well ask what purposes the dreams serve, since they are presented by Anderson not only without their associations but often without clear human sources as well.

One might argue that *United States* presents unconscious material not as intrapsychic but as interpersonal. Dream texts are wrested from individual people and diffracted and refracted by different voices. At the same time, dreams themselves are comprised of pop culture's banalities (Dairy Queen), stars (Jerry Lewis, Jane Fonda), personalities (Hitchcock), rhetoric ("democratic") and jargons ("structuralist filmmaker").[34] In *United States*, cultural debris litters the psychic landscape. Because of the way it manipulates and confuses popular culture and personal dream, Anderson's work might be viewed in relation to the social dimension of the unconscious proposed in Lacan's theories.[35] Within Anderson's work, dreams are presented not by a singular personality but through a social fabric comprised of different speakers. With its overtly Surrealistic style, *United States* as a whole becomes a kind of dream ("you can do this in your sleep"), a shifting, violently

Figure 4.11. Laurie Anderson, from United States, *1984. Courtesy of Laurie Anderson and the Institute of Contemporary Art, University of Pennsylvania.*

comic *collective* dream filled with distortions and displacements, ellipses, and ambiguities.

Thus Anderson's is a predominantly social art, social in much more profound ways than the obvious shift of the artist towards the audience as entertainer. Her art reflects larger cultural trends and finds parallels in those contemporary theories that are also rethinking the social dynamics of language (as "discourse," for instance, in Benveniste, Bakhtin, and Kristeva)[36] and the social dimension of the unconscious as well (Lacan). Anderson's work marks a renewed commercialism in art. But it also paradoxically suggests that there is an ethical component to this postmodern style: the continuous oscillations and confusions of languages, codes, and media counter political, verbal/visual, and sexual hierarchies, precluding any hegemonic relation among the nations, the sexes, and the arts. The heterogeneity of such a style and its heteroglossia does not assume a commonality of languages or values, but it does speak many languages, and therefore speaks to many people in a democratic impulse of some significance in the development of the arts. The new avant-garde is intent, as Umberto Eco says, on "reaching a vast audience . . . capturing readers' dreams." And this, he continues, "does not necessarily mean encouraging escape; it can also mean haunting them" (72).

The continuous alterity of Anderson's art, the way in which it oscillates between at least two and often more languages, voices, ideological positions, genders, and media constitutes a style that can be viewed as paradigmatic for postmodernism as a whole. The conceptual "flickering" of Wittgenstein's picture puzzle may serve as an apt emblem for postmodern interdisciplinary art. We might keep it in mind, not only as we consider the sensory switching of Anderson's art, but as we continue to explore the conceptual and disciplinary switching that some works of postmodernism require of us (Fig. 4.11).

"POSITIVE DISINTEGRATIONS"
5
Working Language into the 1990s

V isual artists, Performance artists, poets, novelists, and drama-
tists of the postmodern period all continue to foreground lan-
guage in their work. This is the period in which the major
innovations in poetry are produced by the L=A=N=G=U=A=G=E
poets, (a tautology if ever there was one). Mac Wellman, David Ives,
and Len Jenkin all produce a drama with words "at center stage," as
Mel Gussow has observed.[1] Walter Abish's *Alphabetical Africa* is not
literally but letterally about a fictive Africa and the alphabet used to
construct and deconstruct it. John Jesurun produces a performance
piece in which shards of language are hurled at the audience. Anselm
Kiefer, Joseph Beuys, Jenny Holzer, Barbara Kruger, Marcel Brood-
thaers, and Jonathan Borofsky are just a few of the visual artists whose
work is comprised of verbal signs. This art exemplifies that which is
most prevalent in our culture as we enter the last decade of the century:
there is throughout a preoccupation with and serious investigation of
the nature and meaning of language.

But are all works that treat language therefore interesting and worthy
of our attention? Take, for example, the case of Jenny Holzer. Her early
work *Truisms* is a sequence of mock clichés or contrived platitudes dis-
seminated into the environment. Her "art," like that of Kosuth, is com-
prised of scattered linguistic signs, so that the interest rests in the
various contexts in which her signs appear. Like Kosuth, too, Holzer
rejects the notion of *la patte*, or the artist's hand, as she uses commer-
cially manufactured signs and electronic signboards to present her
phrases within a public forum. While Kosuth appropriates his texts
(from dictionaries, for instance), Holzer generates her own.

But one wonders, given the fact that Holzer's work is so indebted to
the pop tradition, if she has changed the "language of art" in any signif-
icant way. Moreover, if her texts are "original," they have a peculiar

status in relation to the cultural clichés they purportedly parody. Some-
times a deadpan humor or subtle irony is detected in the *Truisms*:

A NAME MEANS A LOT JUST BY ITSELF
AWFUL PUNISHMENT AWAITS REALLY BAD PEOPLE
CHANGE IS VALUABLE WHEN THE OPPRESSED BECOME
TYRANTS

But more often, the *Truisms* are just familiar cultural clichés:

A SINCERE EFFORT IS ALL YOU CAN ASK
A SOLID HOME BASE BUILDS A SENSE OF SELF
ALL THINGS ARE DELICATELY INTERCONNECTED

The *Truisms* are like *New Yorker* cartoons without the pictures to tell us
how to read them. The short sentences stand alone, with all of their
ambiguity and contradiction:

CHILDREN ARE THE MOST CRUEL OF ALL
CHILDREN ARE THE HOPE OF THE FUTURE

Or ponder: ***"BAD INTENTIONS CAN YIELD GOOD RESULTS."***
These are fortune-cookie aphorisms that intrigue for a passing moment.

For all of its use of language, the real message of Holzer's work con-
cerns the media, the electronic display boards and digital units that
empty language of any stable "meaning." Her work imitates not nature
(Cage) but culture in its manner of operation. Transformed into pop
signs throughout our culture, linguistic meaning "implodes" (to use
Jean Baudrillard's phrase for the disintegration of the signified beneath
the signifier). One could argue that Holzer is using Baudrillard's tactic
of strategic resistance to the dominant discourse system, by simulating
"in a hyper-conformist manner the very mechanisms of the sys-
tem . . . turning the system's logic back on itself by duplicating it, re-
flecting meaning, as in a mirror, without absorbing it."[2] But, one might
ask of Baudrillard and Holzer, is this enough? Are the silent masses—
and their artists—destined to merely repeat the implosion of meaning
that pervades contemporary culture? And can "hyper-conformism" in
fact work as a form of resistance? If, in the "Survival Series," Holzer
writes, ***"USE WHAT IS DOMINANT IN A CULTURE TO***

CHANGE IT QUICKLY," it becomes clear that she is "using what is dominant" in our culture in order to mirror it, and that mirroring is a doubtful form of change at best.

Jonathan Borofsky's energetic multimedia installations present a much more compelling use of language in art. Like Holzer, Borofsky began as a conceptual artist. *Counting from One to Infinity* is a column of papers comprised of his lengthy counting activity. Of this "work" he said, "It was the cleanest, most direct exercise that I could do that still had a mind-to-hand-to-pencil-to paper event occurring. It was very linear and very conceptual" (Rosenthal and Marshall 33). Since that time, Borofsky has generated a unique and distinctive style of installation. Canvases appear on the floor, on the ceiling, upside down, and tilted. Huge images and texts are painted directly on the walls. The entire space is energized and filled with vitality. There may be a Ping-Pong table or a basketball court included in the area. Coke machines, videotapes, sculptures, strobes, street sounds, TVs, and leaflets littering the floor may all be included in this multimedia extravaganza.

Borofsky's dream texts are the basis for much of his visual imagery.[3] "I dreamed I could fly" becomes *The Flying Figure*, expressing Borofsky's desire to get an "overview of the larger issues" (Rosenthal and Marshall 160–61). "I dreamed I found a red ruby" inspires the imagery of red rubies that appears throughout his installations and which becomes associated by the artist with the heart and beauty. "I dreamed a dog was walking a tightrope" is the source for numerous ingenious drawings. Borofsky recognizes that he is every figure in his dreams. "I seem to be every character," he says, "the victim as well as the oppressor" (Rosenthal and Marshall 66). Despite the personal nature of the texts, they have public appeal and concern social issues: "I dreamed that some Hitler-type person was not allowing everyone to roller-skate in public places. . . ." (Fig. 5.1). How does one live in a post-Holocaust age? Borofsky seems to imply the question throughout his texts, in his obsessive numbering of objects and images, and in *Running Man*, painted on the Berlin Wall in 1982. "It's me," says Borofsky, "but it's also humanity looking back with anxiety . . . being chased by a person, my past, Hitler, whatever."

Many of Borofsky's dreams are simply funny. "I dreamed I was taller than Picasso" shows his triumph over a powerful precursor—at least in a dream. Consider the following text: "I dreamed my model for the universe was much better after I removed 3 cylinders . . . from the top"

I dreamed that some Hitler-type person was not allowing everyone to roller-skate in public places. I decided to assasinate him, but I was informed by my friend that Hitler had been dead a long time and if I wanted to change anything, I should go into politics. This seemed like a good idea since I was tired of making art and was wondering what to do with the last half of my life

2454568

Figure 5.1. Jonathan Borofsky, "I dreamed that some Hitler-type person. . . ." Courtesy of Jonathan Borofsky and Isshi Press/Watari-Um.

(Fig. 5.2). However humorous, the text reveals Borofsky's desire to get his model of the universe right, or to make the universe better. His sensitivity to political and social issues expresses this sensibility as well. His famous *Hammering Man* (sometimes 24 feet in height) works verbally and visually as it calls attention to the status of the worker in contemporary society. Sometimes painted with the word "strike" on it, the arm hammers mechanically and monotonously, perhaps like a worker on an assembly line. The word "strike," Borofsky reminds us, is a pun with diametrically opposed meanings; to strike is to hit and also to stop working, to act aggressively and also to stop acting. A third level of meaning suggested by the artist is the striking Polish workers and the Russians striking the Poles with blows (Rosenthal and Marshall 171). The monotony of the mechanical action recalls the monotony of everyday jobs that are "essential but lack glamour and financial support."

Borofsky's Ping-Pong table is even more pointedly political. Here it is the text surrounding the very real object that generates meaning. Sometimes painted on the walls next to the Ping-Pong table, and sometimes painted directly on the table, are the Cold War defense budgets

I dreamed my model for the universe was much better after I removed 3 cylinders (each made of 3 layers of construction board) from on top.

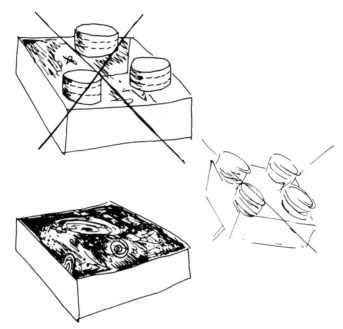

Figure 5.2. Jonathan Borofsky, "I dreamed my model for the universe. . . ."
Courtesy of Jonathan Borofsky and Isshi Press/Watari-Um.

for the U.S.S.R. and the United States. Hanging over the table is a sign that reads: "Feel free to play." Again, Borofsky's language has contradictory meanings; he describes the ambiguity this way: "Can you feel free to play on this planet when the arms race is going on around you?" and "You are welcome to play in this museum today" (Rosenthal and Marshall 146). Many spectators *do* play at the Ping-Pong table, becoming participants in an art designed to provoke and activate them. In it-

self the Ping-Pong table embodies the mixing of media that typifies Borofsky's work. He has said, "The Ping-Pong table is everything: installation, content, sculpture, painting, sound, and participating piece. It's an ultimate work for me" (Rosenthal and Marshall 146). Given the mixed-media nature of individual pieces and the installations as a whole, Henry Sayre is correct in arguing for the interdisciplinary nature of Borofsky's art.[4] If Borofsky's work attests to anything, it is to the theatricalization of the visual arts, as we witness the museum becoming a mixed-media theater. The artist has said, "I was making almost a three-dimensional theater set, but not for people to view from their seats; they walked into it" (Rosenthal and Marshall 141).

The prevalent use of language by visual artists outlined within this study is merely the most blatant example of what is now a cross-cultural phenomenon. Even the traditional theater is witnessing a new trend that foregrounds language in the work of such writers as Mac Wellman, David Ives, and Len Jenkin. The drama of Mac Wellman stands as the most extreme example of a theater stripped of all features except for language. His monologue *Terminal Hip*, played in New York by Stephen Mellor (January 1990), received rave reviews despite the willful obscurity of much of the text (Fig. 5.3).[5]

> Anyone can understand this, right?
> Anybody with half a brain can trot the trot.
> Any damn fool can winterize the octagon.
> Any bojar walloon can strip the pentagon
> of its fluffy stuff and egg the wax. . . .

"Anyone can understand this, right?" Hardly. Wellman is being purposely difficult and obscure:

> Strange the Y all bent up and dented.
> Blew the who to tragic eightball.
> Eightball trumpet earwax and so forth.
> Pure chew, loud thump and release pin.
> Grabity gotta nail him too sure.

Terminal Hip is in part about its own impenetrability, the difficulty of deciphering these linguistic signs:

Figure 5.3. From Mac Wellman's Terminal Hip, *with Stephen Mellor, New York, January 1990. Courtesy Mac Wellman. Photo copyright © Dona Ann McAdams, New York City.*

> Men like signs. Signs make sense of things.
> Anyone can understand signs, right?
> Anyone can up down when the
> sign says up down.

For most of the performance, it is almost impossible to understand Wellman's signs, let alone follow them ("up down").

And yet, we would do well to remember that Wellman is as much a Language Poet as he is a playwright, and that in 1977, he published *Breathing Space*, the first American anthology of sound-art text. Like much sound and Lettrist poetry, Wellman's text plays upon the relation of sense and nonsense, meaning and meaninglessness. When *Terminal Hip* is published, it will appear in poetic form. Further, there are a number of literary echoes within the piece. The excessive alliteration and odd syntax of the following lines recall Gertrude Stein:

> Nine of spades, what waterway tours the
> black heart crispy like and crepes cake?

Like Edward Dorn in *Gunslinger,* Wellman toys with the whole notion of a coherent "I": "'I' flies to Mexico to seek grotesque food." Like Pynchon, he fabricates absurd names: "Bogus Stilton cheese revives . . . waxes the Studebaker, arms the wrong insurrection, posts no bills, panfries rebop, mumbos jumbo. . . ." The most pervasive literary connection is probably to the energized language of Ginsberg's *Howl,* and *Terminal Hip* offers its own version of Moloch:

Momotum woofs down ungodly ballot boxes in the name of Y.
Momotum's the necessary crock, it moonrakes shuttle's embers, staffs
 the handjobs, pats our brown brothers, paints the town red, greases
 the uncubed and dusky part of the world, loses radicals their jobs,
 maintains the upbeat, though a little off.
If offs the longterm for the shortfall, X in the same old name of Y,
 whye, O whye.

We get carried away by the momentum (Momotum) of Wellman's language, as it describes the momentum of progress responsible for the Challenger disaster ("shuttle's embers") and the false valuing of short-term profits ("the shortfall") over long-term goals. But if Ginsberg's experience and personality organize the disparate imagery of *Howl,* we have no such locus of perception and organization here. Wellman explodes the "I" with a pop:

 "I" pops and charges disaster
 "I" pops and bears the foregone conclusion to a guilty grave.
 "I" barfs, bellows, curses the light and croaks. . . .

Not "I," but language speaks this bop apocalypse.

Although playing on the relation of sense and nonsense, *Terminal Hip* is not without meaning. The media, for example, seem to be a central subject:

 Peep down the daynight tube horror horror.
 On TV airs the hogfarm snapshots.
 On TV pears glide in hokey glue and pop up all tipped over.

Conrad's "The horror! The horror!" is what we see not when we look deep in ourselves but when we face the TV, with all of its mundane

("hogfarm snapshots") and quirky imagery ("pears glide in hokey glue"). Mark Poster has brilliantly argued for the effect of contemporary media and computer technology on our sense of language, arguing that we inhabit a new linguistic space because of the new "mode of information" that this technology creates.[6] Perhaps the very dissociated quality of Wellman's text reflects the new linguistic experience of our time, with all of its "momentum," disconnection, and fragmentation.

In her review of *Terminal Hip*, Alisa Solomon suggests that "Wellman is word processor as Cuisinart, chopping clauses, grating grammar, pureeing parallelism into a 'strange salad' just for the fun of dissing discourse."[7] Perhaps so. Pleasure is vital to the kind of writing Wellman is producing. But the linguistic dissociation may also have more serious implications than Solomon acknowledges. One of the subjects of *Terminal Hip* is the Cold War: "Xerox your face, cold war America," and blacklisting is a recurrent theme: "To blacklist brothers and sisters and feathers/until what steam, from what vent, loops the loop." Wellman forces us to consider the devastation that a cold war mentality might produce:

> . . . refry
> tomorrow in today's name . . .
> till the balled
> up orange blast clocks you good, all aero-
> spaced, to smithereens wafting, seven miles
> above the vast encrudded seascape O.

Language is here blasted to smithereens. Wellman is thinking the end of mankind and enacting the end of language. It's as though the bomb has already exploded ("terminal hip"), and what we are witnessing is just so much linguistic fallout.

An equally original and provocative use of language appears in John Jesurun's theater/media piece "Everything That Rises Must Converge."[8] Again, language seems to be a central subject in a drama divested of all theatrical conventions. For this piece, Jesurun divides the audience and the stage in half, separated by a central wall with five actors and actresses on each side. Above the wall perch five video monitors, which are the audience's only access to the action behind the wall (Fig. 5.4). Four video cameras focus on the actors in order to relay information from one side of the stage to the other. For much of the per-

Figure 5.4. From John Jesurun's "Everything That Rises Must Converge." Courtesy John Jesurun. Photo copyright © 1990 Paula Court.

formance, the central monitor pictures the media apparatus itself, projected from a rotating camera overhead.

The language in this work, which comes to the audience in fastpaced fragments, is disjointed and jumbled. It is filled with incessant non-sequiturs, as the speakers only briefly communicate with each other:

J: He won't live without you.
S: He is clandestine, reckless, provocative
M: You have a cold.
L: We have prepared the menu.
S: How are you?
L: What a smile. It's profound, violent, unraveling me.
J: Get ready for the abduction, the abdication, the seduction.
L: I'm well prepared.
M: I don't approve.

The dialogue and the stage set produce a communications short circuit; the same video technology designed to effect communication also impedes it. "Everything that Rises Must Converge" is a visible manifestation of Baudrillard's claim that the media "implode" meaning.

Within the piece, information gets "spun through codes" and purposely obfuscated by the characters and by the technology "mediating" between them:

P: Prepare for re-entry and send this.
L: What about the 1230 feed?
K: Send it without an answer as if we never read it
O: Why would we do that? . . .
S: It is precisely because it doesn't mean anything that they will imagine it does and become confused.

Messages get translated and repeated so that the same phrase echoes six or seven times in different languages, but no definitive communication occurs among the speakers or with the audience:

P: But the rest of the message is unclear.
J: Not so clear. Some kind of syntactics going on.
S: Oh my dear, not again. I cannot bear it.
L: Call in the theoretician.

Perhaps it would take a theoretician to unravel Jesurun's "syntactics." The "plot" of "Everything that Rises Must Converge" remains indeterminate and uncertain. Two opposed imperialistic superpowers are interfacing with each other. On one level they are futuristic space powers ("prepare for re-entry") familiar with an advanced technology and its lingo ("Resignify the feedback"). At the same time, they stand for the U.S.S.R. and America, the two superpowers that organize our lived experience. In addition, the language of domination and submission, conquest and discovery distinctly recalls Christopher Columbus and imperial Spain:

O: I hope in some measure to convey to your majesty not merely a report of positions and distances, flora and fauna, but of the customs of the numerous barbarous people I talked with and dwelt among. . . .
J: Since this narrative in my opinion, is of no trivial value for those who go in your name to subdue those countries and bring them to a knowledge of the true word and bring them under the imperial dominion. . . .

On each side of the wall is a monarch, one male and one female. "Her Highness" is in charge of a crumbling empire ("Do I have to sit here and smell my empire rotting?"). One imperialistic expedition has failed miserably, and the only survivor is a figure named "Lagrimas."

But like the language used to convey it, this plot "slips" into others, as when a strange detective search for a killer is interrupted by a discussion of "painkillers." Indeed semantic slippage controls the plot, which shifts with the meanings of individual words:

P: Her lovely blue coat was open and her white batiste dress revealed a small hole ringed with black and barely encrusted blood.
O: (translation)
S: We're not talking about the bullet hole
L: We're talking about the budget
K: There is a hole in the budget. . . .

Similarly, the cliché "harboring a secret" is narrativized and becomes part of the plot:

O: I want the body of Cabrito and your eye in that order and then I want the identity of the secret harbor where you have been harboring a secret army.

In addition to the continuous puns, translations, repetitions, and non-sequiturs, the text includes numerous inverted clichés ("A death worse than fate"; "Let me put you out of your mystery"). If the speakers are experiencing a "communication crack-up," so, too, is the audience.

The "plot" of the piece takes yet another turn when the stage set is spun around, leaving the two monarchs lying on platforms and talking to each other through the wall. In Jesurun's script, the section is titled "Pillow Talk," suggesting a muted love relation between these rival and antagonistic rulers. The key word of the conversation is "turn." Her highness is waiting for her pillow of nails to "turn" soft. She wonders when her present enemy "turned against" her ("When was it that you turned?"). The stage set has just "turned," and the camera above the action turns around as well. Clearly, a parallel is being drawn between countries and individuals turning against one another. The political, personal, and even sexual levels are neatly confused, as one of the characters concludes: "We've finished together, side by side, a

tie, a stalemate . . . a sort of bilateral plundering to the point of satisfaction." And this is perhaps Jesurun's main point: the political rivals, with all of their clandestine operations and communications, are effectively equal, two sides of the same coin, two sides of the same stage, enacting the same drama. "What are they doing?" one character asks. The answer: "The same thing we are."

Thus Jesurun and Wellman, along with other postmodern writers, succeed in conveying meaning despite the fragmentation and dissocia- tion of their verbal styles. The linguistic distortions serve different thematic purposes in their work, but in both cases a strange sort of "syntactics" takes place. Both could be accused of producing "schizo- phrenic" writing of the sort Fredric Jameson criticized in his essay "Postmodernism, or the Cultural Logic of Late Capitalism."[9] In this es- say Jameson used the term "schizophrenic discourse" to disparage the Language Poets and their emphasis on the materiality of the linguistic signifier. Within this kind of writing there is "a breakdown in the sig- nifying chain" so that coherent subjectivity and identity are called into question. But, as George Hartley observes in his rebuttal to Jameson, "There is a world of difference between the schizophrenic's *inability* to get beyond the material signifier and the artist's deliberate reduction to one . . ." (47).[10] What we have in Language Poetry is not "free-floating signifiers with little or no connection to the 'real world'" (Hartley 48), but an emphasis upon the material quality of language in such a way that the social dimension and constitution of language is stressed. Moreover, as Hartley's reading of "China" (by Bob Perelman) shows, Language writing does not subvert but generate meaning, as does the writing of Wellman, Jesurun, and other writers stylistically allied to Language Poetry. Steve McCaffery's description of "Sound Poetry" ap- plies to Jesurun, Wellman, and Language poetry as a whole:

> Personal collapse into flux. Dilations. Positive disintegra-
> tions. Structures abandoned, departed from or deconstruc-
> ted and modified into flows. . . .[11]

The literary influences upon the Language Poets have already been well documented (Dickinson, Stein, Williams, Breton, Tzara, Ash- bery, and Zukofsky). Especially interesting is the close tie between Language poetry and Conceptual art. Hannah Weiner, a Language

Poet, was at one time a Conceptual artist. Bruce Andrews and Charles Bernstein include a piece by Conceptual artist Lawrence Weiner in their important $L=A=N=G=U=A=G=E$ *Book* (1984). In his study of the Language Poets, Hartley discusses the influence of Robert Smithson upon them (89–92). More specifically, Steve McCaffery's "A State of Mind" (1978) includes numerous satires on Wordsworth, many of which rely on the Conceptual style of "scripting."[12] Here, for example, is "Wordsworth: A Performance Transform":

> Enter the cottage in mid-May.
> Go out through the back door into the garden.
> For each daffodil you find, pluck it & replace it with
> its dictionary definition. . . .

Then follows one dictionary definition of "daffodil." The imperative style combined with the emphasis on definitions distinctly recalls Conceptual art, and not surprisingly, language has replaced nature as the subject of poetry. What the Language Poets share with the Conceptualists is an acute sense of the materiality of language. "Being itself (language) a material one is then able to work generally with rather specific materials," writes Weiner.[13] Furthermore, like many of the Conceptual artists, the poets are deeply influenced by the philosophy of Ludwig Wittgenstein. Wittgenstein is the subject of Charles Bernstein's essay "The Objects of Meaning: Reading Cavell Reading Wittgenstein,"[14] and the influence of the philosopher can be found throughout Steve McCaffery's volume of poetry, *Evoba: The Investigations Meditations 1976–78*.

> Language is a labyrinth of paths. You approach from one
> side and know your way about; you approach the same
> place from another side and no longer know your way
> about. (*PI* 82e, 203; *Evoba* 53)

Direct quotations from *Philosophical Investigations* appear throughout *Evoba* and separate its various segments. McCaffery's text itself enacts the labyrinthian quality of language described by Wittgenstein. *Philosophical Investigations* is not only quoted but invoked in varied ways throughout the poems:

> I am here
> in a common space/face:
> a (visual) reality behind
> the chin's particular temptation
> to think this is a chain
> of occult peculiar connections
> I in the eye of
> 'I have pains'. . . . (47)

Relying more upon the sound of words than semantics, McCaffery's language slips—from "space" to "face," from "chin" to "chain," from "I" to "eye." The poet compounds allusions: Wittgenstein discusses "pain" at length in *Philosophical Investigations* (246, 272, 288, 293, 303–304), and the reference to language as (appearing to be) an occult phenomenon is described in *The Blue Book* (5). When McCaffery writes, "every line by *itself* seems dead . . . /alive/in this use. . . ." (43), he is alluding to Wittgenstein's idea of use: "Every sign *by itself* seems dead. *What* gives it life?—In use it is *alive*. . . ." (*PI* 432). The allusions to Wittgenstein are incessant within *Evoba*. The title itself derives from Wittgenstein's discussion of reading, more specifically the case of reading "ABOVE" backward (*PI* 160). "He puts his hand on her head to prove how tall she is" (28) is McCaffery's version of Wittgenstein's humorous conception: "Imagine someone saying: 'But I know how tall I am!' and laying his hand on top of his head to prove it" (*PI* 279). "How can he know what it is/to continue . . . algebra, intuition. . . ?" asks McCaffery, echoing Wittgenstein's concern for the teaching of math and language and, finally, knowing how to "go on" (*PI* 179–80). "If a lion could talk," writes McCaffery (81), referring to Wittgenstein's observation that "we could not understand him" (*PI* 223). Seeing "someone writhing in pain with evident cause" is a phrase that McCaffery (17) takes directly from *Philosophical Investigations* (*PI* 223).

Well, what does all of this "use" of Wittgenstein mean? And how does this use of language philosophy shape the poetry? First of all, the collaging of one text with another is typical of the Language Poets; like Perelman's "China," *Evoba* is intertextual. As such, it suggests that "words are never our own," as Ron Silliman puts it; "language is one strategic part of the total social fact."[15] More importantly, many of the references to Wittgenstein point out the social and exterior nature of meaning rather than what has traditionally been associated with poetry,

namely interiority and private experience. Wittgenstein's lengthy discussion of pain reminds us that the inner process is not what gives words like "pain" or "remember" their meaning (*PI* 304–305): "The impression that we wanted to deny something arises from our setting our faces against the picture of the 'inner process'" (*PI* 305). Now consider part of *Evoba*:

> the paradox, the passion
> the inhibition &
> the panic
> an inner process taking place
> so:
> > what difference could be greater?
> to imagine the *private*
> > > exhibition
> looks/as
> > > if we had denied them

In Wittgenstein's theory, the purely private experience, the beetle in the box, for instance (*PI* 293), simply cancels out.[16] Like Wittgenstein, the Language Poets stress meaning as an "exterior" rather than "interior" process, and this has a number of technical and stylistic implications.

First of all, there is no persona, no lyric "I" or controlling consciousness that organizes the verbal flow of *Evoba*. The emphasis is on the transformations of meaning that occur in the surface of words:

> S to the side of an old wall sees
> G appear inside a doorway offering drinks to friends
>
> eyes (he said 'e' she said 'yes')
> with ears appears to be teas and occurs
>
> to posit voices in position (55)

"Posit" becomes "posit/ion," "eyes" becomes "e/yes" and the long "e" sound is repeated insistently in "appears," and "teas" before it changes to "occurs." Letters ("S"; "G") and phonemes orchestrate a continuous semantic flux, as in the following:

```
what is
as is            is        ais
o        as        is    (52)
```

Despite the repetition of the words "as is," the meaning shifts from "what is" to "oasis." *Evoba* is filled with all of the syntactic and semantic indeterminacy that has come to be associated with Language writing. It explores the conditions of meaning by working language at its (semantic) limits. It is filled with incomplete statements and disjunctive syntax, replete instead with metonymic gaps. Referential meaning is undercut, as the words do not point to a "real world" outside of themselves. "Does she know/what she has?" writes McCaffery in one poem, "or how her meaning moves to mean/to not refer?" (27). In his "Intraview," McCaffery explains, "Kicking out reference from the word (and from performance) is to kick its most treasured and defended contradiction: the logic of passage."[17]

But how, then, does this non-referential poetry sustain interest? A close analysis of just one section in *Evoba* will help to illustrate the intriguing possibilities of Language writing (67–69). The passage begins:

> Beyond the door
> to your door
>
> is my door his
> & theirs
>
> on the stairs
> but above the entrance
>
> (possibly)
>
> the word is clouds
> with beyond it
> clouds beyond
>
> the order of
> empirical observation.

The opening image has all the unreality of a Surrealistic painting by de Chirico or Dali or Magritte. We are situated in an unreal space with doors that open out not into rooms but only toward other doors. McCaf-

fery thus offers an image that resists the "logic of passage," as nothing moves through these doors. "Above the entrance" is not an exit sign (though that word will appear later), but the word "clouds" instead. Mc-Caffery switches signs on us, and he reminds us not to turn to "empirical observation" for their meaning. The poetry continues:

> Everything is already
> there
>
> in the dead line direction
> is a surface
>
> when we mean a page
> we move
>
> (going up to the thing we mean
> it misses us)
>
> forming the current when
> con/tent with form
>
> a form of order shows . . .

The poet seems to be implying that meaning "is already/there" in the poetic "line," the "surface" and the "page." We miss the meaning if we go to "the thing" instead of following the "current" of language itself. And that current takes us in many directions, as the poet leads us from one pun to another ("con/tent"; "order"). A "form of order" in poetry would usually be a balance of "content" and form. But "order" in Mc-Caffery's poem leads elsewhere immediately:

> but an order orders
> its own execution
>
> the door
> in the room in
>
> language
>
> > exit:
>
> > > draw a circle around the mental process
> > > of an expectation

call it a head and sail
a thought on it until

a gun
begins

a shout
a sh
a sho t

and the red you see is
not the red

expected
so i dreamed last night of the word pain
in my arm lodged
by the tongue as a bullet would

. . . and the noise filled my arm.

It is pain it is red and
it is in it

What is happening here is occurring not in a room, but in language ("the door/in the room in/language"). With all of its imagery of bullets and shooting, the poem explores the double meaning of "execute" as in to "execute an order" and "execute" a man. The poem has already toyed with our expectations for a "proper" sign over the door, and now it addresses "expectation" as an explicit theme: "exit:/draw a circle around the mental process of an expectation/call it a head and sail/a thought on it." Wittgenstein discusses the linguistic quality of "expectations": "It is in language that an expectation and its fulfillment make contact," he writes (*PI* 445). The experience, Wittgenstein argues, is predominantly a verbal one. "The red you see is/not the red/expected," extends the puns and proliferation of meanings, suggesting at one level that what we "re(a)d" here has everything to do with our expectations for poetry. Although McCaffery's poetry does not have what we "expect" in terms of poetic "content," we may, finally, be "con/tent" with it in the end. If we look more closely at the speaker's dream of pain, we realize that it, too, is predominately linguistic: "i dreamed last night of the word pain. . . " In the dream, the tongue is compared to a gun, and the word to a bullet: "the word pain/in my arm lodged/by the tongue as a bullet would."

All we can say of the speaker of this poem is that he "has a door," a dream, and perhaps pain: "It is pain it is red and/it is in it." But note the shift of pronouns. What, now, is "it"? The pain in the arm? In the man? Thus the "I" does not control the flux of language or imagery here, and the self does not function a central organizing force. As throughout all Language writing, the implication is that the individual does not stand outside language in order to use it; rather, the self is a process constituted through and by means of discourse. Within the poem, the focus moves suddenly from "I" to "he," so that, as Marjorie Perloff has observed in other Language writing, "the poet's voice functions as no more than a marginal presence:"[18]

> so what does he see to say
> to see
>> there are patches regions
>
> a surface to things
> on stones named 'plants
>>> in our skin'
>
> terms in
>> his larynx
>> her larynx
>> (the same brain goes for the same 'in' his brain

Seeing and speaking are presented as intertwined ("see to say/to see"), as the poem moves into another allusion to *Philosophical Investigations*, namely this passage:

> Let us imagine the following: The surfaces of the things around us (stones, plants, etc.) have patches and regions which produce pain in our skin when we touch them. . . . In this case we should speak of pain-patches on the leaf of a particular plant just as at present we speak of red patches. . . . (312)

Here is the source of much of the imagery in the poetry: the color "red," the surface on "stones," and "plants." In Wittgenstein, the passage calls attention to our "forms of life" and the general conditions of nature that help to shape our conceptual and linguistic systems. In McCaffery's

poem, the emphasis seems to be on the notion of "surface," the surface that in Wittgenstein's writing produces pain, as well as the surface of language itself. The poem concludes by repeating terms of interiority: "in our skin," "in/his larynx," "in his brain." Yet, McCaffery's poem describes an interiority which it also resists. The emphasis on sound foregrounds the materiality of language ("the same brain goes for the same 'in' his brain") and wordplay calls attention to the surface relations of letters and words (the "in" within "bra/in").

Everything points to the surface, including the presence of graphics in *Evoba*. Handwritten pages, drawings, arrows, diagrams, and typography all present the page as a spatial organization. McCaffery observes that "the drawings, in introducing pictorial and spatial concerns, return the word to the written gesture. . . ."[19] In other words, attention is brought to the surface of the page, and the book is less artifact and commodity than archive. The endpapers of the book themselves deserve attention: the book opens with the image of a bombed-out bookstore and ends with the parodic profile of McCaffery in front of Karl Marx's grave in Highgate Cemetary. The accompanying quote from Maurus ("the fate of books are in the heads of their readers") suggests that the poet is speculating about the fate of books and authors. The visual dimension of the book is central to it, as is the philosophical nature of its content.

Intent on undermining the distinction between language theory and poetic practice, many of the Language poets produce generic hybrids.[20] With its incessant quotations and allusions to *Philosophical Investigations*, *Evoba* itself purposely confuses language theory and poetry. As Charles Bernstein has written, "Poetry and philosophy share *the project of investigating the possibilities (nature) and structures of phenomenon*."[21] Or as McCaffery writes, poetry "reimagines the project of Philosophy."[22]

The interdisciplinary and intermedial nature of all the "textual art" explored in this study suggests not that language is everything, but that it is our first and foremost institution. Within this work, language is always presented in the context of other media, other cultural and social institutions, and their practices. It is not, as the detractors of deconstruction would have it, a textuality severed from all else. On the contrary, language in the postmodern age is interwoven with behavioral, social, historical, and cultural forces that also help to shape it. Language is no longer an invisible window onto the world and "truth," but a mechanism for generating subjectivity and meaning. Our

postmodern condition may be typified by the decline of metanarratives (Lyotard), but language games and "language art" continue to proliferate. The best "textual art" of the postmodern period follows a moral imperative to explore the nature of "meaning." In the process, it expands the limits of the signifiable and the boundaries of human experience. It offers pleasure and insight, leading us, finally, "to revise what counts as the domain of the imaginable" (*PI* 517).

NOTES

Chapter 1. The Text in the Eye

1. For "language works" by Conceptual artists, see Battcock, "Documentation in Conceptual Art" and *Idea Art;* Meyer; and Lippard. For examples of "story" art, see Collins. Edited by Mac Low and Young, *An Anthology* contains numerous Fluxus works that employ words. Weber's catalogue, *Discussion,* includes works encompassed by that "genre." For a survey of other "word art" in the sixties, see *Icons and Images of the Sixties* by Nicholas and Elena Calas. Battcock and Goldberg both provide excellent discussions of Performance art.

2. An observation also made by Ulmer 225 and by Lischka 23.

3. See Terry Atkinson et al., henceforth cited as Atkinson.

4. See Ulmer 228, 255–264: "Beuys's interviews and lectures do not constitute interpretations but exist at the same level as, even as part of (verbal extension of) the art."

5. In the introduction to *Desire in Language,* Leon S. Roudiez says, "The object of her [Kristeva's] investigation in these pages is not called literature, for this is an ideologically loaded term that enables one to exclude any number of writings . . . and exalt others by placing them in an untouchable category (something like 'masterpieces of all time')" (5). Kristeva's resistance to artistic hierarchies is also evident in the works to be discussed here.

6. My study therefore bears out Ihab Hassan's assertion that hybridization is a distinguishing feature of the postmodern (1987, 170).

7. "Software Show," Jewish Museum, 1970. See Vinklers.

8. The exhibition "Discussions" was held at New York University, 9–20 May, 1977. "It was comprised of artists who utilize the medium and technique of linguistic discourse in various ways" (Weber 11). Included were: Joseph Beuys, "Public Dialogue"; David Antin, "The Currency of the Country"; Carolee Schneeman, "ABC—We print Anything—In the Cards"; and works by Ian Wilson, International Local (Kosuth, Charlesworth, and McCall), and Robert Ashley, among others.

9. For an excellent discussion of the Performance poetry of Antin and Cage and its relation to Conceptual art, see Perloff, *Poetics of Indeterminacy.*

10. See Rosalind Krauss, "Poststructuralism and the 'Paraliterary.'"

11. See especially Sandler.

12. This style can be related to Wittgenstein's repeated imperatives. I will return to this subject in the discussion of Joseph Kosuth.

13. See Mitchell's essay *"Ut Pictura Theoria"* for more on the latent linguisticism of modern art.

14. As Mussman notes, Duchamp "provided a dramatic point of departure and inspiration for the later business of questioning the limits of art" (Mussman 148). The readymades, according to Harold Rosenberg, "were symbols commemorating the end of the separate existence of art objects" (*Artworks and Packages* 23), or in Allan Kaprow's terms, "a form for denying the possibility of defining art." With the readymades, art as a whole was "dedefined" (Rosenberg), and it continues to be de-defined in the art of our time.

15. See also Paz 5.

16. "I was mixing story, anecdote, with visual representation," says Duchamp, "while giving less importance to the visual elements" (Cabanne 38).

17. See Weschler.

18. See Sheppard.

19. I have written on this subject in more detail in "Beckett and Duchamp: The Fine Art of Inexpression."

20. See Wittgenstein, *Letters to C. K. Ogden*. For all of the logical argumentation in *The Meaning of Meaning*, its theory is really much more confused and confusing than Wittgenstein's, despite the discontinuous structure of fragments in *Philosophical Investigations*; so it is not surprising that Duchamp had difficulty understanding the book (Tompkins, *Bride* 32). Richards and Ogden fall into all sorts of philosophical traps, holding on to logical positivist theories of verification, "false" notions of meaning as intention, and not pushing their theory as far as Wittgenstein does in terms of social ramifications (forms of life). But they do discuss meaning as contextual, albeit in a very different way than Wittgenstein. For Ogden and Richards, context is psychological context, an idea that stands in marked opposition to Wittgenstein's theory. Whether or not Duchamp's interest in context derives from their work or curiously coincides with it, the relation of context to meaning is an important theme in Wittgenstein's work and Johns's.

21. See Tomkins: "Johns," he says, "had become deeply immersed in the philosophy of Ludwig Wittgenstein. He also thought increasingly about the work of Duchamp" (*Off the Wall* 197).

22. See Crichton 42 and Tomkins, *Off the Wall* 197. This dating of Johns's reading of Wittgenstein was confirmed in correspondence with the artist in 1984.

23. Crichton, in fact, compares Johns with Dupin (70).

24. The result of Wittgenstein's investigation here is not to collapse all of seeing into interpretation and language, but merely to draw attention to

those cases in which our concepts ("seeing" and "knowing") merge. Both in language learning ("colors"; "shapes"), and in the picture puzzles, Wittgenstein focuses on cases in which vision and language are intertwined in complex ways ("duck"; "rabbit"). But given his preoccupation with differences (between usages, for instance), and his own use of visual diagrams and schema within the work, the implication throughout is that seeing and language are *not* the "same" but different experiences. With a simplicity that gives way to a greater complexity, Wittgenstein's point is that "We find certain things about seeing puzzling, because we do not find the whole business of seeing puzzling enough" (p. 212).

25. Kozloff also observes correctly, I think, that Johns's paintings are "refutations of Wittgenstein's theses in the *Tractatus*," that the paintings "employ logic only to subvert it," and that they are "rife with tautologies and contradictions" (39–41).

26. See also *PI* 97–98. But not every usage will be meaningful (*BB* 65).

27. In *PI* 77, Wittgenstein describes the concepts of ethics and aesthetics as complex and vague. Yet this entry appears within a larger section that emphasizes how inexact terms and concepts can still be useful, indeed in certain cases (like aesthetics) may be exactly what is needed.

28. For a closer analysis of the complex relation of word, object, and image in this painting, see Foucault.

29. Wittgenstein's famous phrase "forms of life" refers to coherent patterns of human experience ("general facts of nature") that shape and are shaped by linguistic conventions. See *PI* 19, 23, 142, 230, 226, 241; *BB* 134. Given the varied, even oppositional responses to Wittgenstein's later work, *Philosophical Investigations* might best be described as itself a kind of picture puzzle, with changing aspects determined by the philosophical assumptions or conceptual schema of the readers. Thus Charles Altieri sees the "forms of life" argument and Wittgenstein's project in general as a restabilization of philosophical language (with conventions *determined* by forms of life), while Henry Staten emphasizes the deconstructive nature of Wittgenstein's thought (with conventions not "determined" but fluid, changing and variable [75, 100–101]). The differences between Altieri and Staten turn on key passages (for example, *PI* 139–40) that can be read either way, precisely because both of the arguments are built into the book as a whole; the different interpretations show just how clearly our perceptions are determined by prior conceptual schema.

30. Creating another paradox, Johns's work can be highly representational and nonrealistic at the same time (*Three Flags*, for instance).

31. See Battcock and Nickas xxi.

32. Indeed Johns has been variously called an Expressionist, a Pop artist, a formalist, and a Conceptualist.

33. Johns's interest in contradiction and paradox predates his reading of Wittgenstein and structures many of his early paintings. The sounds produced by the music box mechanism of *Tango* (1955) are not a tango at all. In *Liar* (1961), Johns exploits the paradoxical fusion of truth and falsity in any revelation of dishonesty or deception. Popularized in the anecdote of the Cretan liar, the paradox is also addressed by Wittgenstein: "'Now I'll deceive him.' But if you had said the words, would you necessarily have meant them quite seriously? Thus the most explicit expression [of intention] is by itself insufficient evidence of intention" (*PI* 641).

34. See Pincus-Witten 24–25.

35. See Calas and Calas 147.

36. See Weschler.

Chapter 2. Text and Context: Reading Kosuth's Art

1. The important critical works on the movement variously called "Concept art," "Idea art," "Conceptual art" and "Inferential art" are those of Lippard, Meyer, and Battcock (*Idea Art*).

2. The term "scripting" is formulated by Ulmer xiii.

3. Kosuth abandoned painting in 1965 and began to treat art as a philosophical and linguistic problem (Burnham 50). By 1970, his work was consistently cited by critics as the most accomplished example of Conceptual art. Represented by The Leo Castelli Gallery, he quickly achieved international critical acclaim. His notoriety was widespread but temporary, paralleling the trajectory of Conceptual art as a whole, from its eruption in the art scene in the late 1960s to its transformation into more accessible forms of art (like Narrative and Performance art).

4. *Art Investigations* is a chronological survey of Kosuth's work divided into five volumes as follows: Volume 1: Protoinvestigations and The First Investigation (1965, 1966–68); Volume 2: The Second Investigation (1968); Volume 3: (The Third, Fourth, Fifth, Sixth, and Seventh Investigations (1968–71); Volume 4: The Eighth and Ninth Investigations (1971, 1972–73); Volume 5: Biography, Bibliography, and Photographs [of the artist]. The books also include the following critical essays by members of the Art & Language Group: "Introduction to a Partial Problematic" by Michael Baldwin, Terry Atkinson, P. Pilington, and D. Rushton; "Memo, some Display Problematics" by Terry Smith; "Artworks and Explications," by Mel Ramsden. The most interesting aspect of the essays is the way they are themselves "displayed": the content of each page is translated into five languages; the texts are interspersed, fragmented, interrupted, and overlapping; typos are left in (presum-

ably) to preserve a raw and unfinished quality. The structure of the book thus relates to the non-linear, collage techniques in Kosuth's work. *Art Investigations* will henceforth be cited as *AI*.

5. *Arte povera* is part of the "vision of the collapse and disintegration of forms . . . repeated in the art and literature of our time in thousands of metaphors." (Rosenberg, *Artworks and Packages* 217–18.

6. Arakawa's work is formally allied to Johns and theoretically tied to Conceptual art. His refined and elegant paintings show the same double influence of Duchamp and Wittgenstein, although Wittgensteinian themes (the meaning of meaning, for example) are treated finally with a lighthearted sense of humor. As in Kosuth's art, definition is an exploration without closure—a verb and not a noun (process not product). See Arakawa and Madeline Gins. See also Charles Bernstein and Susan Laufer, "Meaning the Meaning: Arakawa's Critique of Space" in Milazzo 59–66, for an astute and thought-provoking analysis of Arakawa's art.

7. In *Function*, Kosuth describes his art as "investigation and not in any sense . . . any mental object." The "idea" in his "Art as Idea as Idea," then, is not stable (a "mental object"), but fluid and changing instead.

8. E. H. Gombrich popularized the term "the language of art" (9) and the corresponding theory of the conventional basis of vision and art. The importance of this study for Conceptual art cannot be emphasized enough. The impact of the book was great, although it was based on a widespread misreading of Gombrich's text. James Collins, for example, criticizes Conceptual art for (among other things) merely repeating a point already made by Gombrich: "Gombrich made the eminently tenable point 'all art is conceptual.'" Collins goes on to doubt that Gombrich would condone the excessive cerebralism of the art. Apparently it is not just the cerebralism of Conceptual art that Gombrich would question, but the focus of conventionalism as well. Ambiguities within Gombrich's own study led many aestheticians and artists to interpret his emphasis on "the beholder's share" as advocating a form of cultural relativism or conventionalism, which Gombrich expressly wished and still wishes to deny. See the debate between Murray Krieger and Gombrich on this point in Krieger 181–94, and Gombrich's retort, 195–201.

9. Kosuth's notion of art as tautology is a direct reflection of similar "art for art's sake" ideas expressed by Ad Reinhardt and Donald Judd (both quoted in "Art After Philosophy"). It also relates to Kosuth's view of art as essentially an act of definition: "the artist is saying that the particular work of art *is* art" ("AAP" I:136).

10. What makes Beuys, for example, a postmodern artist and not just a belated modernist (a Surrealist, say) is his interest in shifting and dislocating the entire conceptual framework of art. "My objects," he says, "are to be stim-

ulants for the transformation of the idea of sculpture, or of art in general" (quoted by Ulmer, *Applied Grammatology* 227).

11. See Buren, "It Rains, It Snows, It Paints": "The neutrality of the statement—painting as its own subject—eliminates all style and leads to an anonymity which is neither a screen to hide behind nor a privileged retreat, but rather a position indispensable to the questioning process. An anonymous, or rather impersonal . . . 'work' offers the viewer neither answer nor consolation, nor certainty, nor enlightenment about himself or the 'work.'" On Buren, see Crimp, "The End of Painting."

12. See Weibel. Burnham also focuses primarily on the *Tractatus* as an influence upon Kosuth. However, he does say that, like Wittgenstein, "Kosuth stresses art as a process rather than as a set of truths." But these ideas are not developed further (57–58). While Robert C. Morgan makes the connection between Kosuth and the *later* Wittgenstein, here too the author does not expand since the focus of his study is on photography.

13. Because Irwin's art operates similar premises in very different ways, a more extensive comparison with Kosuth would be interesting. Irwin's reading of Wittgenstein is expressed in his attention to the conventional boundaries of perception. Rather than accepting language as a conceptual system, Irwin's enterprise is to eliminate all linguistic and visual coding, (thus Weschler's title, *Seeing is Forgetting the Name of the Thing Seen*). Irwin proceeds on the assumption that immediate, "innocent" perception is the remote yet retrievable ground of experience. We might recall, however, Gombrich's thesis that there is no "innocent eye" (394). Weschler nevertheless offers an interesting description of one man's quest for "innocent" vision.

14. A phrase used by Kosuth to describe "The Second Investigation," which I think also applies to the "Notebook."

15. Kosuth is also, perhaps, playing a rather subtle joke on Worringer's theory in *Abstraction and Empathy*, which posits as antithetical the geometric and organic modes of art. Kosuth invokes that theory with his quotation from Donald Judd, written into one of the sketches in the *Notebook on Water*: "A form that is neither geometric nor organic would be a great discovery." The quotation calls attention to the fact that water is neither geometric nor organic—neither are words and ideas, which are the real substance of Kosuth's art. See Worringer.

16. Thus I disagree with Ursula Meyer, who proposes that Kosuth lapses back into a form of Platonic idealism. While it is true that his "forms of presentation" and his essays can be clearly separated from one another, his forms do not stand for ideas so much as constitute procedures essential to his art. (See Meyer xi). Kosuth's ideas are not stable and definite (Plato) but in a constant process of transformation, a process of posing questions without stable an-

swers (or Ideas). He does prefer the "ideational over the visual," since his "forms of presentation" are designed to be thought as much as seen. It is not necessary to view his work in a gallery or a museum, but it is essential to his enterprise that he use conventional gallery and museum spaces.

17. Wittgenstein, like Derrida, uses puns to emphasize the un-motivatedness of language, but their strategies are entirely different. Rather than occupying the center of Wittgenstein's theory, puns serve as additional examples for the multiple functions and meanings of each word, the natural flexibility of word usage. Therefore, he focuses on "puns" that are commonplace and usually ignored, for example, "558. What does it mean to say that the 'is' in 'The rose is red' has a different meaning from the 'is' in 'twice two is four?'" See also *PI* p. 18n, p. 175.

18. Like Derrida, Kosuth "conceptualizes collage," "the biting out," "the cutting out" of other texts, a "de-compositional procedure" that wrests texts from their "origins" and shows that they can be repeated (iterability) in new and different contexts. See Ulmer 58–59.

19. I therefore disagree with Douglas Davis, who proposes that Kosuth's theory (of art as tautology) leads him back to a modernist, Greenbergian notion of the autonomous object. See Davis 52.

20. See Atkinson.

21. See Staten: "The point Wittgenstein is making . . . is related to, but must not be confused with, Saussure's point . . . that the sign has no 'positive content,' only a relational value arising from reciprocal demarcations among an entire system of terms. . . . Although Wittgenstein agrees with Saussure in treating the 'value' of words as relational, he goes a different way in treating these 'relations' as *syntactic* rather than as systematic . . . not to be thought of as its place as defined within an abstract, synchronic system. . . ." (79–80).

22. Staten is actually making a more specific observation concerning the implications of this theory for the speaking subject. The complete phrase reads as follows: "it ensures that the self that is expressed in the characters of meaning will be illimitably torn and carried away into an illimitable spread of new contexts." My deletions, while changing the meaning of the passage are not, however, inconsistent with the general theory.

23. An additional sequence of such pseudo-syllogisms is published in Lippard's *Six Years* 164–65. That Lippard's "Chronological Bibliography" includes so many Conceptual works unpublished elsewhere is one of the many strategies used by the artists to confuse critical and artistic practice. Another variation is Robert Barry's "Three Shows and a Review by Lucy R. Lippard," Yvon Lambert Gallery, Paris, April 1970 (*Six Years* 231). Responding to the artists' appropriation of critical and theoretical roles, the critics closest to the

movement (Lippard, Meyer, and Battcock) generally did not comment theoretically on the art but presented new avenues of publication for it instead (such as critical anthologies, magazine articles, and bibliographies).

24. Speaking of his own work, Daniel Buren says, "This form is the object questioning its own disappearance as object. It is not the result or the reply to the question. It is the question, the question endlessly being asked. . . . Moreover, no solutions to enigmas are to be expected; the fundamental question [as to art's essence and theoretical formulation] does not necessarily imply an answer. . . ." ("It Rains, It Snows, It Paints" 178–79).

25. My sentence cites a phrase from Derrida: "The necessary decentering cannot be a philosophic . . . act as such, since it is a question of dislocating, through access to another system . . . the founding categories of language." (*Of Grammatology* 92; quoted by Ulmer [*Applied Grammatology*]).

CHAPTER 3. WORDS *EN ABîME*:
SMITHSON'S LABYRINTH OF SIGNS

1. Robert Smithson was born in Rutherford, New Jersey in 1938. William Carlos Williams was the family physician, and they met again in 1959. During high school, Smithson attended the Art Student's League and frequented the Cedar Bar. Early influences were Newman, Pollock, Dubuffet, de Kooning and Rauschenberg (*WRS* 146). While formalism and abstract expressionism were artistic influences to be eventually overturned, early literary influences (Williams, Ginsberg, Kerouac, Hulme, and Borges) continued to be used in varied ways within the writings. From 1963 to 1973, Smithson read profusely, wrote prodigiously, and exhibited widely. He died at the age of thirty-five in a tragic plane accident while photographing the staked-out site of *Amarillo Ramp* in Texas. He is now widely considered to be one of the foremost artists of our time. Stephen Melville, for example, says, "Art history now belongs to him, what we call his achievement" (102). For a complete biographical chronology, see Hobbs 231–43.

2. See *The Writings of Robert Smithson* 173; henceforth cited as *WRS*. The artist's task, according to Smithson, is to create his/her own limits and not just fit into "fraudulent categories" (132). "For too long artists have taken the canvas and stretcher as given, the limits. . . . I think the major issue in art right now is what are the boundaries" (159). At the same time, he also believes that: "There's no way you can really break down limits" (164). When asked if Yves Klein overcame limits in art by signing the world, Smithson responded, "No, because he still had the limits of the world" (173). See also Norvell 90; *WRS* 133, 164–65.

3. Smithson: "I selected sites—physical sites—which in a sense are part of my art" (*WRS* 160).

4. Even Robert Hobbs admits that his decision to consider Smithson as a sculptor was, at least in part, a way of containing and controlling "the cumbersome treadmill of meanings he has attached to it. . . ." (Hobbs 23). Yet Smithson's art *is* precisely this "cumbersome treadmill of meanings," and Hobbs's book is a major contribution to our understanding of it.

5. A phrase adopted from Shoshana Felman describing postmodern interdisciplinarity (in particular between literature and psychology) which neatly sums up Smithson's vertiginous interdisciplinary tactics as well (especially if one thinks of the vertigo described and inscribed within *The Spiral Jetty* and the shifting ground of Smithson's work in general): "No longer . . . will one text . . . serve as model-master-reference-explanation of another. . . . The idea is to have them reciprocally displace each other, creating an oscillation. The ground slips beneath us: vertigo once more" (Krupnik 6).

6. Smithson constructs a comprehensive and complex art that yields a variety of interpretations. Thus John Beardsley reads him primarily as an Earth artist, Robert Hobbs as a sculptor, while Harold Rosenberg describes Smithson's work as "speculative philosophy." Critics who acknowledge the purposeful confusion of media and disciplines within his work are David Antin, Stephen Melville, and Thomas Lawson. Antin reads Smithson's work as a hybrid form, "partly literary and partly visual," and Melville says, "Smithson worked the boundaries between art and criticism as he worked the boundaries between the arts" (102). Lawson agrees: "By mixing genres (aesthetics, anthropology, and science fiction) and styles (from parody to visionary) Smithson muddied the waters, disrupting the flow of art criticism" (63).

Critics Robert Hobbs, Stuart Morgan, Carter Ratcliff, Elizabeth Childs, and Philip Leider all consider the writings to be works of art in their own right. David Antin, Thomas A. Zaniello, Nicholas Calas, and Craig Owens, moreover, acknowledge that the art of Smithson's essays overlaps with literature in significant ways. Thus Calas calls *The Spiral Jetty* a "poem" (70), while Owens describes it as a Barthean Text. With an eye on Borges's fictional forms, Zaniello proposes that the essays are "fictions" (114). That all of these labels can be justified is itself significant, an expression of the artist's successful subversion of traditional artistic categories. My own reading of "Quasi-Infinities" adopts and extends Owens's use of the Barthean term "Text" because it is so inclusive and can accommodate all of the other genres.

7. First published in *Arts Magazine*, November, 1966, and reprinted in *WRS*.

8. "Quasi-Infinities", therefore, participates in that theoretical debate between Michael Fried and Susan Sontag on the boundaries of the arts and the role of the frivolous within them. Quoting Sontag describing the boundary-breaking strategies of contemporary art, which mixes the "scientific" and the "artistic," "art" and "non-art," "form" and "content," "high" and "low,"

the "frivolous" and the "serious," Fried contends, "The distinction between the frivolous and the serious becomes more urgent, even absolute every day." In general he calls for clear classifications between the separate arts and artistic values in a way that deeply annoys and troubles Smithson. See Sontag 276–77. For Fried's argument against Sontag, see "Art and Objecthood". See Smithson's "Letter to the Editor" *WRS* 38 and "A Sedimentation of the Mind: Earth Projects" *WRS* 82–91 for his argument against Fried.

9. Despite his criticism of the latent anthropomorphism in abstract expressionism, Pollock was still an important precursor of Smithson's art. Smithson's response to the problem of biological forms in art can be (roughly) divided into three phases: 1) In the early 1960s, his religious and figurative paintings countered latent anthropomorphism with manifest figuration; 2) In the mid 1960s, he retreated completely from the biological toward the abstract forms of crystallography; (3) In the 1970s, especially in *The Spiral Jetty*, a shifting balance between the two was maintained; both were admitted but neither controlled or mastered the other, "they kind of met—a kind of dialectic occurred" (*WRS* 151).

10. See, for example, Jung's discussion of "The Philosophical Tree: 253, 272, 304, which shows that the tree is a symbol of such complexity that interpretations branch out and encompass almost all possible variations. The dead tree (Smithson's inverted tree) does not undercut this symbolism so much as fit into it. If anything, his tree represents symbolism itself and symbol-making processes. In general, Smithson chooses heavily loaded, archetypal symbols (for example, the spiral) so that stable meaning cancels out. But the symbolic still functions as a time-binding procedure. An article by Joost A. M. Meerloo, to which the artist refers, contains the following passage: "Another time-binding process is that of symbolization. For, just as the history of evolution is condensed and stored in the genes as bearers of genetic memory, the history of human thinking and communication is condensed and stored in human symbols. . . ." (239).

11. "An instructive fantasy," says Kubler, "is to imagine the exploration of a historical manifold of dimensions in which all times could co-exist." (65). If the artist "seeks the fiction that reality will sooner or later imitate," as Smithson once said (WRS 76), perhaps some day this multidimensional perspective on time will be imitated by reality. A fragment from *Time Magazine*, Sept. 24, 1984, reads as follows: "Sakharov's article, 'Cosmological Transitions with Alteration of the Metric Signature,' is an attempt to postulate the existence of more than one time dimension in the physical universe" (43).

12. See Childs.

13. "What we perceive is multiple, irreducible, coming from a disconnected, heterogeneous variety of substances and perspectives. . . . All

these . . . are *half*-identifiable: they come from codes which are known, but their combination is unique" (Barthes, *Image-Music-Text* 159).

14. Smithson says: "In information theory you have another kind of entropy. The more information you have, the higher degree of entropy, so that one piece of information tends to cancel out the other" (*WRS* 190). The way in which contradictions build up, I would argue, is as important as the fact that they do so.

15. In the same way that the earth "entombs" prehistoric material, language is continually presented by Smithson as a sort of tomb as well. *A Heap of Language*, after all, is a funereal pyramid. "Books," we are told, "entomb words. The mind of this death, however, is unrelentingly awake" (*WRS* 104). The blocks of print in "Quasi-Infinities" relate not only to the paratactic blocks or boxes of minimalist sculpture but also to André's "blocks of print,' which Smithson describes as "grave[s] for metaphors and meaning" (*WRS* 69–70).

16. Smithson continues, "If I ever saw a system or an object, then I might be interested, but to me they are only manifestations of thought that end up in language. It is a language problem more than anything else. It all comes down to that" (Norvell 90).

17. See Hobbs 113–15.

18. "The whole idea of gathering together remnants and then trying to make sense of them—that's what I find interesting" (Smithson quoted by Tomkins, *Scene* 143). "I was always interested in Borges's writing and the way he would use leftover remnants of philosophy . . . that kind of taking of a discarded system and using it . . . this has always been my kind of world view" (*WRS* 155). Like postmodernism in general, "Quasi-Infinities" quotes, scavenges, and plunders the past.

19. As Owens says, "This confusion of genre, anticipated by Duchamp, reappears today in hybridization, in eclectic works, which ostentatiously combine previously distinct art mediums" ("Allegorical Impulse" 1:75).

20. Smithson's phrase "usage precedes meaning" (*WRS* 46) is a witty condensation of Wittgensteinian ideas (the meaning is the "use" and justified by later action) which, as Ehrenzweig observes, pertains as much to creativity as to language. See Ehrenzweig 40–42.

21. See also *WRS* 44, 87, 89, 104, 157.

22. It is important to remember that "erosion" is never "bad" in Smithson's aesthetic.

23. The rapid transitions in linguistic style, the use of quotations, and the confusion of theory and practice can also be related to the collage techniques of modern poetry, especially for example, Williams's *Spring and All* and *Paterson*. The numerous connections between Smithson's aesthetic and Williams's can only be sketched every briefly here. Both create an art "rooted

in the experience of American" (Smithson), an "art of the local" indigenous American experience. Williams takes Paterson as his subject; Smithson takes Passaic; both "fictionalize" the history of America, in particular the Mayan Conquest (Smithson's "Mirror Travel in the Yucatan" and Williams's "The Destruction of Tenochtitlán," *In the American Grain*). Both celebrate the real and create an aesthetic that integrates the "ugly" detritus of city life; both are concerned with interpenetration and interdependence of word and thing ("no ideas but in things"). Both employ the imagery of geological strata ("Substratum") and natural catastophe, creating an art in which destruction and creation are intertwined. In short, there are more than biographical connections here.

24. Ehrenzweig describes the connections between his own Freudian theory of creativity and Wittgenstein's theory of language. Creativity breaks down ego boundaries, says Ehrenzweig, just as ordinary language usage (for Wittgenstein), continuously breaks "rules" and shifts conceptual categories. In general, the connection between Wittgenstein and Ehrenzweig rests in their willingness to release language (Wittgenstein) or consciousness (Ehrenzweig) from the control of logic and view their subjects (language/ego) operating not "according to strict rules" but in flexible and variable ways. Both extol the human capacity to hold contradictions in view. And finally, the boundaries of the ego are shown by Ehrenzweig to be as fluid and shifting as the boundaries of concepts for Wittgenstein (Ehrenzweig 40–42).

25. Ehrenzweig's book, for instance, influenced (or confirmed) Smithson's own interest in maps and mapping procedures. Ehrenzweig reproduces a map of the London subway system and says, "Seen as an informative diagram the pattern remains flat; seen as an aesthetic design, it is transformed into plastic pictorial space" (60). Furthermore, Smithson tells us that his nonsites are indebted to Ehrenzweig's discussion of scattering and gathering (*WRS* 168–69). Finally, Smithson continuously associates the mind and the earth because, as in any Freudian scheme, both are stratified. ("As you know," says Freud, "I am working on the assumption that our psychic mechanism has come into being by a process of stratification" 235); Ehrenzweig repeatedly discusses the unconscious as the "substratum of the mind" (190). In "Freud and the Scene of Writing," Derrida remarks, "The subject is a *system* of relations between strata . . . within that scene, on that stage, the punctual simplicity of the classical subject is not found" (227). Strata of the mind and of the earth are suggested in Smithson's sculptures (*Glass Stratum, Mirror Stratum*), in his textual strategies (*Strata: A Geophotographic Fiction*) and in his metaphors: "The artist begins to know the corroded moments, the carboniferous states of thought, the shrinkage of mental mud, in the geological chaos—in the strata of aesthetic consciousness" (*WRS* 85).

26. De-differentiation is associated with the death instinct (Ehrenzweig

219) and constitutes a temporary destruction of the rational ego (Ehrenzweig 124). Therefore Smithson's use of the term "entropic" is highly appropriate. The artist continually describes his site selection process as a temporary loss of selfhood: "When I get to a site that strikes the kind of timeless chord, I use it. . . . Where the disintegrating of space and time seems very apparent. Sort of an end of selfhood . . . the ego vanishes for a while" (Norvell 89). The annihilation of the stable, coherent, and rational self is expressed in a different way in *Enantiomophic Chambers*. There is thus a willful self-annihilation operating throughout Smithson's work, a destruction and fragmentation of ego boundaries that is associated with the unbounded and fragmented quality of expansive geological sites.

27. Stuart Morgan accurately describes Smithson's experience in *The Spiral Jetty* as "the complete paradox of a simultaneous heightening and eradication of pure consciousness." However, to suggest, as Morgan does, that this "frenzy was brought about by sheer intellectual overload" fails to acknowledge the kind of creative process that shapes all of Smithson's work. The experience is not a culminating "breakdown," but an expression of Smithson's indebtedness to Ehrenzweig's theories, and the purposeful engagement with primary processes that Ehrenzweig describes. Nevertheless, see Morgan's invaluable essay on Smithson's early paintings.

28. "The existence of 'self,'" says Smithson, "is what keeps everybody from confronting their fears about the ground they happen to be standing on" (Norvell 89).

29. The cinders and the rubble of the nonsites too are emblems of this psychic fragmentation. In *Speculations*, Hulme locates the "cinder" element of the earth precisely in the human psyche: "In an organized city," he says, "it is not easy to see the cinder element of the earth—all is banished. But it is easy to see it psychologically. What the Nominalists call the Grit in the machine, I call the fundamental element of the machine. . . . Man is the chaos highly organised, but liable to revert to chaos at any moment" (226–27). Smithson quotes one sentence of this passage (*WRS* 84) and might be said to be quite sympathetic with Hulme's perspective in general.

30. Bachelard quoted by Derrida in "White Mythology: Metaphor in The Text of Philosophy." *Margins of Philosophy* 207–272, espec. 265. Although Derrida agrees with Bachelard's emphasis on syntax, he counters the "monosemic" view expressed in Bachelard's discussion of metaphor.

31. Many of the Smithson's essays ("The Crystal Land" and "Monuments of the Passaic," for example) are narrative fictions. He once said, "When the word 'fiction' is used, most of us think of literature, and practically never of fictions in a general sense. The rational notion of 'realism,' it seems, has prevented esthetics from coming to terms with the place of fiction in all the arts" (*WRS* 71).

32. Mirrors also establish a continuously changing system of metaphoric associations. In *Mirror Vortex*, mirrors produce a "Pythagorean chaos" (*WRS* 4); in *Enantiomorphic Chambers*, they become "emblems of nothingness" (*WRS* 50), or symbols of the abyss, as they do in all the *Mirror Displacements*. They are the "symbol of illusion" (*WRS* 49–50), and, in *Mirror Stratum*, neoplatonic "steps" (*WRS* 50). They also represent representation and mimesis in an art that reflects on itself and its own act of reflection. They are linked to other metaphoric systems within Smithson's work: spirals ("the ever receding square spirals" of "Ultramodern"; labyrinths (*Mirror Vortex*; see Hobbs 64); steps or stairs (the *scala* of *The Spiral Jetty* and *Mirror Stratum*); trails or roads (*Mirror Trail*); and the earth (the strata of *Mirror Stratum*). As Hobbs says, "Mirrors suggest . . . art as an ongoing means of symbolic displacement" (83).

33. Tony Smith's description of his ride on the New Jersey Turnpike is well known in the art world as an important case of the text supplanting the art object.

34. In his description of editing *The Spiral Jetty* film, Smithson generates an image that characterizes his entire aesthetic: "Adrift amid scraps of film, one is unable to infuse into them any meaning, they seem wornout, ossified views, degraded and pointless, yet they are powerful enough to hurl one into a lucid vertigo" (*WRS* 115).

35. See Robert Smithson, *Movie Treatment for the Spiral Jetty*, 1970, in Hobbs 194–95.

36. It is difficult not to fall into this trap of finding spirals (if not nummilites) everywhere. Here are just two more which are both unrelated and strangely related to Smithson's:

"Myth grows spiral-wise until the intellectual impulse which has produced it is exhausted. Its *growth* is a continuous process, whereas its *structure* remains discontinuous. If this is the case, we should assume that it closely corresponds, in the realm of the spoken work, to a crystal in the realm of physical matter" (Lévi-Strauss, "The Structural Study of Myth" 105).

The famous hermeneutical circle is really a spiral: "From the fixed text we discover meaning, and the meaning we discover infuses the fixed text with a new significance. In turn this new significance leads to new meanings, and the cycle continues in a *spiral* of discovery" (Kent 15).

37. The conceptual decentering of *The Spiral Jetty* is played out visually in works like *Pointless Vanishing Point* or *Nonsite #6*; one has no vanishing point, while the other multiplies vanishing points. This visual "decenterment" parallels the thematic decenterment of works like *The Spiral Jetty* and *Broken Circle*, as well as the disciplinary decenterment enacted by Smithson's work in general. See Owens's essay "Earthwords" for an astute account of these strategies of decenterment. Like poststructuralism, the artist "replaces the old no-

tion of center [with] the notion of supplementarity. . . . The center is not a natural or fixed locus but a function" (Ulmer 40).

38. See Childs 77.

39. Mel Bochner, with whom Smithson wrote *The Domain of the Great Bear* (1966), paraphrases Foucault in his own description of the relation of language and art: "Most essentially Johns raised the question of the relation of language to art. His paintings demonstrated that neither was reducible to the other's terms. It is in vain that we attempt to show by the use of images what we are saying. After Johns we can never again slide surreptitiously from the space of statements to the space of events . . . in other words, fold one over the other as if they are equivalents" (Pincus-Witten 105).

40. These "reproductive" strategies can also be related to Kubler's theory of art history as a "linked succession of prime works with replications."

41. "A geopolitics of primordial return" occurs both within the Jetty (Childs 77) and in the relation of the film to it (*WRS* 114). Whether this "return" is, for Smithson, "actual" or part of the artifices of art, we do not know.

42. *The Savage Mind*, a text read and referred to by the artist, includes the following passage by Lévi-Strauss: "It seems very likely that every scale model has an aesthetic calling—and where would it derive this constant virtue, if not from its very dimensions?—conversely the great majority of works of art are also scale models."

43. Nabokov's character, like Kubler and Smithson, is preoccupied with the "interchronic pause": "Maybe the only thing that hints at a sense of Time is rhythm; not the recurrent beats of the rhythm but the gap between two such beats, the gray gap between black beats: the Tender Interval" (421).

CHAPTER 4. "ALWAYS TWO THINGS SWITCHING": ANDERSON'S ALTERITY

1. From the videotaped interview with Laurie Anderson shown at the retrospective "Laurie Anderson, Mid-Career." Frederick S. Wight Gallery, UCLA, 31 Jan.–4 Mar., 1984.

2. This turn towards the incorporation of "content" within art became the basis for an excellent exhibit of contemporary art curated by Howard Fox, Miranda McClintic, and Phyllis Rosenzweig at the Hirshhorn Museum in 1984. "Content" and the will to "meaning" is presented by them, in fact, as the distinctive feature of postmodern art. See Fox.

3. The score for *Motor Vehicle Sundown Event* is included in *An Anthology*.

4. Describing *Duets on Ice*, Anderson said that "skating and violin-

playing are the same: a blade on the surface—and when it's a duet, it's like coordinating your skates—trying to keep time" (Kardon 9).

5. The term refers both to any hybrid art form and in particular to Marinetti's "Synthetic Theater" described in his 1915 manifesto, *Futurist Synthetic Theatre*. See Goldberg, *Performance* 19.

6. See Kubisch 17 and Kardon 7 for references to the "Duchampian influence" in Anderson's art. Interestingly enough, one of the more chaotic Dada performances included Janco playing an invisible violin (Goldberg 40). Anderson's own miming of violin playing is predominantly a form of self-parody. Yet it also shows her allegiance to Dadaist playfulness in the mixing of "artistic" forms.

7. Owens and Foster argue that *United States* constitutes a critique of phallocentrism (Owens "Sex and Language"), a "decentering of the masculine subject of representation" (Foster, *Recodings* 132). On the relation of performance to the rise of feminism, see Goldberg, Nabakowski, Forte, and Sayre (*The Object of Performance*).

8. For a full length study of the role of mass culture in postmodernism, see Huyssen's excellent book.

9. See John Rockwell's excellent discussion of Anderson as a text-sound composer.

10. Anderson's work bears out Mitchell's observation that hybridism preserves rather than erases differences between the verbal and the visual, image and text (*Iconology* 55).

11. I would like to thank the Video Library of Warner Bros. Studios for allowing me to borrow this tape.

12. According to Flood, *O-Superman* "concludes with a matriarchal embrace as crushing as the one Athena inflicted on Laocoon" (80). It is a "viciously ironic paean to a superpower," says Owens ("Amplifications" 123). According to Goldberg, it is "an appeal for help" ("Performance" 87).

13. See Owens on Anderson's transvestism, which as he says, "is a matter of signs, language" ("Sex and Language" 51).

14. See Derrida, "The Law of Genre." See also W.J.T. Mitchell's seminal *Iconology*, which traces the history of the text-image relation and argues against the long tradition of privileging one artistic mode at the expense of another. His study reveals that artistic and sexual categories have been associated with each other by numerous theorists, primarily as a technique for justifying some hegemonic relation between the arts (55, 109).

15. Quoted from the videotaped interview, Wight Gallery.

16. Quoted from the Wight Gallery flier for "Laurie Anderson: Mid-Career." Henceforth cited as *WGF*.

17. See Goldberg for an excellent discussion of the relation of performance and conceptual art ("Performance" 170–73).

18. This view of language, and its emphasis on the conventional and cultural basis of meaning, is itself a cultural "convention" which typifies our time. See Barthes, for example, in *Image-Music-Text* (27).

19. Burroughs refers to Wittgenstein in *The Job* (168). Anderson's reading of Wittgenstein is listed in the official chronology of Marincola (Kardon 63).

20. See Staten 75.

21. Each section of *United States* has a thematic focus and a particular directional movement: Part I, Transportation (left to right motions, the arc or metronome); Part II, Politics (vertical movements suggesting social mobility and hierarchies); Part II, Money (the movement is toward the audience, parodying the extended hand); Part IV, Love (crossing axes, intersections). See Kardon 22.

22. See Burroughs 56. In one interview, Anderson states that she has been very influenced by Burroughs's politics, "and also in terms of style, his absolute precision . . . he's just not sloppy. . . ." (La Frenais 255–56).

23. The novelty of this manipulation of a musical instrument recalls Cage's "prepared piano." Anderson's art is indebted in many additional ways to Cage's aesthetic: the use of dissonance and noise for "musical" purposes, the confusion of artistic categories, the understated humor and the ironic twists of Cage's Zen stories, the cut-up used for musical composition, and the use of performance strategies.

24. Quoted from the videotaped interview (Wight Gallery, UCLA, 1984).

25. "My work," she says, "is about what happens when you pick up the phone and try to get through" (La Frenais 264). But Anderson is really more ambivalent about technology than Owen's article suggests. In one interview, she says, "It's true that even though I've been very very critical of technology in terms of what I say, I find that I make those criticisms through 15,000 watts of power and lots of electronics. And that says a couple of things at least, that I hate it and love it" (See Amirkhanian 220). For an excellent discussion of Anderson and postmodern space, see Herman Rapaport's "'Can You Say Hello?' Laurie Anderson's *United States*." Here, too, I would argue that Anderson is essentially ambivalent about postmodern travel and transit. I think her work suggest that she both loves *and* hates crossing postmodern surfaces and states; she is simultaneously critical and celebratory of "Americans on the Move."

26. Anderson's use of popular genres (musical and verbal), her comic situations, jokes, and one-liners, all belie her sensitivity to language. We might recall that Bakhtin's theory arose from his study of comic writers (Rabelais, Cervantes, and Dickens), and that heteroglossia, as he repeatedly emphasizes, finds its proper home in the "low" and popular genres, "on the itinerant stage . . . in street songs and jokes," "in the satiric-realistic folk

novella and other low parodic genres associated with joksters" (273, 400–401). Bakhtin seems to have been unaware that heteroglossia, the mixing of voices in multi-languagedness, was the prevailing mode of modernism in Anglo-American poetry (for example, *The Cantos*). Even though this undermines the validity of his generic distinctions (between poetry and the novel), I think his essay can still be read as an astute account of how heteroglossia works, and it offers a fascinating perspective on the ideological implications of verbal styles. It is important to remember that even though Bakhtin uses "heteroglossia" to distinguish between poetry and prose (mistakenly, I believe), he gives priority to the novel precisely because (in his view) it is capable of greater generic complexity; it can accomodate all verbal genres, including, above all, extraliterary discourses (320–21).

27. "But this," says Bakhtin, "is not just another's speech in the same language—it is another's utterance in a language that is itself "other" to the author as well" (303). Anderson, therefore, speaks *through* language, a language that has somehow more or less materialized, become objectivized, that [s]he merely ventriloquates" (Bakhtin 299, 313). In "It's Not the Bullet," Anderson "sings": "Like a ventriloquist, I've been throwing my voice long distance, it's the story of my life." See also the interview with Michael Dare, in which Anderson describes herself as a "ventriloquist."

28. A "semantic hybrid," as Bakhtin defines it, is one utterance that contains two speech manners or styles, two languages, two semantic and axiological belief systems" (304). "The main and sub clauses are constructed in different semantic and axiological conceptual systems" (306). The last section of *O-Superman* is a "semantic hybrid," but the piece as a whole might (more loosely) be considered one as well.

29. What Bakhtin would call "ideologemes."

30. Margarite Duras's experimentations with voice inspire Durand's discussion here, but the quotation seems fitting for Anderson's use of voice as well.

31. On the "futile talk rituals" of Antin's poetry, and the subordination of characterization to language by him, see Perloff, *Poetics of Indeterminacy*, especially 332.

32. Interviewing Anderson, Michael Dare asked if she was surprised at being a pop star. She replied, "When I think of myself, I think of my role in my work. I'm a narrator, or maybe a ventriloquist. Being pop is about consolidating, about going, 'I'm me; I have a certain attitude,' rather than chopping myself up. I prefer to chop myself up" (9).

33. "The writing of our day," says Foucault, "has freed itself from the necessity of "expression"; it only refers to itself, yet it is not restricted to the confines of interiority. On the contrary, we recognize it in its exterior deployment." And he continues in a note, "the 'exterior deployment' of writing re-

lates to Ferdinand de Saussure's emphasis of the acoustic quality of the signifier, an external phenomena of speech. . . ." (*Order* 116).

34. See Kardon 19.

35. See Eagleton, *Literary Theory* 173. For a more extensive description of Lacan's theories, see Anthony Wilden's essay "Lacan and the Discourse of the Other" (Lacan, especially 264–65).

36. Eagleton explains this movement from "language to "discourse" as follows: "The shift from structuralism has been in part, to use the terms of the French linguist Emil Benveniste, a move from 'language' to 'discourse'. 'Language' is speech or writing viewed 'objectively', as a chain of signs without a subject. 'Discourse' means language grasped as *utterance*, as involving speaking and writing subjects and therefore also, at least potentially, readers or listeners" (*Literary Theory* 115).

CHAPTER 5. "POSITIVE DISINTEGRATIONS": WORKING LANGUAGE INTO THE 1990s

1. See Gussow.

2. See Baudrillard, "The Implosion of Meaning" 148.

3. See Borofsky.

4. See Sayre, "Installation and Dislocation: The Example of Jonathan Borofsky" in Perloff, *Postmodern Genres* 175–92.

5. I would like to thank Mac Wellman for a manuscript copy of the dramatic version of *Terminal Hip*.

6. See Poster.

7. See Solomon.

8. I would like to thank John Jesurun for a manuscript copy of "Everything That Rises Must Converge." It was performed February 11, 1990, at the Wexner Center for the Visual Arts, Columbus, Ohio.

9. See Jameson, "Postmodernism."

10. See Hartley 42–52.

11. See McCaffery, "Sound Poetry," Andrews and Bernstein 88–91.

12. See McCaffery and bpNichol.

13. See Lawrence Weiner, "Regarding The (A) Use of Language within the Context of Art," in Andrews and Bernstein 183.

14. See Charles Bernstein, *Content's Dream* 165–83.

15. See Andrews and Bernstein 167.

16. This discussion in *Philosophical Investigations* may be the source for McCaffery's line: "The word 'beetle' in a box" (31).

17. See "Intraview," Andrews and Bernstein 189.

18. See "L=A=N=G=U=A=G=E Poetry in the Eighties," in Perloff, *The Dance of the Intellect* 221.

19. Letter, July 19, 1990.
20. See Perloff, *Dance of the Intellect* 215–38.
21. See "Writing and Method," *Poetics Journal* 3 (May 1983):7.
22. Letter, July 19, 1990.

WORKS CITED

Abish, Walter. *Alphabetical Africa*. New York: New Directions, 1974.

Altieri, Charles. *Act and Quality: A Theory of Literary Meaning and Humanistic Understanding*. Amherst: U of Massachusetts P, 1981.

———. "From Symbolist Thought to Immanence: The Ground of Postmodern American Poetics." *Boundary 2* (Spring 1973): 605–41.

———. *Self and Sensibility in Contemporary American Poetry*. Cambridge: Cambridge UP, 1984.

Amirkhanian, Charles. "Interview with Laurie Anderson." *The Guests Go In To Supper*. Oakland, Calif.: Burning Books, 1986. 217–49.

Anderson, Laurie. "Autobiography: The Self in Art. Notes from a Talk Delivered at the CAA Convention, January 1978." *LAICA Journal* (June–July 1978): 34–35.

———. *Dark Dogs, American Dreams*. In *Hotel*. New York: Tanan P, 1980. 108–31.

———. "From Americans on The Move." *October* 8 (Spring 1979): 45–57.

———. "Juanita." *Word Image Number*. Ed. Mary Delahoyd. Exhibit. Catalogue. New York: Sarah Lawrence Gallery, 1975.

———. *Laurie Anderson*. Documentation of an installation and performance at And/Or, June 6–14, 1978. Seattle: And/Or, 1979. N. pag.

———. "Laurie Anderson: Mid-Career." Exhibition Flier. Frederick S. Wight Art Gallery, UCLA. January 31–March 4, 1984.

———. "Notes from 'Like A Stream.'" *Performance by Artists*. Ed. A. A. Bronson and Peggy Gale. Toronto: Art Métropole, 1979. 41–48.

———. *United States*. New York: Harper, 1984. N. pag.

———. *Words in Reverse*. New York: Top Stories, 1979. N. pag.

Andrews, Bruce, and Charles Bernstein. *The L=A=N=G=U=A=G=E Book*. Carbondale: Southern Illinois UP, 1984.

Antin, David. "Duchamp and Language." Notes of an improvised talk, 12 April 1972. D'Harnoncourt and McShine 100–15.

———. "Is There a Postmodernism?" *Romanticism, Modernism, Postmodernism*. Ed. Harry R. Garvin. Lewisburgh, Pa.: Bucknell UP, 1980. 127–35.

———. "It Reaches a Desert Where Nothing Can Be Perceived But Feeling." *Art News* 70 (March 1971): 38–41, 66–69.

————. "Modernism and Postmodernism: Approaching the Present in American Poetry" *Boundary 2* 1 (1972): 98–133.

Appignanesi, Lisa, ed. *ICA Documents 4: Postmodernism*. London: Institute of Contemporary Arts, 1986.

Arakawa, and Madeline Gins. *The Mechanism of Meaning*. New York: Abrams, 1979.

Arnheim, Rudolf. *Entropy and Art: An Essay on Disorder and Order*. Los Angeles: U of California P, 1971.

Atkinson, Terry, David Bainbridge, Michael Baldwin, Harold Hurrel, and Joseph Kosuth. *Art and Language*. German-English Edition. Ed. Paul Maenz and Gerd de Vries. Köln: Verlag M. DuMont Schauberg, 1972.

Auslander, Philip. "Toward a Concept of the Political in Postmodern Theatre." *Theatre Journal* (March 1987): 20–34.

Bakhtin, M. M. "Discourse in the Novel." *The Dialogic Imagination*. Ed. Michael Holquist. Trans. Caryl Emerson and Michael Holquist. Austin: U of Texas P, 1981. 259–422.

Baracks, Barbara. Review. *Artforum* 15 (April 1977): 64.

Barth, John. "The Literature of Exhaustion." *Atlantic* 220 (1967): 29–34.

————. "The Literature of Replenishment: Postmodernist Fiction." *Atlantic* 245 (1980): 65–71.

Barthes, Roland. *Elements of Semiology*. Trans. Annette Lavers and Colin Smith. New York: Hill & Wang, 1967.

————. *Image-Music-Text*. Ed. and trans. Stephen Heath. New York: Hill & Wang, 1977.

Battcock, Gregory. "Documentation in Conceptual Art." *Arts Magazine* (April 1970): 42–47.

————, ed. *Idea Art: A Critical Anthology*. New York: Dutton, 1973.

————, ed. *Minimal Art: A Critical Anthology*. New York: Dutton, 1968.

————, ed. *The New American Cinema: A Critical Anthology*. New York: Dutton, 1967.

Battcock, Gregory, and Robert Nickas. *The Art of Performance*. New York: Dutton, 1984.

Baudrillard, Jean. "The Ecstasy of Communication." Trans. John Johnston. Foster, *The Anti-Aesthetic* 126–34.

————. "The Implosion of Meaning in the Media and the Implosion of the Social in the Masses." Trans. Mary Lydon. *The Myths of Information: Technology and Postindustrial Culture*. Ed. Kathleen Woodward. Madison: Coda Press, 1980. 137–48.

————. "The Precession of Simulacra." *Art After Modernism: Rethinking Representation*. Ed. Brian Wallis. New York: New Museum of Contemporary Art; Boston, Mass.: Godine, 1984. 87–111.

Bauman, Richard, Ed. *Verbal Art as Performance*. Rowley: Newbury House, 1978.

Beardsley, John. *Earthworks and Beyond: Contemporary Art in the Landscape*. New York: Abbeville, 1984.

Beckett, Samuel. *Proust*. New York: Grove, 1957.

———. *The Unnamable*. New York: Grove, 1970.

Benamou, Michel, and Charles Caramello, eds. *Performance in Postmodern Culture*. Madison: Center for Twentieth-Century Studies, 1977.

Benhabib, Seyla. "Epistemologies of Postmodernism: A Rejoinder to Jean-François Lyotard." *New German Critique* 33 (Fall 1984): 103–26.

Benveniste, Emile. *Problems in General Linguistics*. Trans. Mary Elizabeth Meek. Coral Gables, Fla.: U of Miami P, 1971.

Bernstein, Charles. *Content's Dream: Essays 1975–1984*. Los Angeles: Sun and Moon, 1986.

———. "Writing and Method." *Poetics Journal* 3 (May 1983): 6–16.

Bertens, Hans. "The Postmodern *Weltanschauung* and its Relation with Modernism: An Introductory Survey." Fokkema and Bertens, 9–51.

Booth, Wayne C. "Freedom of Interpretation: Bakhtin and the Challenge of Feminist Criticism." *Critical Inquiry* 9 (1982): 45–76.

Borges, Jorge Luis. *Labyrinths: Selected Stories and Other Writings*. Ed. Donald A. Yates and James E. Irby. New York: New Directions, 1964.

Borofsky, Jonathan. *Dreams*. Tokyo: Isshi, 1987.

Bradbury, Malcom. *Possibilities: Essays on the State of the Novel*. London: Oxford, 1983.

———. *The Modern American Novel*. New York: Oxford, 1983.

Breton, André. "Lighthouse of the Bride." *Surrealism and Painting*. Trans. Simon Watson Taylor. New York: Harper. 85–99.

Brooke-Rose, Christine. *A Rhetoric of the Unreal: Studies in Narrative and Structures, Especially of the Fantastic*. New York: Cambridge, 1981.

Bryson, Norman. *Vision and Painting: The Logic of the Gaze*. New Haven: Yale UP, 1983.

Buren, Daniel. "Beware!" Meyer 61–77.

———. "It Rains, It Snows, It Paints." Battcock, *Idea Art* 175–79.

Bürger, Peter. *Theory of the Avant-Garde*. Trans. Michael Shaw. Minneapolis: U of Minnesota P, 1984.

Burgin, Victor. *The End of Art Theory: Criticism and Postmodernity*. London: Macmillan, 1986.

Burnham, Jack. *Great Western Salt Works: Essays on the Meaning of Post-Formalist Art*. New York: Braziller, 1974.

Burroughs, William S., and Daniel Odier. *The Job: Interviews with William S. Burroughs*. New York: Grove, 1974.

Butler, Christopher. *After the Wake: An Essay on the Contemporary Avant-Garde*. Oxford: Oxford UP, 1980.

Cabanne, Pierre. *Dialogues with Marcel Duchamp*. Trans. Ron Padgett. New York: Viking, 1971.

Cage, John. *Silence*. Cambridge: MIT, 1961.

Calas, Nicholas. "Scandal's Witness: Grafting Smithson on Bataille." *Artforum* 19 (February 1981): 68–70.

Calas, Nicolas, and Elena Calas. *Icons and Images of the Sixties*. New York: Dutton, 1971.

Calinescu, Matei. *Faces of Modernity*. Bloomington: Indiana UP, 1977.

———. "Postmodernism and Some Paradoxes of Periodization." Fokkema and Bertens 239–54.

———. "Ways of Looking at Fiction." *Romanticism, Modernism, Postmodernism*. Ed. Harry R. Garvin. London: Associated University Presses, 1980. 155–70.

Caramello, Charles. *Silverless Mirrors: Book, Self, and Postmodern American Fiction*. Tallahassee: University Presses of Florida, 1983.

Carroll, David. *The Subject in Question: The Languages of Theory and the Strategies of Fiction*. Chicago: U of Chicago P, 1982.

Casademont, Joan. Review (*Dark Dogs, American Dreams*). *Artforum* 18 (Summer 1980): 85–86.

Caws, Mary Ann. "Literal or Liberal: Translating Perception." *Critical Inquiry* 13 (Autumn 1986): 49–63.

Celant, Germano, ed. *Arte Povera: Earthworks, Impossible Art, Actual Art, Conceptual Art*. New York: Praeger, 1969.

Childs, Elizabeth C. "Robert Smithson and Film: *The Spiral Jetty*." *Arts Magazine* 56 (October 1981): 68–81.

Cohen, John. "Subjective Time." Fraser 257–75.

Collins, James. "Narrative." *Narrative Art: An Exhibition of Works by David Askevol, Didier Bay, Bill Beckley, Robert Cumming, Peter Hutchinson, Jean Le Gac, and Roger Welch*. Preface by James Collins. Palais des Beaux-Arts, 10 Rue Royale, Bruxelles, 26 September–3 November, 1974. N. pag.

Conroy, Mark. *Modernism and Authority: Strategies of Legitimation in Flaubert and Conrad*. Baltimore: Johns Hopkins, 1985.

Cook, David and, Arthur Kroker. *The Postmodern Scene: Excremental Culture and Hyper-Aesthetics*. New York: St. Martin's, 1986.

Cooper, Douglas. *The Cubist Epoch*. London: Phaidon, 1970.

Copeland, Roger. "What You See Is Not What You Hear." *Portfolio* (March–April 1983): 102–105.

Coward, Rosalind, and John Ellis. *Language and Materialism: Developments in Semiology and the Theory of the Subject*. Boston: Routledge, 1977.

Crichton, Michael. *Jasper Johns*. New York: Abrams, 1977.

Crimp, Douglas. "The End of Painting." *October* (Spring 1981): 69–86.

———. "On the Museum's Ruins." Foster, *The Anti-Aesthetic* 43–56.

Danto, Arthur. *The Transfiguration of the Commonplace*. Cambridge: Harvard UP, 1981.

Dare, Michael. "Laurie Anderson: Dancing About Architecture." Interview. *L.A. Extra* (July 1986): 9–10.

Davies, Douglas. *Artculture: Essays on the Post-Modern*. New York: Harper, 1977.

Davis, Bruce. "Recent Acquisitions: Marcel Duchamp, France, 1887–1968." *The Graphic Arts Council Newsletter* 15. Los Angeles: Los Angeles County Museum of Art. 3–4.

Derrida, Jacques. "Freud and the Scene of Writing." *Writing and Difference.* Trans. Alan Bass. Chicago: U of Chicago P, 1978.

———. "The Law of Genre." *Glyph 7*. Baltimore: Johns Hopkins, 1980. 176–232.

———. *Margins of Philosophy*. Trans. Alan Bass. Chicago: U of Chicago P, 1982.

———. *Of Grammatology*. Trans. Gayatri Chakravorty Spivak. Baltimore: Johns Hopkins, 1974.

D'Haen, Theo. "Postmodernism in American Fiction and Art" Fokkema and Bertens 211–31.

———. *Text to Reader: A Communicative Approach to Fowles, Barth, Cortazar, and Boon*. Amsterdam: Benjamins, 1983.

D'Harnoncourt, Anne, and Kynaston McShine, eds. *Marcel Duchamp*. New York: The Museum of Modern Art and the Philadelphia Museum of Art, 1973.

Duchamp, Marcel. "A L'Infinitif." *The Salt Seller*. Ed. Michel Sanouillet and Elmer Peterson. New York: Oxford UP, 1973.

———. *The Bride Stripped Bare By Her Bachelors, Even*. Ed. Richard Hamilton. Trans. George Heard Hamilton. London: Lund Humphries, 1960.

———. *Notes and Projects for the "Large Glass."* Ed. Arturo Schwarz. New York: Abrams, 1969.

———. *Salt Seller*. Ed. Michel Sanouillet and Elmer Peterson. Trans. Elmer Peterson. New York: Oxford UP, 1973.

Dunne, J. W. *The Serial Universe*. London: Faber & Faber, 1934.

Durand, Regis. "The Disposition of the Voice." Benamou and Caramello, *Performance in Postmodern Culture* 99–110.

Eagleton, Terry. "Capitalism, Modernism, and Postmodernism" *New Left Review* 152 (1985): 60–73.

———. *Literary Theory*. Minneapolis: U of Minnesota P, 1983.

Eco, Umberto. *Postscript to The Name of the Rose.* Trans. William Weaver. New York: Harcourt, 1984.

Ehrenzweig, Anton. *The Hidden Order of Art: A Study in the Psychology of Artistic Imagination.* Los Angeles: U of California P, 1971.

Elton, William, ed. *Aesthetics and Language.* Oxford: Basil Blackwell, 1954.

Federman, Raymond, ed. *Surfiction: Fiction Now . . . and Tomorrow.* 2nd ed. Chicago: Swallow, 1981.

Fekete, John. *Life After Postmodernism: Essays on Value and Culture.* New York: St. Martin's, 1987.

Fiedler, Leslie. "The New Mutants." *A Fiedler Reader.* New York: Stein & Day, 1977. 189–210.

Fish, Stanley. "How Ordinary Is Ordinary Language?" *New Literary History* 5 (Autumn 1973): 41–54.

Flood, Richard. "Laurie Anderson." *Artforum* (September 1981): 80–81.

Flynt, Henry. "Concept Art." *An Anthology.* Ed. La Monte Young and Jackson MacLow. N.p.: Heiner Friedrich, 1979. First published 1963. N. pag.

Fokkema, Douwe. *Literary History, Modernism, and Postmodernism.* Philadelphia: Benjamins, 1984.

Fokkema, Douwe, and Hans Bertens, eds. *Approaching Postmodernism: Papers Presented at a Workshop on Postmodernism, 21–23 September 1984, University of Utrecht.* Amsterdam and Philadelphia: Benjamins, 1986.

Forte, Jeannie. "Women's Performance Art: Feminism and Postmodernism." *Theatre Journal* 40 (May 1988): 217–35.

Foster, Hal. *The Anti-Aesthetic: Essay on Postmodern Culture.* Port Townsend, Wash.: Bay, 1983.

———. "(Post) Modern Polemics." *New German Critique* 33 (Fall 1984): 66–78.

———. *Recodings: Art, Spectacle, Cultural Politics.* Port Townsend, Wash.: Bay, 1985.

———. "Wild Signs: The Breakup of the Sign in Seventies' Art." *Universal Abandon? The Politics of Postmodernism.* Ed. Andrew Ross. Minneapolis: U of Minnesota P, 1988. 251–68.

Foucault, Michel. *The Order of Things.* New York: Vintage, 1970.

———. *This Is Not a Pipe.* Trans. James Harkness. Los Angeles: U of California P, 1983.

Fox, Howard N., Miranda McClintic, and Phyllis Rosenzweig. *Content: A Contemporary Focus, 1974–1984.* Washington, D.C.: Hirshhorn Museum and Sculpture Garden. Smithsonian Institution, 1984.

Francis, Richard. *Jasper Johns.* New York: Abbeville, 1984.

Fraser, J. T., ed. *The Voices of Time.* New York: Braziller, 1966.

Frazer, Nancy, and Linda Nicholson. "Social Criticism without Philosophy:

An Encounter between Feminism and Postmodernism." *Universal Abandon? The Politics of Postmodernism*. Ed. Andrew Ross. Minneapolis: U of Minnesota P, 1988. 83–104.

Freeman, Judi. "Layers of Meaning: The Multiple Readings of Dada and Surrealist Word-Images." *The Data and Surrealist Word-Image*. Ed. Judi Freeman. Los Angeles: Los Angeles County Museum of Art and Cambridge: MIT, 1989. 13–56.

Freud, Sigmund. *Jokes and their Relation to the Unconscious*. Trans. James Strachey. New York: W. W. Norton, 1960.

Fried, Michael. "Art and Objecthood." Battcock, *Minimal Art* 116–47.

Gablik, Suzi. *Has Modernism Failed?* New York: Thames & Hudson, 1984.

Giddens, Anthony. "Modernism and Post-Modernism." *New German Critique* 22 (1981): 15–18.

Gilbert-Rolfe, Jeremy, and John Johnstone. "*Gravity's Rainbow* and *The Spiral Jetty*." Part I, *October* (Spring 1976): 65–85. Part II, *October* 2 (Fall 1976): 71–90. Part III, *October* 3 (Spring 1977): 90–101.

Gitlin, Todd. "Hip-Deep in Post-Modernism." *New York Times Book Review*, 6 November 1988: 1, 35–36.

Goldberg, RoseLee. *Performance: Live Art 1909 to the Present*. New York: Abrams, 1979.

———. "Performance: The Golden Years." Battcock and Nickas, *The Art of Performance* 71–94.

———. "What Happened to Performance Art?" *Flash Art* 116 (March 1984): 28–29.

Gombrich, E. H. *Art and Illusion: A Study in the Psychology of Pictorial Representation*. 2nd ed. Princeton: Princeton UP, 1972.

Gordon, Kim. "I'm Really Scared . . . When I Kill in My Dreams." *Artforum* 21 (January 1983): 54–57.

Gould, Stephen Jay. *The Panda's Thumb*. New York: Norton, 1982.

Graff, Gerald. "Babbitt at the Abyss: The Social Context of Postmodern American Fiction." *TriQuarterly* 33 (1975): 305–37.

———. *Literature Against Itself*. Chicago: U of Chicago P, 1979.

———. "The Myth of the Postmodernist Breakthrough." *TriQuarterly* 26 (1973): 383–417.

Gussow, Mel. "Playwrights Who Put Words At Center Stage." *New York Times*, 11 February 1990: 5H, 44H.

Habermas, Jürgen. "Modernity—An Incomplete Project." Foster, *The Anti-Aesthetic* 3–15.

Haftmann, Werner. *Painting in the Twentieth Century*. Trans. Ralph Manheim. New York: Praeger, 1965.

Hartley, George. *Textual Politics and the Language Poets*. Bloomington: Indiana UP, 1989.

Hassan, Ihab. *The Dismemberment of Orpheus: Toward a Postmodern Literature*. 2nd ed. Madison: U of Wisconsin P, 1982.

————. *The Postmodern Turn: Essays in Postmodern Theory and Culture*. Columbus: Ohio State UP, 1987.

————. "POSTmodernISM." *New Literary History* 3 (1971): 5–30.

————. "The Question of Postmodernism." *Romanticism, Modernism, Postmodernism*. Ed. Harry R. Garvin. London: Associated Presses, 1980. 117–26.

Hassan, Ihab, and Sally Hassan, eds. *Innovation/Renovation: New Perspectives on the Humanities*. Madison: U of Wisconsin P, 1983.

Hicks, Emily. "Performance: An Information Continuum." *Art Week* 12 (31 October 1981): 4.

Hobbs, Robert. *Robert Smithson: Sculpture*. Ithaca: Cornell UP, 1981.

Hoffman, Gerhard. "The Absurd and its Forms of Reduction in Postmodern American Fiction." Fokkema and Bertens 185–210.

Howe, Irving. "Mass Society and Postmodern Fiction." *Partisan Review* 26 (1959): 420–36. Reprinted in Irving Howe, *The Decline of the New*. New York: Harcourt, 1970. 190–207.

Hubert, Christian. "Post-modernism." The Young Architects' Circle Symposium. *Reallife Magazine* 6 (Summer 1981): 4.

Hulme, Thomas Ernest. *Speculations: Essays on Humanism and the Philosophy of Art*. Ed. Herbert Read. New York: Humanities P, 1965.

Hutcheon, Linda. *The Poetics of Postmodernism: History, Theory, Fiction*. New York: Routledge, 1988.

————. *The Politics of Postmodernism*. New York: Routledge, 1989.

————. "The Politics of Postmodernism: Parody and History." *Cultural Critique* 5 (Winter 1986–87): 179–207.

Huyssen, Andreas. *After the Great Divide: Modernism, Mass Culture, Postmodernism*. Bloomington: Indiana UP, 1986.

————. "The Search for Tradition: Avant-Garde and Postmodernism in the 1970s." *New German Critique* 22 (1981): 23–40.

Jameson, Fredric. "The Politics of Theory." *New German Critique* 33 (Fall 1984): 53–66.

————. "Postmodernism and Consumer Society." Foster, *The Anti-Aesthetic* 111–25.

————. "Postmodernism, Or the Cultural Logic of Late Capitalism." *New Left Review* 146 (July–August 1984): 53–92.

Jarmusch, Ann. Review. *Art News* 83 (May 1984): 128–31.

Jencks, Charles A. *The Language of Post-Modern Architecture*. 3rd ed. New York: Rizzoli, 1981.

————. *Postmodernism*. New York: Rizzoli, 1988.

Jung, C. G. *Alchemical Studies*. Trans. R.F.C. Hull. Princeton: Princeton UP, 1967.

Kahnweiler, Daniel-Henry. *Juan Gris; His Life and Work*. Trans. Douglas Cooper. New York: Curt Valentin, 1947.

Kardon, Janet. "Laurie Anderson: A Synesthetic Journey." *Laurie Anderson: Works from 1969 to 1983*. Ed. Janet Kardon Exhibition Catalogue, 15 Oct.–4 Dec. U of Pennsylvania: Institute of Contemporary Art, 1983.

Kearney, Richard. *The Wake of Imagination: Toward a Postmodern Culture*. Minneapolis: U of Minnesota P, 1988.

Kent, Thomas L. "The Classifications of Genres." *Genre* (Spring 1983): 1–20.

Klinkowitz, Jerome. *Literary Disruptions: The Making of a Post-Contemporary American Fiction*. 2nd ed. Urbana: U of Illinois P, 1980.

———. *Literary Subversions: New American Fiction and the Practice of Criticism*. Carbondale and Edwardsville: Southern Illinois UP, 1985.

———. *The Self-Apparent Word: Fiction as Language/Language as Fiction*. Carbondale: Southern Illinois UP, 1984.

Kostelanetz, Richard. *Metamorphosis in the Arts: A Critical History of the 1960s*. Brooklyn: Assembling P, 1980.

Kosuth, Joseph. "Art After Philosophy." *Studio International*. Part I: 178 (October 1969): 134–37. Part II: 178 (November 1969): 160–61. Part III: 178 (December 1969): 212.

———. *Art Investigations and "Problematic" Since 1965*. Luzern: Kunstmuseum, 1973.

———. *Function*. Torino, Italy: Sperone Editore, 1970. N. pag.

———. "Introductory Note by the American Editor." *Art and Language*. Ed. Paul Maenz and Gerd de Vries. Köln: Verlag M. DuMont Schauberg, 1972. 100–107.

———. *Notebook on Water*. New York: Multiples, 1970. Photostats unordered and unpaginated in manila envelope.

Kozloff, Max. *Jasper Johns*. New York: Abrams, 1969.

Krauss, Rosalind. *The Originality of the Avant-Garde and Other Modernist Myths*. Cambridge: MIT, 1985.

———. *Passages in Modern Sculpture*. New York: Viking, 1977.

———. "Poststructuralism and the 'Paraliterary.'" *October* 13 (1980): 36–40.

Krieger, Murray. "The Ambiguities of Representation and Illusion: An E. H. Gombrich Retrospective." *Critical Inquiry* 22 (December 1984): 181–94.

Kristeva, Julia. *Desire in Language*. Trans. Thomas Gora, Alice Jardine, and Leon S. Roudiez. New York: Columbia U, 1980.

————. "Postmodernism?" *Romanticism, Modernism, Postmodernism.* Ed. Harry R. Garvin. Lewisburg: Bucknell UP, 1980. 136–41.

Kroker, Arthur, and David Cook. *The Postmodern Scene: Excremental Culture and Hyper-Aesthetics.* New York: St. Martin's, 1986.

Krupnick, Mark, ed. *Displacement: Derrida and After.* Bloomington: Indiana UP, 1983.

Kubisch, Christina. "Time into Space/Space into Time." *Flash Art* (March–April 1979): 16–18.

Kubler, George. *The Shape of Time: Remarks on the History of Things.* New Haven: Yale UP, 1962.

Lacan, Jacques. *Speech and Language in Psychoanalysis.* Trans. with notes and commentary by Anthony Wilden. Baltimore: Johns Hopkins, 1968.

La Frenais, Rob. "An Interview with Laurie Anderson." Ed. Laurie Anderson and Robert Nickas in New York, Dec. 1981. Battcock and Nickas 255–69.

Lawson, Thomas. "The Dark Side of the Bright Light." *Artforum* 21 (November 1982): 63–64.

Lebel, Robert. *Marcel Duchamp.* Trans. George Heard Hamilton. New York: Grove, 1959.

Leider, Philip. "Robert Smithson: The Essays." *Arts Magazine* (Special Issue: Robert Smithson) (May 1978): 96–97.

Lessing, Gotthold Ephraim. *Laocoön: An Essay on the Limits of Painting and Poetry.* Trans. E. C. Beasley. London: Longman, 1953. First ed. 1755.

Levin, Harry. "What Was Modernism?" *Refractions.* Ed. Harry Levin. New York: Oxford UP, 1966.

Levin, Kim. "Farewell to Modernism." *Arts Magazine* (October 1979): 90–93.

Lévi-Strauss, Claude. *The Savage Mind.* London: Weidenfeld & Nicholson, 1972.

————. "The Structural Study of Myth." *Myth: A Symposium.* Ed. Thomas A. Sebeok. Bloomington: Indiana UP, 1970. 81–106.

LeWitt, Sol. "Paragraphs on Conceptual Art." *Artforum* 5 (Summer 1967): 79–83.

Lifson, Ben. "Talking Pictures." Kardon 32–47.

Lippard, Lucy R., ed. *Changing: Essays in Art Criticism.* New York: Dutton, 1971.

————, ed. *Six Years: A Bibliographical Chronology on the Conceptual Art Movement.* London: Studio Vista, 1973.

Lischka, Gerhard Johann. "The Postmodern: A Multilateral Approach." *Flash Art* (January 1984): 22–24.

Lodge, David. *Modes of Modern Writing: Metaphor, Metonymy, and the Typology of Modern Literature.* London: Edward Arnold, 1977.

Lyotard, Jean-François. "Defining the Postmodern." *Postmodernism: ICA Documents 4.* London: Institute of Contemporary Arts, 1986. 6–7.

———. *The Postmodern Condition: A Report on Knowledge.* Trans. Geoff Bennington and Brian Massumi. Minneapolis: U of Minnesota P, 1984.

———. "The Works and Writings of Daniel Buren: An Introduction to the Philosophy of Contemporary Art." *Artforum* 19 (February 1981): 56–64.

Lyotard, Jean-François and Jean-Loup Thébaud. *Just Gaming.* Trans. Wlad Godzich. Minneapolis: U of Minnesota P, 1985.

McCaffery, Steve. *Evoba: The Investigations Mediations 1976–78.* Toronto: Coach House, 1987.

McCaffery, Steve, and bpNichol. *In England Now That Spring.* Toronto: Aya, 1979.

Mac Low, Jackson, and La Monte Young, eds. *An Anthology.* United States: Heiner Friedrich, 1963. Rev. ed. 1970. N. pag.

McHale, Brian. "Change of Dominant from Modernist to Postmodernist Writing." Fokkema and Bertens 53–79.

———. *Postmodernist Fiction.* New York: Methuen, 1987.

———. "Writing about Postmodern Writing." *Poetics Today* 3 (1982): 211–27.

McLuhan, Marshall. *Understanding Media.* New York: Signet, 1964.

Malmgren, Carl Darryl. *Fictional Space in the Modernist and Postmodernist American Novel.* Lewisburg, Pa.: Bucknell UP, 1985.

Marincola, Paula. "Chronology." Kardon 63–83.

Mazzaro, Jerome. *Postmodern American Poetry.* Urbana: U of Illinois P, 1980.

Meerloo, Joost A. M. "The Time Sense in Psychiatry." Fraser 235–52.

Melville, Stephen. "Between Art and Criticism: Mapping the Frame in United States." *Theatre Journal* 37 (March 1985): 31–43.

———. "Robert Smithson: A Literalist of the Imagination." *Arts Magazine* (November 1982): 102–105.

Meyer, Ursula, ed. *Conceptual Art.* New York: Dutton, 1972.

Milazzo, Richard, ed. *Beauty and Critique.* New York: TSL, 1983.

Mitchell, W. J. T. *Iconology: Image, Text, Ideology.* Chicago: U of Chicago P, 1986.

———. *The Language of Images.* Chicago: U of Chicago P, 1980.

———. "*Ut Pictura Theoria*: Abstract Painting and the Repression of Language." *Critical Inquiry* 15 (Winter 1989): 348–71.

Morgan, Robert C. "Conceptual Art and Photographic Installations: The Recent Outlook." *After Image* (December 1981): 8–11.

Morgan, Stuart. "Robert Smithson's Early Work: A Resurrection." *Artforum* 23 (April 1985): 67–69.

Morris, Robert. "Words and Images in Modernism and Postmodernism." *Critical Inquiry* 15 (Winter 1989): 337–47.

Mussman, Toby. "Marcel Duchamp's Anemic Cinema." Battcock, *New American Cinema* 147–55.

Nabokov, Vladimir. *Ada or Ardor: A Family Chronicle*. New York: Penguin, 1969.

Newman, Charles. *The Post-Modern Aura*. Evanston: Northwestern UP, 1985.

Newman, Michael. "Revising Modernism, Representing Postmodernism." *Postmodernism: ICA Documents 4*. London: Institute of Contemporary Arts, 1986. 32–51.

Nickas, Robert. "Introduction." Battcock and Nickas ix–xxiii.

Norris, Christopher. *The Contest of Faculties: Philosophy and Theory After Deconstruction*. New York: Methuen, 1985.

Norvell, P. A. "Fragments of an Interview with Robert Smithson." Lippard, *Six Years* 87–90.

Owens, Craig. "The Allegorical Impulse: Toward a Theory of Postmodernism." Part I: *October* 12 (Spring 1980): 67–86. Part II: *October* 13 (Summer 1980): 59–80.

———. "Amplifications: Laurie Anderson." *Art in America* 69 (March 1981): 121–23.

———. "The Discourse of Others: Feminists and Postmodernism." Foster, *The Anti-Aesthetic* 57–82.

———. "Earthwords." *October* 10 (Fall 1979): 121–30.

———. "Post-Modernism." A Symposium of the Young Architects' Circle. *Reallife Magazine* (Summer 1981): 4–10.

———. "Representation, Appropriation, and Power" *Art in America* 70 (1982): 9–21.

———. "Sex and Language: In Between." Kardon 48–55.

Palmer, Richard. Ed. "Postmodernity and Hermeneutics." *Boundary 2* 5 (1977): 363–93.

Paz, Octavio. *Marcel Duchamp: Appearance Stripped Bare*. Trans. Rachel Phillips and Donald Gardner. New York: Viking, 1978.

———. "Representation, Appropriation, and Power." *Art in America* 70 (1982): 9–21.

Perloff, Marjorie. "*Contemporary/Postmodern: The 'New' Poetry?*" *Romanticism, Modernism, Postmodernism*. Ed. Harry R. Garvin. London: Associated UP, 1980. 171–80.

———. *The Dance of the Intellect: Studies in the Poetry of the Pound Tradition*. Cambridge: Cambridge UP, 1985.

———. "Dirty Language and Scramble Systems." *Sulfur* 11 (1984): 178–83.

———. *The Futurist Moment: Avant-Garde, Avant Guerre, and the Language of Rupture*. Chicago: U of Chicago P, 1986.

———. *The Poetics of Indeterminancy: Rimbaud to Cage*. Princeton: Princeton UP, 1981.

————, ed. *Postmodern Genres*. Oklahoma Project for Discourse and Theory. General Ed. Ronald Schliefer. XX (Fall–Winter 1987).

Pincus-Witten. *Postminimalism*. New York: Out of London P, 1977.

Pitkin, Hanna Fenichel. *Wittgenstein and Justice*. Los Angeles: U of California P, 1972.

Plagens, Peter. "557,087:Seattle." *Artforum* (November 1969): 64–67.

Pleynet, Marcelin. "Painting and *Surrealism and Painting*." Trans. Paul Rogers. *Comparative Criticism: A Yearbook*. Ed. Elinor S. Shaffer. Cambridge: Cambridge UP, 1982. 31–53.

Poe, Edgar Allan. *Eureka: An Essay on the Material and Spiritual Universe*. *The Science Fiction of Edgar Allan Poe*. Ed. Harold Beaver. New York: Penguin, 1976. 205–309.

Portoghesi, Paolo. *After Modern Architecture*. Trans. Meg Shore. New York: Rizzoli, 1982.

————. *Postmodern: The Architecture of the Postindustrial Society*. New York: Rizzoli, 1983.

Poster, Mark. *Critical Theory and Poststructuralism*. Ithaca: Cornell UP, 1989.

Pratt, Mary Louise. *Toward a Speech Act Theory of Literary Discourse*. Bloomington: Indiana UP, 1977.

Prinz, Jessica. "Beckett and Duchamp: The Fine Art of Inexpression." In *Beckett Translating/Translating Beckett*. Ed. Dina Sherzer, Charles Rossman, and Allen Warren Freedman. Philadelphia: Pennsylvania State UP, 1987. 95–106.

Rapaport, Herman. "'Can You Say Hello?' Laurie Anderson's *United States*." *Theatre Journal* 38 (October 1986): 339–54.

Ratcliff, Carter. "The Compleat Smithson." *Art in America* (January 1980): 60–65.

————. "New York Reviews." *Art International* (Summer 1970): 133–34.

————. "Robert Morris: Prisoner of Modernism." *Art In America* (October 1979): 96–110.

Reddy, Michael. "The Conduit Metaphor: A Case of Frame Conflict in our Language about Language." *Metaphor and Thought*. Ed. Andrew Ortony. Cambridge: Cambridge UP, 1979. 284–321.

Richards, I. A., and C. K. Ogden. *The Meaning of Meaning*. New York: Harcourt, 1946.

Rockwell, John. "Laurie Anderson's Music." Kardon 56–62.

Rorty, Richard. "Habermas and Lyotard on Postmodernity." *Praxis International* 4 (April 1984): 32–44.

Rose, Arthur R. "Four Interviews with Barry, Huebler, Kosuth, Weiner." *Arts Magazine* (February 1969): 22–23.

Rose, Barbara. "Channel Changers." *Marcel Duchamp, Jasper Johns, Robert*

Rauschenberg, and John Cage. Exhibition Catalogue. Cincinnati: The Contemporary Arts Center, 1971. 4–7.

———. "The Graphic Work of Jasper Johns, Part II." *Artforum* 9 (September 1970): 65–74.

Rosenberg, Harold. *The Anxious Object.* New York: Mentor, 1969.

———. *Artworks and Packages.* Chicago: U of Chicago P, 1969.

———. *The De-Definition of Art.* New York: Collier, 1972.

Rosenthal, Mark, and Richard Marshall. *Jonathan Borofsky.* Philadelphia Museum of Art and the Whitney Museum of Art, 1986.

Rosler, Martha. "Lookers, Buyers, Dealers, and Makers: Thoughts on Audience." Wallis 310–39.

———. *3 Works.* Halifax: Nova Scotia College of Art and Design, 1981.

Rosmarin, Adena. *The Power of Genre.* Minneapolis: U of Minnesota P, 1985.

Rothenberg, Jerome, ed. *Revolution of the Word: A New Gathering of American Avant-Garde Poetry 1914–1945.* New York: Seabury, 1974.

Roudiez, Leon S. "Introduction." *Desire in Language.* Ed. Leon S. Roudiez. Trans. Thomas Gora, Alice Jardine, and Leon S. Roudiez. New York: Columbia UP, 1980.

Rubin, William. "Talking with William Rubin: The Museum Concept is Not Infinitely Expandable." Interview by Lawrence Alloway and John Coplans. *Artforum* 13 (October 1974): 52.

Russell, Charles. *Poets, Prophets, and Revolutionaries: The Literary Avant-Garde from Rimbaud through Postmodernism.* New York: Oxford UP, 1985.

———, ed. *The Avant-Garde Today: An International Anthology.* Urbana: U of Illinois P, 1981.

———. "The Context of the Concept." *Romanticism, Modernism, Postmodernism.* Ed. Harry R. Garvin. London: Associated University Presses, 1980.

Sandler, Irving. *The New York School.* New York: Harper, 1978. 163–95.

Sanouillet, Michel. "Marcel Duchamp and the French Intellectual Tradition." Trans. Elmer Peterson. D'Harnoncourt and McShine 48–54.

Sarraute, Nathalie. *The Use of Speech.* Trans. Barbara Wright. New York: Braziller, 1983.

Sayre, Henry M. "Installation and Dislocation: The Example of Jonathan Borofsky." *Genre* 20 (Fall–Winter 1987): 409–26.

———. *The Object of Performance: The American Avant-Garde since 1970.* Chicago: U of Chicago P, 1989.

Schlegel, Richard. "Time and Thermodynamics." Fraser 500–23.

Schwarz, Arturo. *The Complete Works of Marcel Duchamp.* New York: Abrams, 1969. 2nd rev. ed., 1970.

Scott, Clive. "The Prose Poem and Free Verse." *Modernism 1890–1930*. Ed. Malcolm Bradbury and James MacFarlane. New York: Penguin, 1976.

"Serving Time: A Sakharov Article Appears." *Time*, 24 September 1984: 43.

Shaffer, E. S. "Editor's Introduction: Changing the Boundaries of Literature, Theory, and Criticism." *Comparative Criticism* 7 (1985): xi–xxiv.

Shepard, Sam. *Tongues. Seven Plays*. New York: Bantam, 1984.

Sheppard, Richard. "The Crises of Language." *Modernism: 1890–1930*. Ed. Malcolm Bradbury and James MacFarlane. New York: Penguin, 1978. 323–26.

Siegelaub, Seth, moderator. "Art without Space." A Symposium with Lawrence Weiner, Robert Barry, Douglas Huebler, and Joseph Kosuth. 2 November 1969. WBAI-FM. New York. Excerpts in Lippard, *Six Years* 127–28.

Smith, Philip. "A Laurie Anderson Story." Interview. *Arts Magazine* 57 (January 1983): 60–61.

Smith, Roberta. "Endless Meaning at the Hirshhorn." *Artforum* 23 (April 1985): 81–85.

Smithson, Robert. "Fragments of an Interview with P. A. Norvell, April, 1969." Lippard, *Six Years* 87–90.

———. *The Writings of Robert Smithson: Essays with Illustrations*. Ed. Nancy Holt. New York: New York UP, 1979.

Solomon, Alisa. "A Grammar of Motives." *The Village Voice*, 16 January, 1990. 99; 102.

Sondheim, Alan, ed. *Individuals: Post-Movement Art in America*. New York: Dutton, 1977.

Sontag, Susan. *Against Interpretation*. New York: Dell, 1979.

Spanos, William V. "The Detective and the Boundary: Some Notion of the Postmodern Literary Imagination" *Boundary 2* (1972): 147–68.

———. *Repetitions: The Postmodern Occasion in Literature and Culture*. Baton Rouge: Louisiana State UP, 1987.

Staten, Henry. *Wittgenstein and Derrida*. Lincoln: U of Nebraska P, 1984.

Steiner, Wendy. "Collage or Miracle: Historicism in a Deconstructed World." *Reconstructing American Literary History*. Ed. Sacvan Bercovitch. Cambridge: Harvard UP. 323–51.

———. *The Colors of Rhetoric: Problems in the Relation Between Modern Literature and Painting*. Chicago: U of Chicago P, 1982.

Stevick, Philip. "Literature." Trachtenberg 135–56.

Sukenick, Ronald. *In Form: Digressions on the Act of Fiction*. Carbondale: Southern Illinois UP, 1985.

Suleiman, Susan Rubin. *Authoritarian Fictions: The Ideological Novel as a Literary Genre*. New York: Columbia UP, 1983.

————. "Naming a Difference: Reflections on 'Modernism versus Postmod-
ernism' in Literature." Fokkema and Bertens 255–70.

Swenson, G. R. "Interviews with Roy Lichtenstein, Andy Warhol, and Jasper
Johns." *Avant-Garde Art.* Ed. Thomas Hess and John Ashbery. New York:
Collier, 1967.

Tancock, John. "The Influence of Marcel Duchamp." D'Harnoncourt and
McShine 160–75.

Terbell, Melinda. "Reviews." *Arts Magazine* (November 1968): 61.

Thiher, Allen. *Words in Reflection: Modern Language Theory and Postmodern
Fiction.* Chicago: U of Chicago P, 1984.

Todd, Richard. "The Presence of Postmodernism in British Fiction: Aspects of
Style and Selfhood." Fokkema and Bertens 99–117.

Todorov, Tzvetan. "The Notion of Literature." Trans. Lynn Moss and Bruno
Braunrot. *New Literacy History* 5 (Autumn 1973): 5–16.

Tololyan, Khachig. "Postmodern Signs." *Novel* 19 (Spring 1986): 264–67.

Tomkins, Calvin. *The Bride and The Bachelors: Five Masters of the Avant-
Garde.* New York: Viking, 1965.

————. *Off the Wall: Robert Rauschenberg and the Art World of Our Time.*
New York: Penguin, 1980.

————. *The Scene: Reflections on Postmodern Art.* New York: Viking, 1976.
142–47.

Trachtenberg, Stanley. *The Postmodern Movement.* London: Greenwood,
1985.

Ulmer, Gregory L. *Applied Grammatology: Post(e) Pedagogy from Jacques
Derrida to Joseph Beuys.* Baltimore: Johns Hopkins, 1985.

————. "The Object of Post-Criticism." Foster, *The Anti-Aesthetic* 83–110.

Venturi, Robert, Denise Scott-Brown, and Steven Izenour. *Learning from Las
Vegas.* Cambridge: MIT, 1972.

Vinklers, Bitite. "Art and Information: 'Software' at the Jewish Museum." Re-
view article. *Arts Magazine* (Sept./Oct. 1970): 46–49.

von Franz, M. L. "Time and Synchronicity in Analytic Psychology." Fraser
218–32.

Waldman, Diane. *Jenny Holzer.* New York: Solomon R. Guggenheim Museum
and Harry N. Abrams, 1989.

Wallis, Brian, ed. *Art After Modernism: Rethinking Representation.* New York:
New Museum of Contemporary Art and Boston: Godine, 1984.

Wasson, Richard. "From Priest to Prometheus: Culture and Criticism in the
Post-Modernist Period." *Journal of Modern Literature* 3 (1974): 1188–
1202.

Weber, Annina Nosei, ed. *Discussion.* New York: Out of London, 1980.

Weibel, Peter. "The Influence of Turn-of-the-Century Science and Philosophy

from Mach to Wittgenstein on American Avant-Garde Art." Lecture, University of Southern California, Los Angeles, March 1984.

Welchman, John C. "After the Wagnerian Bouillabaisse: Critical Theory and the Dada and Surrealist Word-Image." Freeman 57–95.

Weschler, Lawrence. *Seeing is Forgetting the Name of the Thing Seen: A Life of Contemporary Artist Robert Irwin.* Los Angeles: U of California P, 1982.

Wilde, Alan. *Horizons of Assent: Modernism, Postmodernism, and the Ironic Imagination.* Baltimore: Johns Hopkins, 1981.

Wilden, Anthony. *Speech and Language in Psychoanalysis.* Baltimore: Johns Hopkins, 1984.

Williams, William Carlos. *In the American Grain.* New York: New Directions, 1956.

Wilson, William. "Two Shows that Travel the Experimental Route." *Los Angeles Times*, 12 February 1984: 100.

Wittgenstein, Ludwig. *The Blue and Brown Books.* New York: Harper, 1958.

———. *Letters to C. K. Ogden.* Oxford: Basil Blackwell, 1973.

———. *Philosophical Investigations.* Trans. G. E. M. Anscombe. New York: Macmillan, 1958.

———. *Tractatus Logico-Philosophicus.* Trans. D. F. Pears and B. F. McGuinness. London: Routledge, 1961.

Worringer, Wilhelm. *Abstraction and Empathy: A Contribution to the Psychology of Style.* Trans. Michael Bullock. New York: World, 1967.

"Writing and Method," *Poetics Journal* 3 (May 1983): 7.

Zaniello, Thomas A. "Our Future Tends to be Prehistoric: Science Fiction and Robert Smithson." *Arts Magazine* (May 1978): 114–17.

Zavarzadeh, Mas'ud. *The Mythopoeic Reality: The Postwar American Nonfiction Novel.* Urbana: U of Illinois P, 1976.

Ziolkowski, Theodore. "Toward a Post-Modern Aesthetics?" *Mosaic* 2 (1969): 112–19.

Zurbrugg, Nicholas. "Postmodernity, *Métaphore Manquée*, and the Myth of the Trans-avant-garde." *SubStance* 48 (1986): 68–90.

INDEX

192n8, 193n25; de-definitional
impulse in, 51; interdisciplinarity
of, 8, 98, 103, 138, 152–153;
style of writing in, 119
poststructuralism, 80, 82, 93, 101,
190–191n37
Pound, Ezra, 79, 95; *Cantos, The,*
193–194n26
Proust, Marcel, 96
Pynchon, Thomas, 161

Ramsden, Mel, 50, 71–72, 180–
181n4
Rapaport, Herman, "'Can You Say
Hello?' Laurie Anderson's *United
States,*" 193n25
Ratcliff, Carter, 185n6; "Robert
Morris; Prisoner of Modernism," 3
Rauschenberg, Robert, 11, 65,
184n1; *Erased de Kooning,* 11;
Music Box, 127; *Portrait of Iris
Clert,* 11, 46–47; *Soundings,*
126–127; *Trophy II for Teeny and
Marcel Duchamp,* 11
realism, 6, 189n31
Reddy, Michael, 93
Reinhardt, Ad, 50, 92, 93, 181n9
Reverdy, Pierre, 16
*Revolutions Per Minute (The Artists'
Record),* 128
Richards, I. A., *Meaning of
Meaning, The,* 178n20
Rockwell, John, 192n9
Rose, Arthur R., 46, 47, 74
Rose, Barbara, "Graphic Work
of Jasper Johns, Part II, The,"
33
Rosenberg, Harold, 10–11, 185n6;
Anxious Object, The, 11; *Artworks
and Packages,* 23, 130, 178n14,
181n5; *De-Definition of Art, The,*
50, 51

Rosenthal, Mark, 156, 157, 158,
159
Rosenzweig, Phyllis, 191n2
Rothenberg, Jerome, ed., *Revolution
of the Word,* 21
Roudiez, Leon S., *Desire in
Language,* 177n5
Rubin, William, 6
Rusha, Edward, 2
Rushton, D., 180–181n4

Sandler, Irving, 177n11
Sarraute, Nathalie, 148; *Use of
Speech, The,* 147
Sartre, Jean-Paul, 79
Satie, Eric, *Relâche,* 130
Saussure, Ferdinand de, 183n21,
194–195n33
Sayre, Henry: "Installation and
Dislocation: The Example of
Jonathan Borofsky," 195n4;
Object of Performance, The, 159,
192n7
Schlegel, Richard, 91–92
Schlossberg, Edwin, 2
Schneeman, Carollee, "ABC—We
print Anything—In the Cards,"
177n8
Schwartz, Arturo, 13, 20, 21
Schwittes, Kurt, 138
semiotics, 5
Serra, Richard, 42
Severini, Gino, 14
Shepard, Sam, 148; *Tongues,* 147
Sheppard, Richard, 137, 178n18
Siliman, Ron, 168
Smith, Alexis, 2
Smith, Philip, 127, 129, 130, 131
Smith, Roberta, 3
Smith, Terry, 58, 180–181n4
Smith, Tony, 106, 190n33
Smithson, Robert, xiii, 1, 5, 6–8, 9,